CU01022667

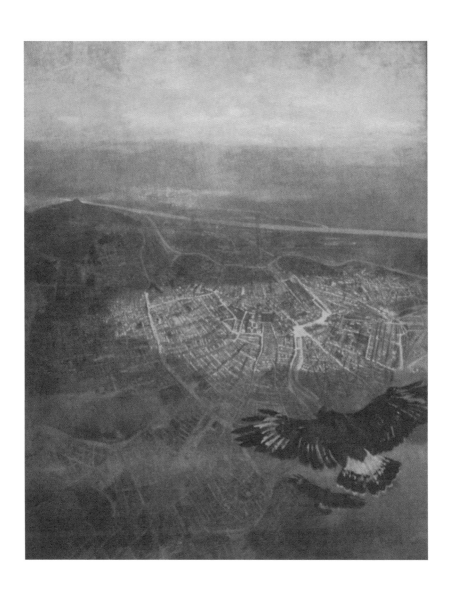

Tag Gronberg

Vienna

City of Modernity, 1890–1914

PETER LANG

Oxford · Bern · Berlin · Bruxelles · Frankfurt am Main · New York · Wien

Bibliographic information published by Die Deutsche Bibliothek
Die Deutsche Bibliothek lists this publication in the Deutsche
Nationalbibliografie; detailed bibliographic data is available on
the Internet at ‹http://dnb.ddb.de›.

British Library and Library of Congress Cataloguing-in-Publication Data:
A catalogue record for this book is available from *The British Library,*
Great Britain, and from *The Library of Congress,* USA

Every effort has been made to obtain permission to reproduce copyright
material. Copyright holders should contact the author regarding any
oversight if proper acknowledgement has not been stated.

Front cover: Hofpavillon Hietzing by Otto Wagner (Imperial Waiting Room
of the Metropolitan Railway), 1898. Copyright Wienmuseum. Photograph
Paul Overy.

Frontispiece: Carl Moll, Bird's-Eye View of Vienna, Hofpavillon, Hietzing,
1898. Copyright Wienmuseum. Photograph Paul Overy.

Cover design: Rika Baggett

ISBN 3-03911-046-2
US-ISBN 0-8204-9334-1

© Peter Lang AG, International Academic Publishers, Bern 2007
Hochfeldstrasse 32, Postfach 746, CH-3000 Bern 9, Switzerland
info@peterlang.com, www.peterlang.com, www.peterlang.net

All rights reserved.
All parts of this publication are protected by copyright.
Any utilisation outside the strict limits of the copyright law, without the
permission of the publisher, is forbidden and liable to prosecution.
This applies in particular to reproductions, translations, microfilming,
and storage and processing in electronic retrieval systems.

Printed in Germany

To my parents
Theresa Zugmann Gronberg and [†]Leslie Charles Gronberg
who bequeathed me fond memories of Vienna

Contents

List of Illustrations

Acknowledgements

I am grateful to many people – family, friends and colleagues – who have helped in the research and writing of this book. I will not repeat here the names of scholars and curators that appear in the endnotes and bibliography, but pay tribute to their publications on Vienna which have afforded me much stimulus and enjoyment.

I thank my colleagues in the School of History of Art, Film and Visual Media at Birkbeck, University of London for their continued support, both practical and intellectual, and in particular Elizabeth Drew for her help in preparing the illustrations. Colleagues elsewhere have also been unstinting in their generosity: Kathy Adler, Gabriele Aigner, Jeremy Aynsley, Pennina Barnett, Tim Benton, Gemma Blackshaw, Barry Curtis, David Crowley, Tamar Garb, Wendy Kaplan, Marcia Pointon, Dorothy Rowe, Jana Scholze, Frederick Schwartz, the late Nikos Stangos, Nancy Troy, Josef and Regina Wagner, Shearer West, Christopher Wilk. I also wish to acknowledge the Leverhulme Trust, whose award of a Research Fellowship was crucial in bringing this work to completion.

The British Library, the National Art Library and the London Library have provided many useful resources for my work. In Vienna I have benefited from the professional and courteous service provided by staff at numerous museums and libraries. These institutions are acknowledged in the picture credits and notes, and I thank also the Vienna City Library, the Wienbibliothek im Rathaus (formerly Wiener Stadt- und Landesbibliothek), where much of my preliminary research was undertaken.

Alexis Kirschbaum, my editor at Peter Lang, has been extremely helpful throughout the final stages of bringing the book into production, as have Adrian Baggett, Rika Baggett and Jennifer Speake.

As ever, my biggest debt of gratitude is to Paul Overy, whose support has sustained me through all stages of the project. I dedicate this book to my parents, to my mother and the memory of my father. It can be only a small recompense for all that I owe them.

Introduction

In a letter of 12 June 1900, Sigmund Freud wrote his colleague Wilhelm Fliess:

> Do you suppose that some day a marble tablet will be placed on the house, inscribed with these words: "In this house on July 24th, 1895, the Secret of Dreams was revealed to Dr. Sigmund Freud". At this moment I see little prospect of it.[1]

This now often quoted remark was written from the Belle Vue, an old spa hotel (*Kurhotel*) on the periphery of Vienna between the wine-growing villages of Grinzing and Cobenzl where in 1895 and 1900 Freud spent his summer holidays as the guest of the Ritter von Schlag family. (Ill. Int/1) Aptly named, the Belle Vue was located at one of several dramatic vantage points high up in the Vienna Woods, popular with urban inhabitants for day excursions and (as in Freud's case) more extended retreats from the city. It is telling that Freud's half-joking query about recognition and commemoration was expressed in terms of a plaque at a renowned *point de vue*, thus implicitly connecting his recently formulated psychoanalytic theories with a sweeping view of Vienna.

As indicated by his allusion to a commemorative plaque Freud was keenly aware of the public profile of his work, the new science of psychoanalysis, vis-à-vis both contemporary and future audiences. His reference to a panoramic view of Vienna in connection with dream analysis was one of several scenarios through which he represented his practice as a psychoanalyst. If the Vienna Woods offered the view of a rapidly growing and modernising imperial capital city, then Freud's frequently recurring metaphor of archaeology made a rather different set of connections between psychoanalysis and the city. Rather than the scanning, broad sweep of the panorama, this involved the patient excavation of layer upon layer of a 'lost' and submerged ancient city, such as Pompeii. Freud created the setting for this work

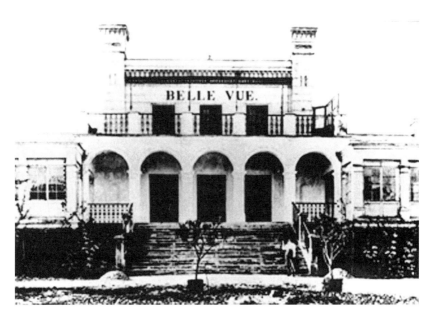

Int.1 Photograph, Belle Vue hotel, Cobenzl, Vienna, c. 1892.
Sigmund Freud Museum, Vienna.

of psychic excavation in the city centre, in his study and consulting rooms at 19 Berggasse, which adjoined the Freud family's apartment.[2] (Ill. Int/2) Here he displayed his collection of archaeological antiquities and reproductions, including the plaster cast depicting a young woman walking, now known as *Gradiva* (a key feature in his essay on Pompeii, 'Jensen's *Gradiva*').[3] Freud thus deployed two ostensibly rather different aspects of modern Vienna – the panoramic view and the urban interior – in order to represent not only his practice but also his professional identity as a psychoanalyst. As is well known, Freud himself had an ambivalent relationship with Vienna. The issue addressed here in *Vienna: City of Modernity* however concerns not so much any individual's personal feelings about the city but rather how, around the turn of the century, certain Viennese sites, views and spatial relationships played a part in signifying the new and the innovative.

The example of Freud indicates the importance of particular types of urban *mise-en-scène* in representing what was 'modern', a modernity now often identified by the catchphrase 'Vienna 1900'. Recent claims for the status of Vienna as a significant cultural centre in the early years of the twentieth century have usually focused on a group of well-known (largely male) protagonists – men whose professional and artistic identities are often produced through association with particular Viennese urban spaces. Take for instance the largescale exhibitions mounted since the 1980s which have presented turn-of-the-century Vienna as a major arts centre equivalent to other European capitals such as Paris or Berlin.[4] Although these exhibitions have usually taken place in art museums or galleries, they nearly all included displays drawn from a wide spectrum, from literature, politics and psychoanalysis as well as from the visual arts of painting, sculpture and architecture. Exhibits of the work of Gustav Klimt and Adolf Loos appeared along with displays relating to Freud, and to writers such as Karl Kraus and Peter Altenberg. This interdisciplinary museological approach was a way of differentiating Vienna from other late nineteenth- and early twentieth-century cities. These displays stressed the distinctive interconnectedness of the city's intellectual life around 1900 – which Edward Timms has characterised as a set of 'overlapping' social circles.[5] A variety of

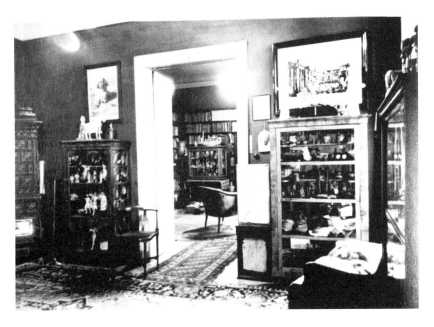

Int.2 Photograph by Edmund Engelman, Sigmund Freud Study,
Berggasse 19, Vienna. Copyright Thomas Engelman.

recurring curatorial strategies was used to link well-known figures with Viennese settings. As a means of evoking the psychoanalytic consulting room, Freud's now-iconic couch featured dramatically in both the 1985 'Traum und Wirklichkeit: Wien 1870–1930' ('Dream and Reality') exhibition at Vienna's Künstlerhaus and in the Vienna section of Tate Modern's first major show, 'Century City: Art and Culture in the Metropolis', in 2001.

Although perhaps the most famous instance, Freud's work rooms were not the only means of representing Vienna through the spaces of the interior. In an arresting museological juxtaposition, the curators of the Vienna section of 'Century City' displayed a confrontation of Freud with Peter Altenberg, the 'proclaimer of modern Vienna' who had also appeared prominently in 'Traum und Wirklichkeit'. Renowned as an '*Asphaltliterat*' and as the 'Verlaine of the Ringstrasse', Altenberg was well suited to 'Century City''s aim of celebrating Vienna as an 'intensely creative environment'. The archetypal coffee-house poet, Altenberg cultivated a Bohemian stance, living in cheap, seedy Viennese hotels in the heart of the city. A quintessentially urban writer in his literary subject matter as much as in his lifestyle, Altenberg found beauty in the detritus of modern city life, like 'cigarettes in the ashtrays of cafés', as Kafka put it.[6] Where 'Traum und Wirklichkeit' had included a partial reconstruction of Altenberg's tiny room in the Graben Hotel, its walls adorned with the poet's collection of framed photographs, the Tate adopted a somewhat less literal approach. Here the psychoanalytic couch at one end of the gallery (along with a selection of artefacts collected by Freud, an Egyptian funerary head and the *Gradiva*) faced a wall hung with thirty inscribed and framed picture postcards from Altenberg's collection. At one level this display highlighted certain differences between Altenberg and Freud. The evocation of Freud's consulting room in his comfortable, middle-class family apartment contrasted with Altenberg's abode in a cramped hotel bedroom. At the same time, exhibition visitors could also ponder certain similarities. Like Freud's preoccupation with slips of the tongue and jokes, Altenberg's prose poems and sketches often deal with apparently trivial and overlooked aspects of life in the modern city.

These museological displays reiterated Freud's and Altenberg's own self-representation through the interiors which they inhabited, the one in the distinguished IXth district of Vienna, the other in the old city centre. For Altenberg as for Freud, the interior with its carefully displayed collection formed a vital aspect of the public persona. In each case, collected objects functioned as metaphors for a professional practice. Altenberg's writing often presents itself as a kind of collecting, as an accumulation of visual observations and overheard conversations. Where the psychoanalytic consulting room displayed artefacts from the past, including Egyptian and classical antiquities, the frame-covered walls of Altenberg's Viennese hotel room revealed a fascination with modern printed ephemera: picture postcards, celebrity photographs, snapshots. While Freud referred to the processes of psychoanalysis by analogy to archaeology, Altenberg compared his poetry to photography, which he claimed was a 'feminine' form of reproduction. Images of young women and pre-pubescent girls proliferated in the poet's picture collection. Altenberg's counterpoint (so to speak) to Freud's *Gradiva* relief sculpture was the photograph of the back of a thirteen-year-old girl's legs, inscribed by the poet 'ideal legs'. Altenberg promoted himself as a protector of children and modern-day 'troubador' of young women, alluding not only to one of his recurrent poetic motifs, but also to the identifying traits of his writing. Altenberg regularly described his writing in ways which stressed its diminutive and feminine attributes. He happily acquiesced in his reputation as a prose miniaturist, an author of literary *Kleinkunst* working in the 'minor' genres (*feuilletons*, short sketches, prose poems, aphorisms). On one occasion he described himself as 'Toilettespiegel, kein Welten-Spiegel' (a 'hand-mirror' rather than a 'mirror of the world').[7] For Altenberg, it would seem that the vastness of the panoramic view was eschewed for the intimacy of the hotel bedroom.

'Vienna 1900' has often been construed in terms of individual interiors transformed through the intellectual and artistic pursuits of their inhabitants. This emphasis on the city as the product of culture coexists with a rather more organic conception of Vienna's development and modernisation. Here the modern city is perceived as the most recent phase of a continuous process, likened to the rings of a

tree or to ever-expanding ripples of water. Stefan Zweig wrote in his memoir *The World of Yesterday*:

> Growing slowly through the centuries, organically developing outward from inner circles, it was sufficiently populous, with its two millions, to yield all the luxury and all the diversity of a metropolis, and yet it was not so oversized as to be cut off from nature, like London or New York. The last houses of the city mirrored themselves in the mighty Danube or looked out over the wide plains, or dissolved themselves in gardens and fields, or climbed in gradual rises the last green wooded foothills of the Alps. One hardly sensed where nature began and where the city: one melted into the other without opposition, without contradiction.[8]

The image was not new. For example, considerably earlier, in his 1911 book *Grossstadt*, the architect and town planner Otto Wagner had described the expansion of the metropolis in terms of circles radiating outwards from the centre.[9] Zweig's version is clearly a rhapsodic and nostalgic evocation of the city's expansion in which economic and political explanations (let alone any sense of conflict) apparently play no role. But his description is compelling in its emphasis on blurred boundaries, for the sense of uncertainty as to where the city actually 'began' or 'ended'. Even more suggestive than the idea of Vienna as a city of unclear outer boundaries – a feature surely of most large towns and cities – is the reference to an absence of oppositions. This might prompt us to reconsider the wider cultural significance of the panoramic city view and the urban interior not so much as different aspects of the modern city, but rather as a series of symbiotic interrelationships.

Freud's allusion to a site in the Vienna Woods and the careful arrangement of his consulting room and study reveal the extent to which such urban imagery – the city's periphery and the interior (the home as the site of work) – played a crucial part in contemporary notions of intellectual and artistic creativity. Another example will serve to illustrate the point somewhat differently. In 1902, the main room of the fourteenth Vienna Secession exhibition was dominated by Max Klinger's brooding statue of Beethoven, who by the later nineteenth century had come to personify not only the archetypal artist but also the processes of artistic creativity. The Beethoven theme was

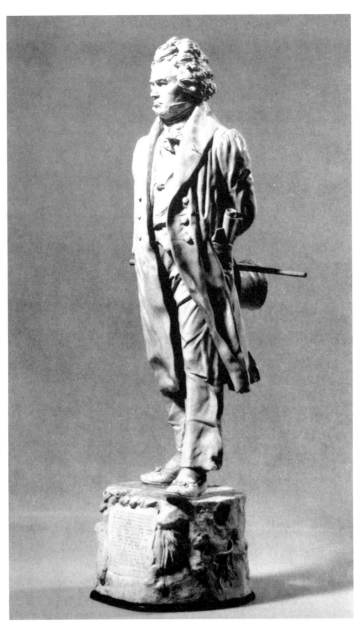

Int.3 Robert Weigl, *Beethoven as Stroller* (*Spaziergänger*),
plaster, 1899.

further elaborated by Josef Hoffmann's designs for the Secession building interior, as well as in decorations by other Secession members. Most dramatic was Gustav Klimt's *Beethoven* frieze, which ran along three walls of a side 'chapel', a symbolic tribute to both the composer and to the nature of great art. As part of a special opening ceremony, Gustav Mahler conducted his own wind arrangement of selected motifs from the fourth movement of Beethoven's Ninth Symphony. With a total of about 58,000 visitors, this was apparently the best-attended of the Secession's exhibitions. Klinger's *Beethoven*, shown seated and deep in thought, is reminiscent of Auguste Rodin's *Thinker*, part of a monumental doorway project on which Rodin had worked extensively at the end of the nineteenth century. But for Viennese audiences, Beethoven signified differently from Rodin's more timeless and universalising allegorical figure.

Although German by birth, Beethoven had composed some of his most famous works in Vienna and his connections with the city played an important role in the ways he which he personified a late nineteenth-century cult of genius. Robert Weigl's bronze statue of *Beethoven als Spaziergänger* ('Beethoven as Stroller') (1899) was shown at the 1900 Paris World Exhibition as part of a display of composers which included Haydn, Mozart and Schubert. (Ill. Int/3) Alluding to a long-standing iconography of the composer, the sculpture's base displays a quote from Grillparzer 'Es geht ein Mann mit raschem Schritt [...]', a reference to Beethoven's many summer walks in the environs of Vienna, occasions when (according to popular belief) he continued composing, jotting down ideas in the notebooks he always carried with him. If his walks identified Beethoven with different locations in the Vienna woods (such as Heiligenstadt), so too did the homes in and near the city where he lived at various points during his life. These were also commemorated, as with Carl Moll's print portfolio of *Beethoven Häuser*, published in 1902 to coincide with the Secession exhibition. Moll's woodcuts illustrated various locations in Vienna (the Schwarzspanierhaus) and on the outskirts (Heiligenstadt and Nussdorf – the Eroikagasse, Wien XIX – as well as Mödling). (Ill. Int/4a & b) Vienna – whether as home or as scenic wooded location – features not merely as the background to artistic creation but also as the necessary spur, the means even,

Int.4 Carl Moll, *Beethoven Houses*, print portfolio published
by the Wiener Werkstätte, 1902, woodcuts. (a) cover of portfolio
(b) Eroicagasse. Copyright Wienmuseum.

of creativity. Again we find the motif of city periphery and centre, views and homes, identified with intellectual achievement and genius. (Revealingly, when Otto Weininger, author of the best-selling book *Sex and Character*, commited suicide in 1903, he chose to do so in one of Beethoven's former homes.)[10] These memorials to Beethoven involve more than tributes to the composer himself. They are at the same time testaments to the artistic and cultural significance of Vienna as a city, not only during the composer's lifetime but also in the years around 1900 at the beginning of a new century.

One hundred years later, the year 2000 marked a significant moment for Austrian institutions of high culture and tourism to work together in promoting refurbished images of 'Vienna 1900'. This was a valuable opportunity to showcase the imperial capital as a city of modernity and centre of artistic innovation. Cafés, and in particular café interiors, were assigned an important role in these millennial celebrations. The turn-of-the-century Viennese coffeehouse is widely recognised as site of intellectual debate and object of artistic transformation.[11] Displays of café interiors were thus an effective means of reinforcing the identity of Vienna as a cradle of modernism in the literary, musical and visual arts. In collaboration with the Kaiserliches Hofmobiliendepot (Imperial Furniture Collection) the Albertina mounted an exhibition on Adolf Loos's Café Museum (1899), presenting the café as artistic meeting place and as evidence of Loos's avant-gardism in architecture and furniture design. At the Café Prückel (1903) on the Stubenring, cabaret artists and actors staged a series of performances entitled 'Tinte & Kaffee' ('Ink & Coffee') proclaiming the motto 'Kaffee ist im Café nicht Zweck, sondern Mittel [...]' ('in the café, coffee is the means rather than the end'). Here the café became a stage on which viewers were invited to participate in the re-enactment of turn-of-the century Viennese literary debate. Such millennial exhibitions and theatrical events merely highlighted, however, the extent to which Viennese urban interiors have long served visitors to the former imperial capital as a means of recollecting the city's *fin-de-siècle* artistic culture. In common with other 'cities of modernity' such as Paris, there are many ways in which the urban fabric of Vienna is preserved and staged so that it can function as souvenir of particular (and carefully selected) 'golden'

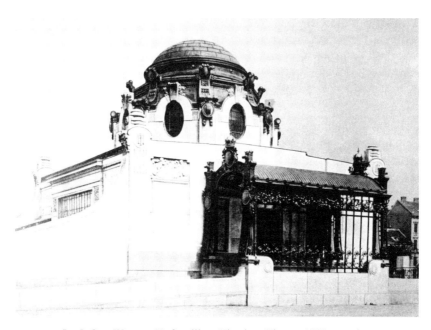

Int.5 Otto Wagner, Hofpavillon, Hietzing, Vienna, 1898, exterior.

epochs.[12] The recent refurbishment of some of the major historic Viennese cafés is indicative. Across the city centre, cafés have been restored (in some cases reconstructed) and promoted in their guise of favoured meeting place for the *fin-de-siècle* Viennese intelligentsia. Visitors are offered a variety of prompts and visual cues to stimulate the imaginative recreation of the city's former intellectual ambiance. At the Café Central on the Herrengasse, for example, one can sip one's coffee at a table adjacent to a startlingly lifelike effigy of Altenberg.

A somewhat different version of the interior as artistic manifestation of urban modernity is presented by the recently renovated waiting room of the Stadtbahn (municipal railway) Imperial Pavilion at Hietzing, designed by Otto Wagner in 1898. (Ill. Int/5) Otto Wagner is renowned as an early exponent of functionalism. But (as commentators have pointed out) the significance of this small, opulently appointed building was always more symbolic than functional. It was used only once by the Emperor Franz Joseph on the occasion of the city railway's inauguration early in the twentieth century. Ostensibly designed to ensure the privacy of the emperor, the building served primarily as public display, signalling a symbiotic interrelationship between the imperial and patriarchal presence and the forces of modernisation. Inside the waiting room, secluded from the public gaze, the emperor would have confronted a vast panoramic birdseye view of Vienna painted by the Secession artist Carl Moll. (Ill. Int/6) Still in situ, this painting shows a pair of eagles soaring at a height of three thousand metres over what is in effect a relief map of the Viennese railway network.[13] Visiting such newly restored interiors, we are reminded that cafés and railway waiting rooms (quite apart from the exceptional case of an imperial waiting room) involve particular and intimate interrelationships between the private and the public sphere. Their walls do not clearly demarcate a hard-and-fast boundary between the private and the public, nor do they indicate the private as an oasis secluded within the public.[14] In both cases, relationships between the interior and exterior spaces of the modern city are clearly signalled. The newspapers provided for customers along with the literary associations of the café, as much as the dramatic railway map, indicate that these interiors were not only linked to but actively involved in the production of the public life of early twentieth-century Vienna.

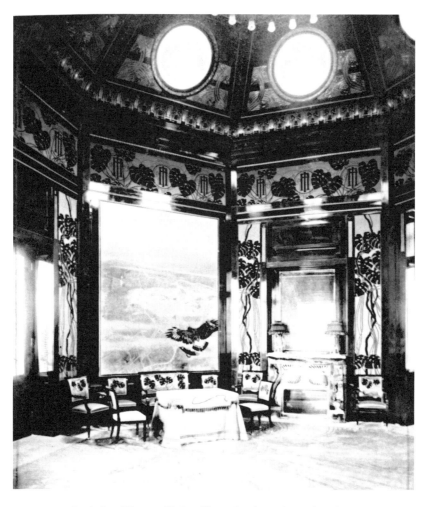

Int.6 Otto Wagner, Hofpavillon, Hietzing, Vienna, interior.
Austrian National Library, picture archives, Vienna, Pk 2.539,770.

Vienna: City of Modernity explores the ways in which the urban fabric of Vienna played an important role in the formulation of artistic concepts of the modern during the late nineteenth and early twentieth centuries. As David Frisby has pointed out in his *Cityscapes of Modernity*, cities are far from being the only site of modernity during this period. At the same time, the city – and in particular the metropolis or *Grossstadt* – offers rich insights into the various modes of experiencing all that is 'new' in modern society. This is in part due to the fact that the discourses of modernity are not only concerned with the actuality of cities (their size and population density, for example) but also with their symbolic potential as representation. There is a preoccupation with how to represent modern cities, but also with how cities themselves can be deployed in order to depict what is modern. Vienna's geographical configuration as an urban entity surrounded by hills enhanced this sense of the city as both the object and the means of representation. Vienna was distinctive too in its preservation of the past in the present. As a result of immigration, largescale municipal construction (in particular the Ringstrasse with its imposing edifices, largely built between 1860 and 1890) and innovations in public transport, Vienna expanded tremendously in the second half of the nineteenth century, both in population and in size. However, its medieval and renaissance *Altstadt* remained, encircled by the Ringstrasse, a constant reminder that modernisation did not necessarily involve the obliteration of the past. Here, modernity was clearly the product of ongoing connections between the past and the present, the outdated and the modern. Vienna, perhaps more than any other European capital city of this period, offered a vivid picture of the tensions and ambiguities inherent in modernity.

This book explores some of the implications of that 'inner-outer dialectic' (as David Frisby has described the dynamics of Viennese modernity) for the aesthetic realm during the years between 1890 and 1914.[15] This was a period which saw many changes. Following on from the Ringstrassen developments, the city continued to be physically transformed through extended transport systems, electrification and urban planning. Immigration, particularly from the constituent countries of the Austro-Hungarian Empire had produced an ever more culturally diverse city. In 1900, those born out of Vienna exceeded those born

within. Women were becoming more visible in professional and public life. They were admitted to the University's philosophy faculty in 1897 and the medical faculty in 1900. Bertha von Suttner won the Nobel Peace Prize in 1905. At the same time however, when 'universal' suffrage was implemented in 1907, it was only for men. At a symbolic level, the image of patriarchal (and aristocratic) authority was maintained in the form of the Emperor Franz Joseph's long reign, from 1848 to 1916. In the realm of gender, as elsewhere in Vienna, tradition coexisted with innovation and change. What then, given these complexities, did it mean to be modern? This was an issue extensively discussed in the aesthetic realm. Newly formed institutions of art such as the Vienna Secession (founded in 1897) and the Wiener Werkstätte (which opened in 1903) not only promoted innovative forms of art and design, they also created new contexts for debate on the role of art and visual culture in the modern city.

The case studies that make up the following chapters have been chosen for the insights they afford into the ways in which Vienna – and ideas about Vienna – played an important part in the artistic debates during the period around 1900. By focusing on a range of work crucially identified with different aspects of Vienna – with its centre, its periphery, as well as with the countryside outside the city – *Vienna: City of Modernity* reconsiders the ways in which Vienna's art and design, as well as its practitioners, were presented as distinctively modern. There is a particular emphasis on the cultural significance of certain types of urban interior (public as well as private) and also, an exploration of how different kinds of panoramic views formed a vital aspect of urban modernity. However superficially different, *Vienna: City of Modernity* argues that these spaces and views were crucially interrelated aspects of modern life around the turn of the century. A major concern of this book has to do with the ways in which 'interior' and 'exterior' functioned not so much as alternative but rather as mutually inflecting spaces. Instead of a sequence of oppositions – exterior versus interior, public versus private, monumental versus intimate – we shall instead explore how in Vienna sweeping vistas and interior spaces were cast into a kind of constant dialogue with each other.

Chapter 1 compares two instances of the artist 'at home': the painter and arts entrepreneur Carl Moll, who commissioned two villas from Josef Hoffmann on the Hohe Warte, then on the outskirts of Vienna, and Peter Altenberg – well known for his lack of any permanent home – who chose to reside in a series of hotel rooms, the last of which was in the Graben Hotel. This juxtaposition establishes the city centre and periphery theme, not only as different geographical locations (the villa in the wooded hills overlooking Vienna and the hotel in the heart of the city), but also in connection with Moll and Altenberg, whose work was identified with locations both in and away from the city's centre. One of the questions addressed here is how such representations of the artist at home complicate notions of domesticity, where it is more often women who are identified with the interior. This chapter explores the significance of these seemingly different permutations of masculinity in relation to contemporary debates on gender and race.

The motif of the Viennese café, so important to Altenberg's writing and public persona, is explored from a different (although related) perspective in Chapter 2. This deals with Adolf Loos's redesign of the interior of the Café Museum in 1899. Altenberg's bohemian lifestyle was but one demonstration of the ways in which the Viennese café offered a 'home from home', particularly for the city's artists and intellectuals. In its pared-down simplicity of design, Loos's 'Café Nihilismus' (as it was dubbed at the time) was identified not only by Loos but also by contemporary critics as a radical contrast to the more elaborately designed ensembles of the Secessionists. Through a reconsideration of the Café Museum's Gibson Room, adjacent to the main space of the café, Chapter 2 addresses the ways in which the spaces of the café both sustained and undermined apparent differences with Secessionist art. It questions the pervasive identification of the Viennese café as a quintessentially masculine bastion of intellectual life.

Chapter 3 examines a very different type of interior: Loos's 1903 design for his wife's bedroom in their city-centre apartment. Like the Café Museum, this redesign was exploited as an aspect of Loos's polemic on modern life; photographs of the bedroom featured prominently in Altenberg's shortlived arts magazine *Die Kunst*. Whereas Loos often

defined the desirably modern in terms of masculinity, and in particular through allusions to men's tailoring, here his preoccupation was with an explicitly 'feminine' space (an emphasis enhanced through the photographs' appearance in *Die Kunst*, which, given Altenberg's involvement, dealt extensively with visual and literary imagery of the feminine). The bedroom for Lina Loos, based on a blue-and-white colour scheme, was notable for the intensity of its tactile qualities. The floor was covered with an angora rug and its walls with fabric hangings, both in white. This chapter explores the significance of tactility as an identifying feature of modern design, both in terms of Loos's ideas but also in the context of contemporary Viennese design of the period more widely.

Chapters 4 and 5 shift attention away from the urban interior to two popular Viennese countryside holiday sites: the Attersee in the Salzkammergut 'lake district' and Semmering, a destination linked to Vienna's Südbahnhof by a scenic railway journey through the lower Alps. As opposed to the wooded hills encircling Vienna, which demarcated a more liminal space, geographically both the Attersee and Semmering clearly lay 'outside' the city. The expansive lake scenery of the Attersee and the *Luftkurort* (fresh-air spa) of Semmering offered two welcome escapes from urban life, particularly during the heat of the summer. But these destinations did not function only as sites of relaxation and leisure. Gustav Mahler retreated to his hut on the Attersee in order to compose undisturbed, while Klimt conceived many of his best-known landscape paintings during his summer stays at various sites on the lakeside. Freud and Altenberg wrote while staying in the Semmering region, and Schnitzler (for example) was known to make day-return journeys to the spa in an attempt to overcome bouts of writer's block. Both the Attersee and Semmering therefore constituted an extension rather than a forsaking of the professional lives and practices of Vienna. In addition to their popularity with Viennese visitors, this intellectual and artistic activity ensured that at the level of representation, far from simply signifying as countryside, the imagery of the Attersee and Semmering was incorporated into that of the modern city.

Chapter 4 focuses on a series of photographs of the fashion designer Emilie Flöge, a number of which were published in 1906–7

in the German arts journal *Deutsche Kunst und Dekoration*. The photographs, taken at various sites around the Attersee, show Flöge modelling flowing, loose-fitting dresses and adorned with Wiener Werkstätte jewellery. This chapter explores how, by contrast with Loos's vehement critique of women's fashion, feminine apparel was assigned a positive role in promoting the kind of Viennese modernism advocated by the Wiener Werkstätte. In this respect, women's clothing was important not merely in terms of its style, but also for the ways in which it identified the modern both spatially and temporally.

Chapter 5 deals with Semmering, which like the Vienna Woods, has long been identified with wide-reaching landscape views. Although perhaps not an obvious milieu for Peter Altenberg, so well known as a Viennese coffeehouse poet, Semmering provided the subject for one of his major works. In 1913, he published '*Semmering 1912*', a collection of prose poems ostensibly based (like much of his other writing) on personal experiences. '*Semmering 1912*' recollected Altenberg's stay in the Hotel Panhans as part of an attempt to recuperate his health. The theme of '*Semmering 1912*' was elaborated by Altenberg not only in literary form but also as an album containing postcards and photographs of the resort. This chapter explores the complex dynamic between the visual and the written in Altenberg's Semmering 1912 project in order to show why this famous Alpine setting was so important for an artistic practice centrally concerned with modern city life. Altenberg was often characterised as eccentric, and indeed he seems to have willingly colluded with this reputation. But however apparently unconventional and innovative its author, '*Semmering 1912*' provides vivid insights into the artistic and social milieu of Viennese society on the brink of World War I.

The historian Carl E. Schorske's groundbreaking study of Viennese culture *Fin-de-Siècle Vienna: Politics and Culture,* first published in 1980, argued that Viennese modernism of this period – artistic and literary – was based on a withdrawal from the public life of the city, its politics and its conflicts, into a life of interiority.[16] In recent years, Schorske's claims have been challenged on a number of fronts.[17] Like so many of those challenges, *Vienna: City of Modernity* remains heavily indebted to Schorske's important study, while at the same time seeking to reassess what may have been involved in various

forms of 'retreat' from the city. By the later nineteenth century in Europe, there existed numerous permutations on (and also refutations of) the motif of a dynamic ebb-and-flow of crowded city streets celebrated by Baudelaire as the principal identifying feature of modernity – the De Goncourts' *Maison d'un artiste*, for example, or Huysmans' novel *A Rebours*. Symbolism, both in literature and in the visual arts, was characterised by an intense preoccupation with interiority and the interior.

The different kinds of cultural practice explored in *Vienna: City of Modernity* however constituted not so much eschewal but rather the attempt to somehow reconfigure modern urban life. Even when explicitly formulated in the context of a withdrawal or departure from the public life of the city, the work produced through such Viennese 'retreats' reveals strategies addressed to and formed by the aesthetic and political debates of the period. Crucial in each case, for example, was the issue of gender, and in particular the importance of different notions of femininity in the production of masculine artistic identities. It has long been a truism that Vienna was, at all levels, a city obsessed by theatre and the theatrical. *Vienna: City of Modernity* explores these artistic moves away from the city street – whether construed as a retreat into the interior or as departure into the countryside – in terms of peformativity. Not so much a matter of seeking solitude, these 'withdrawals' were in fact a form of performance aimed at the inhabitants of the Austro-Hungarian *Residenzstadt* as well as at audiences on a wider international level. Here, Vienna signified more than simply an urban backdrop or an object of necessary reform and modernisation. As a series of sites and views, as the means of articulating complex and shifting relationships, the city played a crucial role in reconceptualising what it meant to be modern – in art as well as in everyday life.

Notes

1 'Glaubst Du eigentlich, dass an dem Hause dereinst auf einer Marmortafel zu lesen sein wird?: "Hier enthüllte sich am 24.Juli 1895 dem Dr. Sigmund Freud das Geheimnis des Traumes." Die Aussichten sind bis jetzt hierfür gering.' Quotation, and date of 12 June cited in '1900: Es erscheint Sigmund Freuds Buch "Die Traumdeutung"', *Traum und Wirklichkeit Wien 1870–1930*, cat. no. 9/2/2, p. 253. The date of 16 June 1900 is cited in Harald Leupold-Löwenthal et al., *Sigmund Freud Museum*, English edn, p. 58.
 A plaque bearing this inscription is now installed on the site of the former Belle Vue; see my Conclusion.
2 On Freud's study and consulting room, see Fuss and Sanders, 'Berggasse 19: Inside Freud's Office'. For a visual record, see *Berggasse 19. Sigmund Freud's Home and Offices*. Mary Bergstein discusses Freud's self-representation in '"The Dying Slave" at Berggasse 19'.
3 See for example, Donald Kuspit, 'A Mighty Metaphor: The Analogy of Archaeology and Psychoanalysis' in Gamwell and Wells (eds), *Sigmund Freud and Art*, pp. 133–51. Freud's essay 'Delusions and Dreams in Jensen's *Gradiva*' (originally published in 1903) appeared in 1907.
4 A series of largescale exhibitions on Viennese late nineteenth- and twentieth-century visual, literary and musical culture was mounted in the 1980s. In addition to 'Traum und Wirklichkeit' shown in Vienna in 1985, these included: 'Le arti a Vienna. Dalla Secessione alla caduta dell'impero asburgico' at the 1984 Venice Biennale; 'Vienne 1880–1938: L'Apocalypse Joyeuse' at the Centre Pompidou, Paris, 1986; 'Vienna 1900: Art–Architecture–Design' at the Museum of Modern Art, New York, 1986. For a recent publication focused on well-known individuals in Vienna, see Brandstätter, *Vienna 1900 and the Heroes of Modernism*.
5 Timms, *Karl Kraus: Apocalyptic Satirist*, pp. 7–10: 'But the whole structure of avant-garde culture in Vienna can be pictured as a series of intersecting "circles"' (p. 7).
6 Barker, *Telegrams from the soul*, p. 176. For the literature on Peter Altenberg, see Chapter 1 The Inner Man, n. 6.
7 'Ich bin so ein kleiner Handspiegel, Toilettespiegel, kein Welten-Spiegel' ('I am a little handmirror, a boudoir mirror, no mirror on the world'). See '"Ich hasse die Retouche": Altenberg's letter to Schnitzler, July 1894' in Barker, *Telegrams from the Soul*, p. 32.
8 Zweig, *The World of Yesterday*, pp. 13–14.
9 Frisby, *Cityscapes of Modernity*, p. 20.

10 On Otto Weininger, see for example, Sengoopta, *Otto Weininger: Sex, Science, and Self in Imperial Vienna*, and Luft, *Eros and Inwardness in Vienna. Weininger, Musil, Doderer.*

11 See for example, Johnston, 'Conversation Triumphant in Coffeehouse and Feuilleton' in *The Austrian Mind*, pp. 119–24, and Segel (trans. and ed.), *The Vienna Coffeehouse Wits.*

12 On tourism in Vienna, see Jill Steward, '"Gruss aus Wien": urban tourism in Austria-Hungary before the First World War' in Gee et al. (eds), *The City in Central Europe*, pp. 123–40; Steward, 'The Potemkin City: tourist images of late imperial Vienna' in Driver and Gilbert (eds), *Imperial Cities*, pp. 78–95. Recent guides to Viennese architecture which address questions of preservation and restoration of the city's architectural 'past' include Almaas, *Vienna: A Guide to Recent Architecture*, and Sarnitz, *Architecture in Vienna.*

13 Geretsegger and Peintner, *Otto Wagner 1841–1918*, pp. 53–6.

14 On the Viennese coffeehouse and relationships between the public and private sphere, see for example, Olsen, *The City as a Work of Art*, pp. 241–3; Janet Stewart, *Fashioning Vienna*, p. 33. Recent studies of the historical and cultural significance of the coffeehouse more generally include Ellis, *The Coffee-House.*

15 Frisby, *Cityscapes of Modernity*, p. 187.

16 Schorske, *Fin-de-Siècle Vienna*. First published by Alfred A. Knopf, New York in January 1980, this book was based on essays published since 1961. See also Schorske, *Thinking with History.*

17 See, for example, Beller, *Rethinking Vienna 1900.*

1 The Inner Man: Interiors and Masculinity

Selbstdarstellung, the public and theatricalised representation of self, has often been cited as a distinctive feature of nineteenth- and turn-of-the century Viennese modernity. Historians regularly describe nineteenth-century Vienna as an urban stage, as a city structured for and by the display of self.[1] The daily afternoon stroll (*Korso*) along the Ringstrasse – the dramatic circular boulevard built to replace the city's ramparts – epitomised this culture of appearances.[2] The ceremonious perambulation of the city's streets revealed a society in which nuances of class and professional status were performed and calibrated, social relationships enacted. The street was not however the only stage for such performances of self. We saw in the Introduction that the intellectual café and the imperial railway waiting room were simultaneously part of and counterpoint to the spectacle of the Ringstrasse. These suggest that the city's interiors were just as much a manifestation of Viennese modernity, similarly implicated in the processes of *Selbstdarstellung*. It is not only the prominence assigned to such interiors in more recent re-presentations of Vienna, but also their emphatic gendering as masculine which have prompted the concerns of this chapter. Although so obviously different in function and appearance, the café and waiting room both present urban interiors as male-inhabited spaces. (Photographs and drawings of coffeehouse 'habitués' invariably gender the space of the café as masculine.) The issue of gender in relation to the Viennese café will be explored in further detail in the next chapter. Here, rather than addressing interiors more obviously associated with the public realm, the focus is on the home to show that even in this ostensibly most intimate, private and 'feminised' form, the interior was crucial to the public staging of masculinity in early twentieth-century Vienna.

This emphasis on the interior (specifically the 'private' interior) follows that of Carl Schorske in his *Fin-de-Siècle Vienna: Politics and Culture*, where he argues that notions of interiority are crucial for an

understanding of Viennese modernity. Disillusioned by the failure of liberal politics, later nineteenth-century writers and artists withdrew from the public sphere and turned their attention inwards. From the 1880s Vienna experienced the rise of mass political movements and growing anti-semitism. The anti-semitic Christian Socialist Karl Lueger was voted mayor of Vienna in 1897; there were anti-semitic student riots at the University in 1897 and 1905; Otto Weininger's highly regarded anti-feminist and anti-semitic book *Geschlecht und Charakter* was published in 1903.[3] Many other historians and commentators have sustained the stress on interiority as a reaction to these circumstances. Jacques Le Rider, for example, in his 1990 essay 'Between Modernism and Postmodernism: The Viennese Identity Crisis' claims: 'The reaction of Vienna's artists and thinkers [...] was to withdraw into themselves. [...] the individual and his inner life were investigated at the expense of social militancy and realistic exposition.'[4] Schorske makes an explicit link between interiority and the interior. Aesthetic culture, he claims, assumed the role of refuge from an uncongenial society. From the 1890s the liberal middle classes had decreased political power but increased wealth. They commissioned Secessionist artists such as Gustav Klimt and Wiener Werkstätte designers (including Josef Hoffmann and Koloman Moser) who worked extensively for the Viennese haute bourgeoisie.[5] In these cases preoccupation with the interior, or more specifically with the aestheticised and artistic interior, is interpreted as signifying withdrawal from political engagement.

The Schorskean view of Viennese modernity has subsequently been elaborated and problematised in a number of different ways. There is now a renewed concern with what is often identified as 'critical' forms of Viennese modernism, such as that produced by the circle of Karl Kraus, which included the architect Adolf Loos and the writer Peter Altenberg. In this context, the interior takes on a somewhat different guise. The case of Peter Altenberg (1859–1919), who during his youth in the 1880s was diagnosed as neurasthenic and hence incapable of pursuing a career in the family business, provides a revealing example.[6] Altenberg became an author, well known for his *feuilletons* and short prose poems. Altenberg never had a home of his own. Apart from a short period (1901–4) when he resided with his

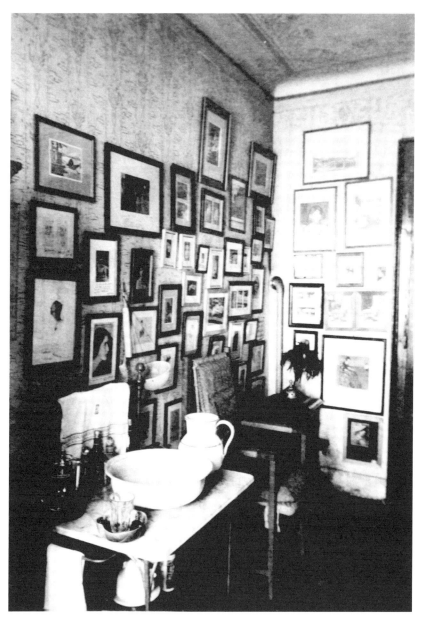

1.1 Photograph, Peter Altenberg's Room, Hotel London, Vienna.
Copyright Wienmuseum.

brother Georg Engländer, for most of his life he lived in cheap Viennese hotels, in the Hotel London (1904–10) and from 1913 to his death in 1919 at the Graben Hotel in the Dorotheerstrasse. (Ill. 1/1) Altenberg worked hard on the interior of his small hotel rooms: inscribed photographs and postcards were framed and carefully hung on the walls.[7] He also wrote and spoke about these rooms, as did his contemporaries, for whom Altenberg was a cult figure.[8] The picturesquely bohemian Altenberg was much lauded by Viennese intellectuals: Arthur Schnitzler, along with Kraus and Loos, figured amongst his admirers, as did Thomas Mann. Jürgen Habermas recounts that Theodor Adorno spoke of Altenberg 'as an example of individualism carried to the extreme, a last hiding place where a private life could escape from the control of totalitarian authorities and allegiances, anticipating a freer conception of mankind.'[9]

Here then, are two versions of the modern interior as a withdrawal from public life. On the one hand the aestheticised Secessionist interior interpreted by Schorske as a kind of cultural cosmetic and compensation; on the other, Altenberg's hotel room defined as critique of and resistance to bourgeois society and culture. It has become something of a cliché to identify the domestic interior with femininity and the public world of the city streets with masculinity.[10] This chapter however suggests that Viennese preoccupations with masculinity and the interior offer revealing insights into the significance of interiority, whether as withdrawal and 'escape', or as critique. Two examples will be examined in detail: Carl Moll's (1861–1945) painting *Self-Portrait in the Studio* (c. 1906, Akademie der bildenden Künste, Gemäldegalerie), alongside Peter Altenberg's rooms at the London and Graben Hotels where he lived for most of his adult life.[11] (Ill. 1/2) The inhabitant of the aestheticised interior and the neurasthenic author closeted away from the modern urban environment are both figures familiar from fin-de-siècle aesthetics.[12] But these Viennese case studies have not been chosen as indicative of 'different faces' of masculinity or indeed of artistic identity. The concern rather is with how such representations of a male-inhabited interior functioned as product of and response to the conditions of modernity in early twentieth-century Vienna.

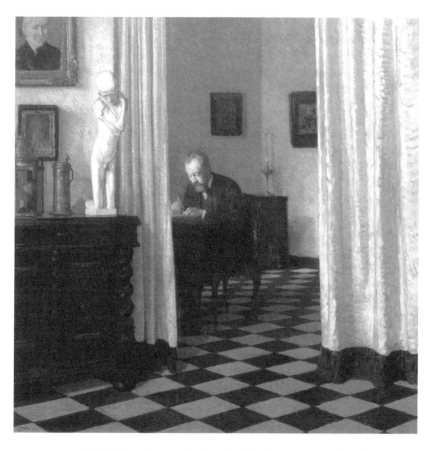

1.2 Carl Moll, *Self-Portrait in the Studio*, oil on canvas, c. 1906.
Gemäldegalerie der Akademie der bildenden Künste Wien.

In considering how modernity might be articulated through the relationship of male body to interior, it is perhaps useful to begin by referring to a much earlier metaphor of the male body in domestic space. In his essay 'Untitled: The Housing of Gender', Mark Wigley traces the stereotype of male mobility in the exterior and female stasis in the interior back to the fifteenth century, to Alberti and through Alberti, even earlier to the fifth-century BC Xenophon. But as Wigley argues, 'in fact, it is the man that is immobile, fixed to the house – in the sense of both family and building.' He quotes from Alberti's *Della Famiglia* (book III):

> You know the spider and how he constructs his web. All the threads spread out in rays, each of which, however long, has its source, its roots or birthplace, as we might say, at the centre. The most industrious creature himself then sits at that spot and has his residence there. He remains in that place once his work is spun and arranged, but keeps so alert and watchful that if there is a touch on the finest and most distinct thread he feels it instantly, instantly appears and instantly takes care of the situation. Let the father of a family do likewise. Let him arrange his affairs and place them so that all look to him alone as head, so that all are directed by him and by him attached to secure foundations.[13]

Alberti's picture of the domestic arrangements of the male spider is suggestive, involving much more than simply notions of patriarchal dominance and control. We might, for example, read the metaphor of the spider as implying a shifting (as opposed to static) gendered identity, masculinity inferred as a constant process of vigilance and renegotiation. Similarly, the imagery of a male-generated web complicates notions of a relationship of inside to outside, in both a visual and a tactile sense. It defines less a hard-and-fast boundary or barrier than a mechanism of engagement and readjustment. The gossamer web suggests both a visual image and a series of relationships, fragility as much as power or the imposition of authority. Far from indicating a feminised or indeed a private and separate sphere, the case of the spider presents us with the idea of home as masculine fabrication and public spectacle.

Alerted, then, to the potential complexities involved in notions of masculinity 'at home', let us return to the question of Viennese early twentieth-century interiors. Carl Moll's *Self-Portrait* is on several levels a testament to his professional involvement with and commitment to

the Vienna Secession. Moll was vice-president of the Secession from 1897, president in 1901, and from 1904 to 1912 director of the commercial Galerie Miethke which represented Gustav Klimt.[14] The square format of this 1906 painting is characteristically Secessionist as are the pale tonalities of the depicted interior, the white walls and curtains and silvery light. The picture also involves specifically Secessionist notions concerning relationships of interior to exterior space. The Vienna Secession building designed by Olbrich in 1898 was conceived as a 'temple to art,' an exhibition space in which the Secessionist ideal of the *Gesamtkunstwerk* (the total work of art) could be presented through carefully contrived exhibition installations such as the famous 'Beethoven' exhibition in 1902.[15] The 'Beethoven' exhibition involved painting, sculpture, music and paid tribute to a masculinity construed as genius. But Secessionist theories of the *Gesamtkunstwerk* were also worked out through the architecture of the house and the domestic interior.[16] Such is the case here with Moll's painting, one of a series in which he depicted the two villas that the Secessionist architect Josef Hoffmann designed for his family in 1901 and 1906 as part of the artists' colony on the Hohe Warte.[17] The concept of home as *Gesamtkunstwerk* involved a blurring of boundaries between inside and outside, a reiteration of motifs both on the interior and exterior (in the case of Hoffmann, for example, geometrical designs). Moll's stepdaughter Alma Schindler (later Alma Mahler and subsequently Alma Mahler-Werfel) refered to the Secessionist concept of aesthetic fusion in the July 1901 entry of her diary: 'It's just like a music-drama: the interior and exterior of the house merge together. Not one running parallel to the other, but like a loving married couple.'[18]

One way this is articulated at the Hohe Warte (architecturally as well as in Moll's paintings) is through a geometricised representation of nature. Flowers and plants are strategically sited indoors while the garden, with its terraces and planters, is designed as an extension of the house.[19] Walter Benjamin asserted that 'with Van de Velde, there appeared the house as expression of the personality.'[20] Similarly, Schorske describes the way in which Secessionist architecture was construed as a form of portraiture. He speaks of the Secession client as a 'man of sensitivity and high aesthetic culture', a masculine identity defined from within – the house as personal expression of the soul,

private mirror and public expression of the owner's personality.[21] Architecture operates as the representation of its owner to the outside world. Moll's picture could thus be seen as a self-portrait on two levels. The reference to Hoffmann's architecture constitutes one dimension of the portrait, his own composition of the painting – with its interior *mise-en-scène* – another. Indeed, the picture draws our attention to Moll's environment as much as to the artist himself. We are shown neither the painter at work (he seems to be writing) nor any of Moll's own paintings. Rather the viewer's attention is drawn to the sculpture by the Belgian George Minne and, just discernible, Van Gogh's portrait of his mother.[22] These signal Moll's status as collector and also his energetic efforts in showing and dealing in European avant-garde art in Vienna, at (effectively) two Secession sites: the Secession building itself and (from 1904) the Galerie Miethke.[23] More an image of a scholar in his study than an artist in the studio, Moll stages himself here as Secessionist impresario, emphasising not only his relation to the Secession but also his part in that movement's attempts to define a specifically Viennese artistic avant-garde.[24]

The nature of that avant-garde was however, a matter of dispute.[25] Chapter 2 considers in more detail the architect Adolf Loos's criticism of the Secession and the Wiener Werkstätte in terms of what he characterised as superfluous and unnecessary ornamentation. He also condemned the tyrannical imposition of one architect's design on every last detail of the interior as a kind of aesthetic straitjacket.[26] Moll's 1903 painting of his wife gives some indication of what this might involve. (Ill. 1/3) The picture shows Anna Moll at her desk wearing a loose, flowing Secessionist dress.[27] She appears as a manifestation of the architectural ensemble, as part – but also as embodiment – of the house as *Gesamtkunstwerk*. Here, everything (the desk, the dress, even the symmetrically arranged flower pots) seems to function as a demonstration of Secessionist 'reform', of an updating and modernising of the interior. However, Moll's Hohe Warte interiors involve somewhat more complex relationships of time – of past to present – than this might seem to imply. In this connection, the location of the villas was itself significant. In his 1903 book *Das Moderne Landhaus* (*The Modern Country House*), Joseph August Lux (like Otto Wagner, and much later, Zweig) compares

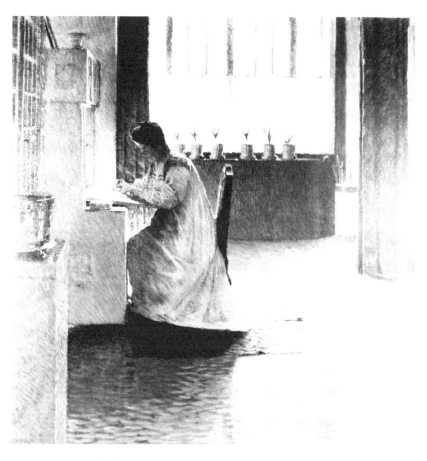

1.3 Carl Moll, *My Living Room (Anna Moll at her Desk)*,
oil on canvas, 1903. Copyright Wienmuseum.

the expansion of Vienna to outward-expanding rings. He refers to 'Villenvorstädte' ('villa suburbs') as 'der jüngste Altersring' ('the newest ring'), a point of encounter between urban and rustic culture. According to Lux, it is in the 'Vorstadt' areas that valuable examples of 'true' Viennese culture are best preserved. He identifies the Hohe Warte as a significant *Kulturlandschaft* (cultural landscape), for its connections with Beethoven, who lived and worked in the area, and more generally, as a popular destination for picnic excursions (*Jausenausflüge*) from the city – a good 'Altwienerisch' ('Old Viennese') Tradition.[28]

But the concept of a *Kulturlandschaft* also involved a domestic dimension. City inhabitants, claimed Lux, shared a powerful desire ('Sehnsucht') to experience country life in a home such as that previously occupied by their grandparents' generation. Leaving behind the city, urban dwellers were entranced by the sight of old whitewashed farmhouses and country houses, with flowers at the windows and gardens in bloom. The modern dream was for a home of one's own, in which the rooms formed an organic connection with the harmonious life of the family.[29] According to Lux, despite a certain amount of indiscriminate modern destruction, it was still possible to discern the traces of this grandparents' generation in the *Villenvorstadt* of Vienna. For Lux, as for many other commentators of the turn of the century, the early nineteenth century – often referred to as the *Biedermeierzeit* – represented a golden age of Austrian society. Biedermeier was identified not only as a period of art and design, but more fundamentally, as a cultural milieu in which the family home acquired enhanced significance as a harmonious idyll.

The Altwiener Hausgärten still visible along the Hohe Warte were an important feature in depicting this domestic harmony. In *Das Moderne Landhaus* Lux dwells lovingly on the ways in which the blue-and-white verandas of the Biedermeier period were, like the terraces and conservatories, an important means of forming a connection between garden and architecture. In this albeit highly romanticised view of early nineteenth-century domestic culture, the interaction between gardens and house is itself symbolic, an indication of Biedermeier architecture as the 'organic' response to the life and needs of the family. As Lux was an ardent supporter of the Vienna

46

Secession, it is not surprising that he should identify Hoffmann's architecture as the most successful attempt to perpetuate such desirable Biedermeier qualities. (*Das Moderne Landhaus* includes lavish photographic coverage of Hoffmann's Hohe Warte villas.) Lux claims that Hoffmann avoided the mistakes of so much other recent villa architecture built on the outskirts of Vienna: the vulgar use of cheap ornamentation and the mishmash ('Ragout') of styles whose only function is to proclaim the status of its inhabitants. As opposed to this emphasis on the façade, Hoffmann's villas took form as an expression of the family life carried out in their interiors. Lux compared these homes to well-fitting garments, in contrast to the 'masquerade' produced by more pretentious villa architecture.

Moll's painting of his wife writing at her desk is roughly contemporary with Lux's book. In its subject matter, with its emphasis on domestic family life, it evokes Biedermeier paintings such as Johann Peter Krafft's portrait of his daughter, *Marie Krafft am Schreibtisch* (1828–34). (Ill. 1/4) Both show female figures in white dresses, seated at desks placed in front of a window. The presence of a garden is indicated in both too: in the form of a view through the open windows in Krafft, and by the artfully arranged row of flower pots on the window sill in the case of Moll. Moll's picture pays tribute to Biedermeier painting in order to evoke a domestic idyll. But there are also telling differences between the two works. Krafft's painting depicts a lyrical engagement with nature. Marie Krafft is shown gazing out of the window, pausing to refresh eyes and mind by looking at the gardens. Sunshine flows through the window into the room, playing on Marie's face and illuminating the page on which she writes. A straw hat and shawl draped casually on an adjacent chair hint at a recently completed walk. Moll's interior scene suggests something rather more introverted. A half-length white curtain blocks the view into the garden, forming a backdrop to the regimented flowerpots. Anna Moll's face is cast into shade, the features of her face indiscernible as if to emphasise the concentration of writing as an intensely inward process. However superficially similar to Maria Krafft's informal summer outfit, Anna Moll's dress signifies differently too. Its flowing lines suggest that this is a version of the *Reformkleid* popular in certain artistic circles at this period. (We shall return to

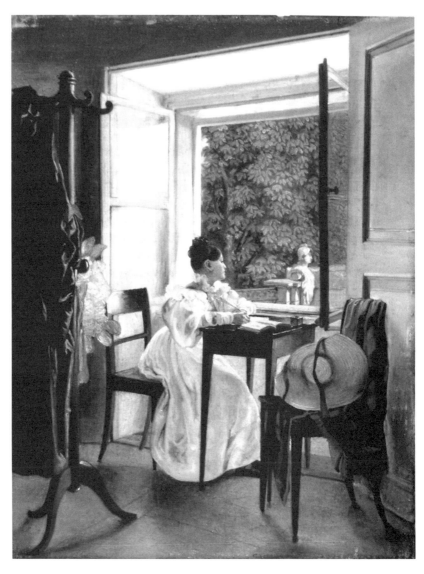

1.4 Johann Peter Kraft, *Marie Krafft at her Writing Desk*, oil on canvas, 1828–34. Oesterreichische Galerie Belvedere Vienna.

the Viennese preoccupation with 'Reform' dress in more detail with Chapter 4.) The implication surely is that, like this dress, the Moll villa is an example of the well-fitting, comfortable architecture so praised by Lux, an architecture whose forms are the 'organic' manifestation of its interiors. Moll's picture acknowledges its Biedermeier antecedents in order to convey a very contemporary, modern message.

Moll used his paintings in a variety of ways to demonstrate Secessionist notions of how the modern was to be construed through reference to the past. Like the painting of his wife, Moll's *Self-portrait* (along with other of his paintings of the two Hohe Warte villas which show pieces of furniture from earlier historical periods) is a demonstration piece on the aesthetic complexities involved in modernising the interior. The domestic interior conceived as *Gesamtkunstwerk* established a space to incorporate both past and present, modern and traditional. Viennese modernism is formulated in the context of a wider European avant-gardism but also in relation to Austria's own heritage. Rather than imposing a restrictive uniformity based exclusively on contemporary design (as alleged by Loos), Secession interiors were intended to function as a framework in which older styles (family heirlooms for example) became part of a new modern ensemble.[30] This strategic incorporation of the past – the painting and furniture of 'Alt-Wien' – was also a policy followed by Moll as director at the Galerie Miethke which dealt simultaneously with modern and earlier art (albeit in two different showrooms). The representation of himself at his desk thus signals Moll's role as the producer of narratives on the identity of Austrian modernism. Moll's Hohe Warte villas and paintings were not merely forms of self-depiction, they were also a form of polemic for the values of the Vienna Secession, indicative of an avant-gardism as much concerned with maintaining (and redefining) relationships to the past as with depicting the changed face of the future.[31]

Let us now turn to Peter Altenberg's Viennese hotel rooms.[32] Walter Benjamin famously characterised the nineteenth-century bourgeois interior in terms of its coverings and casings, describing the nineteenth-century home as 'a receptacle for the person'. 'What didn't the nineteenth century invent some sort of casing for!', proclaimed Benjamin, proceeding to delineate innumerable permutations on the

theme of the *étui*, dust covers and sheets, as well as: 'Pocket watches, slippers, egg cups, thermometers, playing cards – and, in lieu of cases, there were jackets, carpets, wrappers, and covers.'[33] The twentieth century on the other hand, he claimed, advocated porosity and transparency; living space was radically reduced in scale 'for the living, with hotel rooms, for the dead, with crematoria'.[34] Altenberg, on one occasion, referred to his small abode as 'my coffin-closet' but more often he deployed an imagery based on the surfaces of the living, human body. Around the turn of the century he wrote:

> possessions must be like the possessions of one's skin or one's hands! They belong to me, are indispensable, maintain, as it were, the collective organism, are exquisite parts of it, the exterior covering the epidermis! Whatever stands on my table, on my walls, belongs to me like my skin and my hair. It lives with me, in me, of me. Without it I would be almost a rudimentary, something stunted, poorer.[35]

The room, or rather its covered walls, are like living skin, simultaneously *étui* and porous. This involves more than either the familiar idea of the human body as both container and contained or a suggestion of fluid boundaries. Rather it seems to imply a subjectivity (or subjectivities) in a continuous state of formation and reformation. Altenberg's carefully staged hotel rooms were virtually an extension of his daily public life in Viennese cafés – indeed the Hotel London was just across the street from the Café Central. His hotel rooms were conceived (and interpreted) as a rejection of the stifling domesticity of the bourgeois home. Metaphors of the interior as a kind of casing or covering for the inhabitant play a crucial role in the verbal and written accounts of Altenberg's room, but these are deployed in order to portray a responsiveness to life on the streets of Vienna.

In his consideration of the nineteenth-century interior, Benjamin interpreted the myriad manifestations of the *étui* as 'so many measures taken to capture and preserve traces [of the inhabitant]'.[36] In this sense the interior shares something of the characteristics of the photographic plate. Such notions of indexicality are suggestive in considering the significance of the London and Graben hotel room walls, covered with photographs. Altenberg often referred to the processes of photography as metaphor for his own practice as author, describing his writing as

the product of an almost passive receptivity to external stimuli – the artist as photographic plate.[37] Altenberg promoted himself as an artist devoted to '*Kleinkunst*', short sketches and prose pieces picking up on the – often overlooked – details and ephemera of urban life, the 'little people' of Vienna. Altenberg's habitual presence in Viennese coffeehouses, most famously the Café Central, accords with a flâneurial persona of the artist, but it was the flâneur's receptivity as much as his role as boulevardier that he (and others) so often emphasised. Take for example Felix Salten's description: Altenberg's 'deepest need is to sit still and to behold life and while beholding it to be drawn to it or to grieve.'[38] The flâneurial persona is described in terms of closeness rather than distance, and mobility is construed more in terms of multiple and shifting identifications than as urban strolling and erotic encounter.

Altenberg liked to present himself as a collector. He often spoke about his vast collection of photographs and postcards and voiced concern regarding the fate of his *Nachlass* (bequest), part of which was eventually acquired by the Historical Museum of Vienna, today known as the Wien Museum.[39] However Altenberg's photographs were not only collected but also, on occasion, especially commissioned and designed by him, and sometimes turned into postcards.[40] There are some pictures of landscape, but the photographs fall mainly into two categories: photographs of women and young girls and photographs of Altenberg himself. The imagery of attractive young women (often dancers and performers) might seem to accord with notions of flâneurial desire. Those of female children need to be considered in relation to a more widespread preoccupation with underage femininity in male Viennese intellectual and artistic circles: the 'erotic subculture of Karl Kraus' with its cult of *das Kindweib* (the 'child-woman'), as well as the condemnations of Adolf Loos, who claimed that the fascination of Viennese society with youthful femininity was evidence of the as-yet-incomplete project of modernity.[41] The more general point to draw out in this connection, however, concerns the extent to which Altenberg's artistic identity was, in various and complex ways, feminised. As suggested by the comparison of his possessions (the many photographs of girls and women) to his own skin, Altenberg's

whole authorial persona was to an important degree produced by relating to certain kinds (and aspects) of femininity.

This feminisation of Altenberg's artistic persona formed part of contemporary debates on artistic identity and the processes of art. In 1914, Madame D'Ora ('the most important portraitist of the Viennese cultural elite') published a brochure advertising her photography studio. This included an essay by Hans Heinz Ewers, which defines painting as male inwardness and photography as female outwardness (mastery of surfaces is defined as an inherently female talent). Peter Altenberg is here represented as embodying a kind of synthesis:

> Peter Altenberg does not know what a Danae he is himself nor that every artist must be one: masculine and feminine alike, impregnating and giving birth. The purely male man will never have a profound relationship to art, nor will the entirely female woman: Hermes and Aphrodite created the soul of the artist *together*.[42]

Similar characterisations of the artist are of course not difficult to find in other contexts throughout late nineteenth- and early twentieth-century Europe. Nor are they surprising in an intellectual environment where theories of bisexuality were being espoused by writers as different as Freud and Weininger. Such assertions only become meaningful in the specific context of contemporary discourses on the nature of art and culture, in this case a political climate marked by obsessions (such as that, for example, of Weininger) with the over-'feminisation' and 'Judaisation' of Viennese society, a point to which we shall return.[43]

Identification and empathy with the feminine formed an important part of Altenberg's literary pronouncements, including the stories through which he narrativised his origins as a writer. In 'How I Came to Be' (1913) he describes his 'discovery' in the Café Central by the Jung Wien (Young Vienna) circle of authors: 'I had in front of me the *Express* with the photograph of a fifteen-year-old girl who disappeared forever on the way to a piano lesson.'[44] 'How I Became a "Writer"' (1919) tells a rather different story:

> In the summer of 1894, while in Gmunden, two adorable girls, nine and eleven years old, attached themselves to me with a passion. The end of September the family returned to Vienna. On the night of the tearful departure of Alice and

Auguste I wrote the first sketch of my life, at the age of thirty-five, under the title: 'Nine and Eleven.' This became the first sketch in my book *As I See It*.[45]

The same applies to 'Altenberg', the nom de plume adopted by Richard Engländer. Altenberg is a little town on the Danube where the writer had holidayed as a student; 'Peter' was the nickname of the thirteen-year-old Bertha Lecher (sister of a friend) with whom he had fallen in love on that occasion. In all three cases, artistic identity is formulated through reference to children's femininity and to loss: the disappearance of the fifteen-year-old, the 'lost idyll' (as Altenberg would have represented it) of his own youthful love for 'Peter', the innocence of the two children's affection ('9 & 11') for him. Altenberg fought and protested against, he always claimed, men's sexual exploitation of women, which he saw not only as a bourgeois society's but also an intellectual sexual hypocrisy, whether formulated as the Krausian fantasy of the 'child-woman', conceived as an oversexed, undereducated femininity necessary for the male artist's inspiration, or as the Viennese obsession (as narrated by Schnitzler) with the prostitute.[46] Altenberg presented himself not only as the friend and protector of childish femininity, but also as its masculine equivalent: naively innocent, receptive, capable of unerotic love – the male artist reverted to a pre-lapsarian, pre-oedipal state. These pronouncements were also enacted visually, as in the carefully posed photograph inscribed '55 and 4! Peter and Lily' which shows Altenberg on the beach at the Venice Lido.[47] (Ill. 1/5) Here again a holiday environment provided the context for the encounter of age with youth, a physical juxtaposition in which Altenberg's body emerges ambivalently as both protective and vulnerable.[48]

Today, confronted with his obsessive collection of inscribed photographs of young girls, we would undoubtedly question Altenberg's own idealising interpretation of his project.[49] At the same time, any assessment of the full significance of the widespread and various imagery of childhood at this time must take into account turn-of-the-century Viennese anxieties and debates on the position of children vis-à-vis their parents, and more fundamentally, the safety of children in the family home. With his formulation of the Oedipus complex, as is now well known, Freud problematised notions of family harmony,

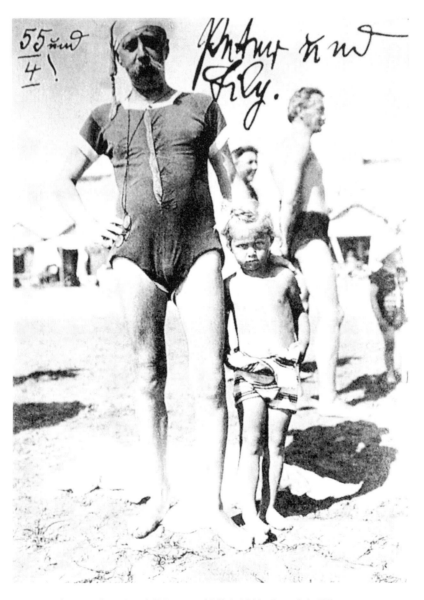

1.5 Photograph, '55 and 4! Peter and Lily', 1903. Copyright Wienmuseum.

characterising attitudes between children and their parents as ambivalent rather than straightforwardly affectionate and loving. His book *The Interpretation of Dreams* was published in November 1899 (with the titlepage postdated to 1900, perhaps to align it with the modernity of the new century) but these ideas were slow to reach a more general, non-specialist public; only 351 copies sold in the first six years. More immediate – and shocking – in impact were the two widely reported Viennese court trials held in November 1899 in which parents were accused and convicted of abusing and murdering their own children. As Larry Wolff demonstrates in his book *Postcards from the End of the World*, the information released at these trials constituted a brutal challenge to ideas of the family home as sanctuary and safe haven.[50]

Anxieties and uncertainties concerning the family and family relationships form (at least part of) the context through which to reconsider the significance of both Secessionist painting and Altenberg's photographs. Secessionist design is often interpreted as an attempt to update early nineteenth-century Biedermeier art. However, this is Biedermeier revived not only in terms of formal qualities of simplicity and light, but also as the picturing of idyllic, bourgeois families – reassuring scenes of loving parents, a harmony ensured by the presence of a benign patriarch.[51] (Ill. 1/6) In the case of Altenberg, on the other hand, disturbing revelations concerning the family home might be deployed to legitimate his rejection of bourgeois domesticity, as well as his claims to represent (or prefigure) a new adult masculinity, capable of different and kinder relationships with children. This stance was ostensibly reinforced by Altenberg's financial contributions towards the protection of children, both during his lifetime and in his will.[52]

The juxtaposition of Moll's painting with Altenberg's hotel rooms seems to involve contrasting images of male interiority: on the one hand, Moll's embrace of bourgeois domesticity as a frame for self-representation; on the other, Altenberg's fabrication of a bohemian persona that was at home everywhere but in the domestic sphere – in shabby hotels, sociable cafés, mental sanatoria. But it is important to stress that for all the apparent differences (the contrast between elegance and shabbiness, harmonious family life as opposed to confirmed bachelorhood) this pairing involves as many similarities as

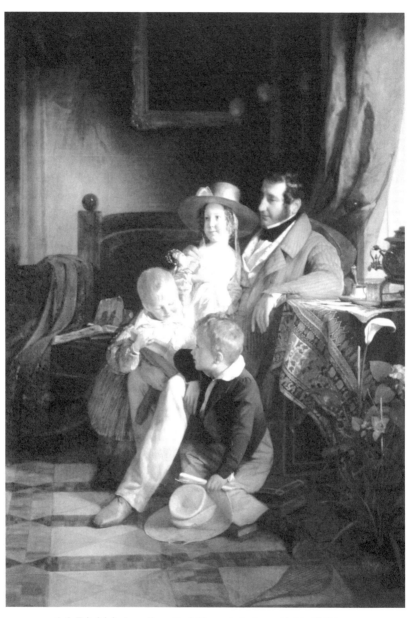

1.6 Friedrich Amerling, *Rudolf von Arthaber with his Children
Rudolf, Emilie and Gustav*, oil on canvas, 1837.
Oesterreichische Galerie Belvedere Vienna.

oppositions. In both cases the interior is presented as a sphere of the masculine intellect, a living space which combined the functions of study, private collection and exhibition.[53] Here was a domain in which the literary and the visual were mutually reinforcing. These interiors were at once the spaces of artistic and intellectual activity and the product of that work.[54] In advocating different concepts of a synthesis between art and life, both interiors performed the role of artistic manifesto. Moll's studio formed the microcosm of a larger totally designed environment, that of the house. The proliferation of photographs in Altenberg's hotel rooms on the other hand was significant not only for what these represented but also for what was implied by the indexicality of photography – the receptivity and openness of the writer. The London and Graben hotel rooms were a declaration on the nature of artistic practice, a claim for the necessity to focus on the banal and mundane aspects of everyday life in the metropolis. The masculinities presented here form a contrast to the artistic personae often identified with 'Vienna 1900', whether the heroic and tormented genius represented by Beethoven or the more flamboyant eroticism associated with Klimt. Moll appears withdrawn, almost merged with his environment; Altenberg as childlike in his physical fragility and febrile sensitivity.[55] These interiors were utopian statements pointing the way towards a new aesthetic and an improved future, a future symbolised in each case by the attributes of youth: the renewal of culture effected by *Jugendstil* (in the case of the Secession); for Altenberg, a new art based on the innocence and naturalness embodied by the pre-pubescent girl.

It is often claimed that in the modern period living space became increasingly distinguished and distanced from the place of work. But it is apparent that Moll's Hohe Warte villas and paintings were produced almost as an extension of his work as a dealer and impresario, in effect, an advertisement for the affluent middle-class home transformed into Secessionist *Gesamtkunstwerk*.[56] (The Viennese ideal of the *Gesamtkunstwerk* – an environment construed as a self-contained aesthetic totality – was, in practical terms, an expensive business, and commissions were few and hard to come by. Adolphe Stoclet apparently commissioned Hoffmann and other Wiener Werkstätte artists to design his Brussels palace partly as a consequence of his

admiration for the Moll villa.)[57] Since his death, Peter Altenberg and his hotel rooms have regularly been presented as emblematic of a certain sector of the Viennese avant-garde. From 1928 to 1938 a reconstruction of the 'Peter-Altenberg-Zimmer' was put on show at Otto Kallir's Neue Galerie as a memorial to the writer, and the largescale 'Traum und Wirklichkeit' ('Dream and Reality') exhibition curated and designed by Hans Hollein in 1985, with the Historical Museum of Vienna, displayed a lifesize partial model of the hotel room.[58] These reconstructions of an 'Altenberg room' invoke neither the domestic interior nor that touristic and museum genre 'the writer's house' (in this sense different from, say, Proust's cork-lined study exhibited in Paris at the Musée Carnavalet). The photograph-covered walls of Altenberg's hotel room, with its many pictures of women and young girls, are presented not only as a shrine to an authorship made possible through a rejection of bourgeois values and family life but also as a tribute to the male inhabitant's power – through his work as author – to appropriate the anonymous and transitory spaces of the modern city as 'his own'.

Although Moll's paintings and the representations of Altenberg's hotel rooms concern the interior, neither of these is strictly speaking a 'private' space. Both involved a carefully staged *mise-en-scène* put on public show. Moll's Hohe Warte paintings were exhibited; the house itself was designed with a view to extensive entertaining and socialising (often for professional and business purposes). There were many written and visual, public and institutional manifestations of Altenberg's hotel room. Although they seem to involve different locations – the Hohe Warte artists' colony with its Hoffmann villas on the edge of Vienna, facing out to the city from the Vienna Woods; the London and Graben hotels right in the heart of Vienna, close to the cafés frequented by the literary and artistic intelligentsia – these urban spaces were not really so far apart. The Galerie Miethke, where Moll worked as Director, was just a few doors down from the Graben Hotel in the Dorotheergasse. More important than the issue of literal geographical space however is the fact that these interiors were in some way addressed to a public, to shared or at least overlapping audiences (albeit audiences with different and often conflicting

views and opinions). Although at one level concerned with self-representation in and through the interior, the significance of Moll's painting and Altenberg's rooms has never been just a matter of their own individual identities. In later periods (as much as in Moll's and Altenberg's lifetime) this retreat to the interior, whether construed as the aestheticisation of everyday middle-class life or as the bohemian rejection of bourgeois domesticity, has been characterised as symptomatic of a specifically Viennese modernity as well as evidence of Vienna's status as a birthplace of modernism.

To return to the issue of Viennese modernity and notions of withdrawal from the world of contemporary politics: to what extent did Altenberg's hotel room represent a resistance to and critique of that world? In what ways did Secessionist interiors constitute a refuge from – even a denial of – political developments, of growing right-wing, nationalist and anti-semitic movements? The two cases examined here, of masculinities represented through the interior, obviously involved various forms of gender politics. But not only the politics of gender. The effects of anti-semitism too are clearly discernible. Adopting the name 'Peter Altenberg' was not simply a tribute to lost, idyllic love and identification with an 'innocent femininity; it was also an act of erasure – the obliteration of the Jewish name 'Richard Engländer'. Secessionist art and design was often characterised as a *goût juif,* either in reference to patrons or more obliquely, as a critique of elaborate and expensive ornamentation.[59] So, for example, an issue of the journal *Die Fackel* published in 1900 pronounced:

> Just as every aristocrat used to keep his Jew-in-residence, so today every stockbroker has a Secessionist about the house. Herr Moll is known to be art-agent to the share pusher Zierer and the coal-usurer Berl [...] This rapport between modern art and idle-rich Jewry, this rise in the art of design, capable of transforming ghettos into mansions, occasions the fondest of hopes. [...] Those who had the opportunity to admire the burgeonings of the celebrated *goût juif* at the recent Secessionist Exhibition will not dismiss such dreams as merely idle.[60]

This diatribe is by Karl Kraus, a Jew, directed at Moll (who would later become a Nazi sympathiser). These examples reveal the painful complexities of anti-semitism in early twentieth-century Vienna. They are also reminders that as a component of a specifically Viennese

modernity, the interior could afford refuge or resistance only in highly problematic and uncertain forms.

<p style="text-align:center">* * *</p>

In these identifications of artistic identities with interiors, the examples of Moll and Altenberg problematise the 'boundaries' between public and private while at the same time revealing the complex social and cultural interrelations between the individually inhabited space and the city more widely. As so vividly epitomised by the presence of Moll's panoramic painting in the imperial waiting room, interiors were in a variety of ways implicated in the expanding city and its processes of modernisation. One aspect of this modernity involved the concern regarding relations – political, cultural and social – between Vienna with other countries, both within and outside the Austro-Hungarian Empire. If J.M. Olbrich's Secession Building of 1898 was often described as a newly conceived temple of the arts, then Hoffmann's Hohe Warte villas in the hills above Vienna formed a kind of modern Acropolis, a prominent showcase for Viennese modernism. In this sense, both the Secession and the Hohe Warte were addressed to audiences abroad as well as in Vienna. Similarly, that favoured haunt of Altenberg – the Viennese café – formed an important means of communication between Vienna and the rest of the world. The coffeehouse was a place not only for intellectual and artistic debate, but also for the dissemination of information, as described by Stefan Zweig:

> all the Viennese newspapers were available, and not the Viennese alone, but also those of the entire German Reich, the French and the English, the Italian and the American papers, and in addition all of the important literary and art magazines of the world […]. Perhaps nothing has contributed as much to the intellectual mobility and the international orientation of the Austrian as that he could keep abreast of all world events in the coffeehouse […].[61]

Coffeehouses enabled their inhabitants to follow 'the *orbis pictus* of artistic events'. Chapter 2 considers in more detail the ways in which debates on modernity and modernism converged on the Viennese *Kaffeehaus*.

60

Notes

1 For example, Schorske's claim that 'Not utility but cultural self-projection dominated the Ringstrasse.' This forms part of Schorske's consideration of the Ringstrasse as 'a visual expression of the values of a social class' in Schorske, 'The Ringstrasse, its Critics, and the Birth of Urban Modernism' in *Fin-de-Siècle Vienna*, pp. 24–115; see also Olsen, 'Vienna: Display and Self-Representation' in *The City as a Work of Art*, pp. 235–48. For an argument on the theatricality and artificiality of Viennese life, see Timms, 'Musil's Vienna and Kafka's Prague: the quest for a spiritual city' in Timms and Kelley (eds), *Unreal City*, pp. 247–63.

2 'And all groups met and mingled in the many cultural and political institutions of the great boulevard, and above all took part in the "Ringstrassenkorso" every afternoon between the Schwarzenbergplatz and the Kärntner Strasse' (Olsen: *The City as a Work of Art*, p. 155).

3 For the most recent translation of Otto Weininger's *Geschlecht und Charakter: Eine prinzipielle Untersuchung*, see *Sex and Character: An Investigation of Fundamental Principles*, Steuer and Marcus (eds), 2005.

4 Jacques Le Rider (Ralph Manheim, trans.), 'Between Modernism and Postmodernism' in Timms and Robertson (eds), *Vienna 1900 from Altenberg to Wittgenstein*, p. 1. These ideas are explored at greater length in Le Rider, *Modernité viennoise et crises de l'identité* (Presses Universitaires de France: Paris), 1990, translated as *Modernity and Crises of Identity*, 1993.

5 For a museological presentation of these ideas, see the catalogue for the touring exhibition: Becker and Grabner (eds), *Wien 1900: Der Blick nach innen*. The exhibition was organised in conjunction with the Österreichische Galerie Belvedere, Vienna and shown at the Van Gogh Museum, Amsterdam and the Von der Heydt-Museum, Wuppertal.

6 For bibliographies on Peter Altenberg, see, for example, Segel, *Vienna Coffeehouse Wits*; Couffon, *Peter Altenberg: Erotisme et vie de bohème à Vienne*; Barker, *Telegrams from the Soul*; Lunzer and Lunzer-Talos (eds), *Peter Altenberg: Extracte des Lebens*.

7 See Bisanz, *Peter Altenberg: Mein äusserstes Ideal*; Lensing, 'Peter Altenberg's Fabricated Photographs'.

8 For example, Friedell (ed.), *Das Altenbergbuch*.

9 Le Rider, 'Between Modernism and Postmodernism', pp. 8–9.

10 These stereotypes are analysed and challenged in Wolff, 'The Invisible Flâneuse'; Pollock, 'Modernity and the Spaces of Femininity'; Adler, 'The Suburban, The Modern and "une Dame de Passy"'; Attfield and Kirkham (eds), *A View from the Interior*.

11 Neither interior survives in the form discussed in this chapter (see Conclusion). The Graben still functions as a hotel. In the past it commemorated Altenberg

with a plaque (which mentioned his name along with those of other writers who were guests of the hotel). Now there is a display of photographs about Altenberg in the lobby. Hoffmann was a pupil of Otto Wagner and co-founder of the Vienna Secession. His villas for Moll were but two of several executed for well-to-do, upper-middle-class clients. The earlier Moll villa, at 6 Steinfeldgasse, took the form of a semi-detached house joined to that of Koloman Moser. As Christian Nebehay points out, 'Moll's house in particular is barely recognizable today' (*Vienna 1900*, p. VII/6).

12 See Debora L. Silverman on the de Goncourt brothers' collection, 'The Brothers de Goncourt between History and the Psyche' in *Art Nouveau in Fin-de-Siècle France*, and Apter, 'Cabinet Secrets'.

13 Mark Wigley, 'Untitled: The Housing of Gender' in Colomina (ed.), *Sexuality and Space*, p. 339.

14 For further information on Carl Moll's life and career, see Natter and Frodl (eds), *Carl Moll*.

15 See, for example Schorske, *Fin-de-Siècle Vienna*, pp. 254–63; 'Beethoven 1902' in Vergo, *Art in Vienna 1898–1918*, pp. 67–77; 'Die XIV. Ausstellung der Wiener Secession und der Beethovenfries von Gustav Klimt', ch. 16 of *Traum und Wirklichkeit*, pp. 527–70; 'The Artist as God' in Whitford, *Klimt*, pp. 82–93; Willsdon, 'Klimt's Beethoven Frieze'. On notions of the *Gesamtkunstwerk*, see Kallir, 'The Austrian Gesamtkunstwerk' in *Viennese Design and the Wiener Werkstätte*, p. 22; also Vergo, 'The origins of Expressionism and the notion of the *Gesamtkunstwerk*'.

16 For example, the 1906 Wiener Werkstätte exhibition on the theme of 'the laid table' (*Der Gedeckte Tisch*); here even the pastry was redesigned to fit the setting. See Vergo, *Art in Vienna*, pp. 141–2; 'The laid table' in Schweiger, *Wiener Werkstaette*, pp. 56–64; Ludwig Hevesi, 'Vom gedeckten Tisch' is reprinted in Becker and Grabner (eds), *Wien 1900*, pp. 145–7 (originally published in *Altkunst-Neukunst: Wien 1894–1908*, Vienna, 1909, pp. 227–31).

17 The project for 'an artists' colony' on the Hohe Warte was originally undertaken by Olbrich; it passed to Hoffmann when Olbrich moved to Darmstadt. On the occasion of the first Secession exhibition in 1898, Olbrich had proclaimed: 'We must build a city, an entire city! Everything else means nothing! The government should give us a field, in Hietzing or at the Hohe Warte, and there we want to show what we are capable of; in the entire settlement and to the last detail, everything dominated by the same spirit' (Sekler, *Josef Hoffmann: The Architectural Work*, p. 41).
For a discussion of the significance of the 'villa colony', on the Hohe Warte, see Waissenberger, *Wien 1890–1920*, pp. 194–6; Kallir, *Viennese Design*, pp. 51–3; Eva B. Ottillinger, 'Vom Historismus zur Moderne: Aspekte der Wiener Wohnkultur 1870–1918' in Becker and Grabner (eds), *Wien 1900*, 1997, p. 138.

18 Beaumont (selected and trans.), *Alma Mahler-Werfel Diaries 1898–1902*, p. 414.

19 On garden design, see 'Garden art' in Schweiger, *Wiener Werkstaette*, pp. 64–8. Also, Noever (ed.), *Der Preis der Schönheit*, pp. 150–2.

20 'Louis Philippe, or the Interior', Exposé of 1935 in Benjamin, *The Arcades Project*, p. 9. 'With van de Velde, the house becomes the plastic expression of the personality', Exposé of 1939, p. 20.

21 'From Public Scene to Private Space: Architecture as Culture Criticism' in Schorske, *Thinking with History*, p. 169: '[…] the house becomes the mirror of the client. But it also presents him to the outer world. The public sphere has not been dissolved, nor the private encapsulated. For now the exterior gives expression to the personality of the private man, projects it into the public realm. The house serves both as private mirror and public image.'

22 For a discussion of this painting, along with identification of the works of art represented, see Becker and Grabner (eds), *Wien 1900*, p.70. George Minne's sculpture (a plaster cast) of a kneeling youth was shown at the eighth Vienna Secession exhibition in 1900, where thirteen of the Belgian sculptor's works were exhibited. Moll acquired the piece as a gift from Julius Meier-Graefe. The Galerie Miethke held an exhibition of Minne's work in December 1905; see Natter and Frodl (eds), *Carl Moll*, p. 159. For a photograph of the sculpture as part of the laid table exhibition (1906), see Schweiger, *Wiener Werkstaette*, p. 57; Becker and Grabner (eds), *Wien 1900*, p. 147. The work was also shown at the Wiener Werkstätte exhibition in Mannheim in 1907; see the photograph in Kallir, *Viennese Design*, p. 64.

23 On Moll's activities at the Galerie Miethke, see the two essays by Tobias G. Natter in Natter and Frodl (eds) *Carl Moll*: 'Carl Moll und die Galerie Miethke: Konturen einer europäischen Avantgarde-Galerie', pp. 129–50, and 'Ausstellungen der Galerie Miethke 1904–1912', pp. 151–90. On the cultural significance of the gallery, see Natter, *Die Galerie Miethke*.

24 In the case of certain earlier painters, and particularly with Hans Makart, the studio – both as representation and as meeting place – had played an important role in the production of artistic identities in Vienna; see Becker and Grabner (eds), *Wien 1900*, pp. 38–40.

25 Disputes also took place *within* the original Secession which in 1905 split into two groups: the 'Naturalisten' (following Josef Englehart) and the 'Raumkünstler', who looked to Gustav Klimt as their spokesperson. For an account of the split, see 'The Split within the Secession' in Vergo, *Art in Vienna*, pp. 84–5, and 'Galerie Miethke exhibition' in Schweiger, *Wiener Werkstaette*, pp. 45–51.

26 See 'The Poor Little Rich Man', reproduced in Loos, *Spoken into the Void*, pp. 124–77 (originally published in the *Neues Wiener Tageblatt*, 26 April 1900). See Janet Stewart's discussion in 'The city as interior' in *Fashioning Vienna*, pp. 132ff.

27 For discussions of the relationship between Secessionist dress and architecture in the context of Viennese debates, see McLeod, 'Undressing Architecture: Fashion, Gender', pp. 38ff, and Mark Wigley, *White Walls, Designer Dresses*,

esp pp. 73–7, 86–9, 133–5, 173–5. On the relation between women's dress and the *Gesamtkunstwerk*, see 'Fashion and Related Developments' in Kallir, *Viennese Design*, pp. 89–102; for dress design and the Wiener Werkstätte, see Völker, *Wiener Mode + Modefotografie*; 'The WW Look' in Schweiger, *Wiener Werkstaette*, pp. 210–45.

28 Lux, *Das Moderne Landhaus*, p. 30. (No date appears on the book; it is dated 1903 in Sekler, *Josef Hoffmann*, p. 24.)

29 'Wenn er vor die Stadt hinauskommt, und eines einfachen weissgetünchten Bauernhauses ansichtig wird, wo Blumen an den Fenstern stehen, oder jener lieblichen und liebenswerten Landhäuser, welche sich noch unsere Grosseltern vor der Stadt erbaut haben, inmitten von Gärten, darin sie ihre Blumen and Rosenstöcke zogen, überströmt seine Freude und seine Sehnsucht, auch ein solches Haus zu haben, darin sichs so schön wohnen lässt, mit der Familie in dem sicheren und frohen Behagen, irgendwo daheim zu sein, ein eigenes Dach zu haben, und Räume darunter, die sich wie ein Organismus an das Leben der Familie anschliessen' (Lux, *Das Moderne Landhaus*, p. 3).

30 For related arguments see Matthias Boeckl, 'Raumkünstlerische Fragmente: Die architektonischen Arbeiten von Josef Hoffmann und Wilhelm Jonasch für das Ehepaar Koller' in *Broncia Koller*, pp. 25–34.

31 This stress on Viennese modernism and avant-gardism as being somehow concerned with both the past and the future is characteristic of a wide range of recent studies of Viennese modernity. See for example, Olsen's discussion of the Ringstrasse as 'a preserving rather than a destroying revolution' (*The City as a Work of Art*, p. 68); also Clair, 'Une modernité sceptique', pp. 46–57; Le Rider's arguments in *Modernity and Crises of Identity*, 1993; Janet Stewart's study of Adolf Loos in *Fashioning Vienna*.

32 Altenberg moved into the Graben Hotel in 1913 and photographs of this room have become well known. He had however been similarly preoccupied with the fitting out of earlier hotel rooms. See Bisanz, *Peter Altenberg*, p. 7, and Ursula Storch, 'Altenbergs Zimmer in der Wohnung seines Brüders', 'Das Altenberg-Zimmer im Hotel London in der Wallnerstrasse' and 'Das Altenberg-Zimmer im Grabenhotel in der Dorotheergasse' in Lunzer and Lunzer-Talos (eds) *Extracte des Lebens*, pp. 162–71.

33 Benjamin, *The Arcades Project*, pp. 220–1 and p. 226 (for the use of the term '*étuis*').

34 Benjamin, *The Arcades Project*, p. 221.

35 Peter Altenberg, 'In München' (1901) in Segel, *Vienna Coffeehouse Wits*, p. 125. I refer to English translations of writings by and on Altenberg in Segel's compilation as it constitutes an easily accessible source. The reader should be aware however of Lensing's review of this volume in *Austrian Studies*, vol. VI, 1995, pp. 195–7. Bisanz (*Peter Altenberg*, pp. 7–8) includes a German version of this piece published in 1899 in *Jugend* (Munich).

36 Benjamin, *The Arcades Project*, p. 226.

37 Such notions of passive receptivity formed part of the characterisation of the 'art' of the *feuilletonist*. See Schorske, *Fin-de-siècle Vienna*, p. 9.

38 Felix Salten, 'Peter Altenberg' (1910) in Segel, *Vienna Coffeehouse Wits*, p. 174.

39 See W. J. Schweiger, 'Peter Altenberg: Realien und Marginalien' in *Traum und Wirklichkeit*, pp. 310–13.

40 On this, see particularly Lensing, as in n. 7 above.

41 See Timms, 'The "Child-Woman', and Patrick Werkner, 'The Child-Woman and Hysteria: Images of the Female Body in the Art of Schiele, in Viennese Modernism and Today' in Werkner (ed.), *Egon Schiele*, pp. 51–78. For Loos's argument, see his 'Ladies' Fashion' (first published in 1898) in *Spoken into the Void*, pp. 98–103, and Janet Stewart's discussion of this essay in *Fashioning Vienna*, pp. 112–24. Wagner's *Geist und Geschlecht* presents a detailed exploration of the Krausian circle's preoccupation with femininity and female sexuality.

42 This material forms part of Lensing's research; see n. 7 above.

43 On the charges of a feminisation and Judaisation of Viennese society and culture, see Le Rider, *Modernity and Crises of Identity*.

44 Altenberg, 'So wurde ich' (1913) in Segel, *Vienna Coffeehouse Wits*, p. 123.

45 Altenberg, 'Wie ich "Schriftsteller" wurde' (1919) in Segel, *Vienna Coffeehouse Wits*, p. 123.

46 Bisanz sketches in what he sees as the cultural context for Altenberg's preoccupation with pre-pubescent femininity in *Peter Altenberg*, pp. 28ff. See Wagner's comments on Altenberg in *Geist und Geschlecht*, esp. pp. 138–9 and 179–81, and 'De l'enfant à la femme' and 'De la petite fille à la femme', Couffron, *Peter Altenberg*, pp. 117–23.

47 Given its location on the Venice Lido, the scenario of '55 and 4!' (1913) invites comparison with Thomas Mann's *Death in Venice* (first published in 1912).

48 Altenberg's slender physique was in part a product of his strong, albeit idiosyncratic, views on health and diet (expounded in detail in *Pròdrŏmŏs*, 1906). Wagner argues that the poet's preoccupation with decreasing his physical and muscular bulk formed part of his identification with pre-pubescent femininity and was symptomatic of a desire to become female (*Geist und Geschlecht*, pp. 180–1). For another discussion of Altenberg's concern with diet and hygiene, see Couffron, *Peter Altenberg*, pp. 90ff.

49 More recently, comparisons have been made between Altenberg and Lewis Carroll (for example, Bisanz, *Peter Altenberg*, p. 30), although such readings often reinscribe a relatively unproblematic interpretation of Altenberg's practice. On Carroll's photography, see Smith, '"Take Back Your Mink"'.

50 Wolff, *Postcards from the End of the World*. Wolff argues that the extensive publicity given to these trials was (at least in part) due to the desire of the Viennese liberal press to deflect attention away from the mounting hysteria concerning accusations of 'Jewish ritual child murder'.

51 Also relevant, in the case of the Moll *Self-portrait*, are the clear references (for example, the black-and-white floors) to seventeenth-century Dutch painting. Moll's paintings of Hoffmann's interiors were described as 'Vermeerisch', a reference perhaps to the qualities of light; see Becker and Grabner (eds) *Wien 1900*, p. 70. But this also involves allusions to seventeenth-century Dutch genre paintings more generally, to images of a well-ordered and happy family life in which children feature prominently. Wolff (*Postcards from the End of the World*, pp. 61–2) cites the French historian Philippe Ariès's comment on 'the special place of children in the paintings of the seventeenth-century Dutch masters' in his book *Centuries of Childhood* (1960).

52 In his 'Eulogy for Peter Altenberg' (1919), Loos writes that the eccentric poet 'always had a small handout for abused children about whom he came to hear in the newspapers. "Peter Altenberg – 10 crowns." It was a standing notice in the bulletin of the Children's Protection and Rescue Society' (*Spoken into the Void*, p. 140, endnote 3 to 'Ladies' Fashion'). On Loos's published expressions of concern for children's welfare, see Janet Stewart, *Fashioning Vienna*, pp. 148–9. See also Couffon, 'Altenberg et la défense des enfants', *Peter Altenberg*, pp. 119–21; Barker, *Telegrams from the Soul*, p. 230.

53 On the significance of the representation of domestic interiors vis-à-vis issues of gender, see Nierhaus, *ARCH Raum, Geschlecht, Architektur*.

54 An exploration of the self-representation of the artist in the context of the studio environment formed an important part of the 1997 *Wien 1900* exhibition; see n. 5 above.

55 As commentators have noted, Moll's artistic identity (as a painter) at this period was to some extent complicated by his professional involvements in exhibition-organising and dealing. For a discussion of Altenberg in relation to contemporary interest in the 'new man', see Couffon, *Peter Altenberg*, pp. 88ff.

56 See Schweiger's claim that 'all the villas erected by Hoffmann strike one as exhibition pieces' (*Wiener Werkstaette*, p. 155).

57 According to Adolphe Stoclet's son, 'Hoffmann's talents were revealed to my parents, who were spending a year and a half in Austria during 1903–4, in the following manner. They were walking one day in the outskirts of Vienna when they were struck by the sight of a villa whose proportions, sober and harmonious at the same time, seemed to them completely new and filled them with admiration. Impelled by curiosity, they penetrated as far as the garden, where they were surprised by the owners [the painter Carl Moll and his wife] who, touched by their enthusiasm, invited them to look over the house, and introduced them to the architect, Professor Hoffmann' (quoted in Vergo, *Art in Vienna*, p. 143).

58 *Traum und Wirklichkeit*, p. 322.

59 See Beller, *Vienna and the Jews, 1867–1938*. The 1998 bilingual exhibition catalogue *Zu Gast bei Beer-Hofmann: Eine Ausstellung über das jüdische Wien der Jahrhundertwende/Visiting Beer-Hofmann: An Exhibition on Jewish Vienna*

at the Turn of the Century (Jüdisches Museum der Stadt Wien) offers a museological consideration of issues of Jewishness vis-à-vis the promotion of 'Vienna 1900'.

60 *Die Fackel*, no. 59, mid-Nov. 1900, p. 19. Quoted in Beaumont, *Alma Mahler-Werfel Diaries*, p. 348, n. 8.

61 Zweig, *The World of Yesterday*, pp. 39–40.

2 Coffeehouse Encounters: Adolf Loos's Café Museum

The newly refurbished Café Museum, at 6 Friedrichstrasse, in Vienna's first district, was opened to the public in spring 1899. (Ill. 2/1) The café's distinctive interior, designed by Adolf Loos, attracted considerable attention in the press. The critic Wilhelm Schölermann, for example, wrote in the *Wiener Rundschau*:

> Vienna has a new coffeehouse! You mean 'Café Secession'? No, we mean 'Café Museum'. Maybe you could call it 'Café Antisecession', for what is modern about it has nothing to do with the 'Secession' whatsoever. For the Secession, tradition is nothing; for Adolf Loos everything. Since the Secession works with ornamentation, Loos would kill ornament.[1]

This juxtaposition of Secession and Loosian interior was geographically as well as stylistically determined. Joseph Olbrich's new building for the Secession, which had opened the previous year in 1898, and the Café Museum existed in close physical proximity, close enough to speak of a confrontation.[2] (Ill. 2/2) Here were two Viennese institutions, both offering lessons as to what constituted 'the modern'. (The ways in which the coffeehouse might be construed as an institution will, I hope, become apparent during the course of this chapter.)

The characterisation of Loosian design as a form of aesthetic negation – as the obliteration of Secessionist decoration and ornament – was in part an extension of Loos's own stance. In 1898 he had published a series of articles in the liberal newspaper, the *Neue Freie Presse*, chastising the Austrian products on show at the Jubilee Exhibition, which celebrated fifty years of the Emperor Franz Joseph's reign. Loos's essays spanned a remarkable range, dealing with everything from interior design to underclothes, furniture to plumbing, transport vehicles to clothing, hats and footwear. Overall the message was clear: not only design, but also the implements of everyday life revealed Austria to be a culturally backward nation.

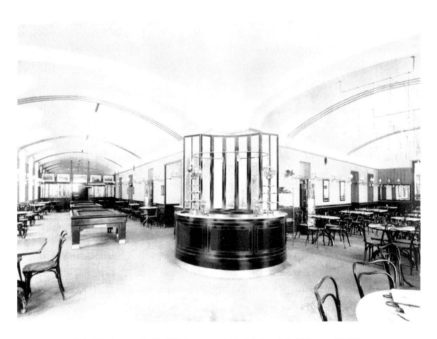

2.1 Photograph, Café Museum, interior by Adolf Loos, 1899.
Albertina, Vienna.

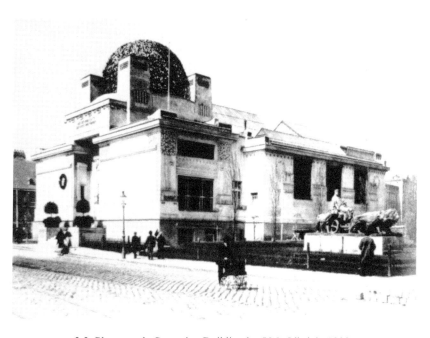

2.2 Photograph, Secession Building by J.M. Olbrich, 1898.
Copyright Wienmuseum.

Plumbing fixtures provided Loos with a particularly vivid example: 'Our taps, sinks, water closets, washstands, and other things are still far inferior to the English and American fittings. […] In this respect, America is to Austria as Austria is to China.'[3] Loos praised what he felt were the lamentably few instances of unostentatious, well-crafted commodities produced in Austria – simple, unadorned leather goods, for instance. The references to America and England were strategic, important to Loos's self-promotion as an architect and cultural critic in Vienna at this period. He had travelled to the United States in 1893 (visiting the Chicago World Exhibition) and returned to Vienna via London in 1896. It was his encounter with a more advanced Anglo-Saxon modernity, Loos claimed, that rendered him an effective critic of Austrian culture.

The 1898 articles enabled Loos to address his ideas to a wider audience. Prior to this, his writing had been published in specialised journals and his executed work as an architect was sparse, consisting of refitted interiors for private apartments and for exclusive Viennese gentlemen's tailors.[4] For Loos, the Café Museum project represented an important opportunity to demonstrate the ideas he had so vociferously argued in his journalism. The fact that the refurbishment involved a café (an urban space accessible to the public) rendered the project ideal for producing a high-profile demonstration piece on the issue of modernity. So too did the café's location, surrounded by many of the city's most distinguished institutions of art: close to the Academy of Fine Arts, the Künstlerhaus, the Opera and the Musikverein as well as to the Secession.[5] The proximity of the café to the Secession Building enhanced the polemical aspect of Loos's refurbishments. Contemporaries responded to Loos's designs for the café not only in relation to his writings, but (like Schölermann) also more specifically as a critique of the Secession – both the building and all that it seemed to stand for as an arts institution. Ludwig Hevesi, writing a few years later in *Acht Jahre Sezession*, claimed that the designs for the Café Museum revealed Loos to be a sincere 'Nichtsezessionist' ('anti-Secessionist') – although at the same time not an enemy of the Secession as both were fundamentally modern.[6]

The Loosian critique was often personalised – by Loos indirectly, by others often more explicitly – as an attack on Josef Hoffmann, co-

founder of the Secession. (Hoffmann had apparently rejected Loos's offer to design the interior of one of the smaller rooms in the new Secession Building.) Personalising the confrontation between the Café Museum and the Secession as a conflict between two individuals enhanced the topicality of, and public interest in, the Loosian polemic. For both architects, 1899 marked an important point in the development of their careers. Unlike Loos, Hoffmann (who had been appointed Professor at the Wiener Kunstgewerbeschule in 1899) was not a polemicist. He established his reputation as an architect in numerous other ways: through the Secession exhibitions – in which he was involved both as a participant and as a designer – and through the design of furniture for Secessionist artists' studios, such as those of Koloman Moser and (somewhat later) Gustav Klimt.[7] For Loos on the other hand, the one-off commission for the Café Museum afforded particular advantages in his bid for professional identity.

The late nineteenth-century Viennese café was an important site for the representation of the city's intelligentsia and was often referred to as the place of 'discovery' of subsequently famous personalities. Peter Altenberg and Hugo von Hofmannsthal, for example, were both said to have been 'discovered' as writers in the milieu of the *Kaffeehaus*.[8] Different forms of portraiture were variously inflected in the context of the café. Prior to its demolition in 1897, photographic group portraits of its famous habitués were taken in the renowned literary *Kaffeehaus*, the Griensteidl. Cafés also offered a fertile terrain for another kind of portraiture – caricature, the visual equivalent of the witty banter popularly assumed to characterise these establishments. (In 1898, Carl Moll had referred to 'the Viennese coffeehouse joke' as 'the most fertile of homegrown Viennese products'.)[9] Often identified with particular professional groupings and organised through a series of recognised *Stammtische* (tables habitually occupied by certain customers), cafés were not merely places of leisure but also part of the processes of urban communication and debate through which individual professional identities were produced, challenged and negotiated.

Loos claimed that his aim in producing an appropriately up-to-date café was not to invent anything new, but rather to reformulate the simplicity of an earlier form, the Biedermeier *Kaffeehaus*. Indeed for

Loos, the Viennese café of this period (the early nineteenth century) represented a repository of the values which for him constituted the genuinely modern. 'They look for bizarre models in far-off countries, just as they looked for American models for my Café Museum. But [...] I collected features from old Viennese coffee houses and facades in order to find the modern, the truly modern style.'[10] Given Loos's admiration for Anglo-Saxon modernity, this may seem a somewhat surprising claim but the stress here on indigenous building types again underscores Loos's formulation of the modern by contrast with that of the Secession Building, which at the time was regularly chastised by critics for its unseemly exoticism. Equally important perhaps were the ways in which cafés signified and embodied modernity. Whereas the Secession Building was often described by both critics and supporters as a kind of temple, Viennese cafés (particularly of the Biedermeier period) were clearly a modern urban phenomenon, closely identified with the burgeoning expansion of Vienna as a city in the late eighteenth and early nineteenth centuries.

With its location on a street corner and expanses of windows looking out onto the two adjoining streets (Friedrichstrasse and Operngasse), the Café Museum followed a traditional Biedermeier café layout. Similarly, Loos's fittings accorded with what had (since the Biedermeier period) become the standard accountrements of a Viennese *Kaffeehaus*. Three billiard tables were prominently positioned in the main space of the Café and there was also a separate *Spielzimmer* (games room). A particularly Biedermeier feature was the positioning of the elaborate cashier's seat and display counter opposite the Café's main entrance. Loos drew an analogy with male clothing in order to reinforce the sense of constancy of design represented by the Biedermeier *Kaffeehaus*: just as the man's frock coat had changed little between 1800 and 1900, so (we might infer) the *fin-de-siècle* café should resemble that of the earlier nineteenth century.[11] Of 'the truly modern style', Loos claimed that: 'A hundred years ago it was tailors and architects who had it. Today it is only the tailors. But buildings have changed just as much as coats have. No more, no less. That is, very little'.[12] The affiliation with men's dress emphasises not only the plainness but also the apparently inherent masculinity of the café as an urban space, a gendering reinforced (in

74

the case of the Café Museum) by the gentleman's club atmosphere created by the presence of billiard tables and newspapers. This is not to claim that late nineteenth-century cafés were only inhabited by a male clientele. Photographs and illustrations of the *Kaffeehäuser* of the period show women customers (as well as staff) and, in addition, numerous cafés advertised dedicated 'ladies' rooms'. But as we have seen, both through public encounter (at the *Stammtische*) and representation, cafés played a significant role in the formulation of what were predominantly masculine professional identities.

It is in this sense that Loos's publicly stated admiration of the Biedermeier café further reinforced a sense of the masculinity of the institution. At a popular level, the Biedermeier café was closely identified with a 'golden age' of Viennese culture. Vinzenz Katzler's coloured lithograph *Die Kassierin vom silbernen Kaffeehaus* (1871) is a good example. (Ill. 2/3) During the period 1825–45, this café (on the corner of Plankengasse and Spiegelgasse) was renowned as the meeting place of writers, actors and artists. Recent histories of the Viennese coffeehouse claim that until about 1840 the clientele would have largely consisted of men, with the *Kassierin* (cashier) often the only woman present.[13] This is certainly what Katzler's print depicts: the woman cashier enthroned at the centre of the composition is flanked by well-known personalities including the actor Ferdinand Raimund, the director Ignaz Schuster, Kapellmeister Josef Lanner and Johann Strauss.[14] Here the female figure functions less as the focus of the viewer's attention than as an embodiment of the audience for the cultural brilliance enacted by the café's distinguished clientele. The symmetrical composition of the print reinforces the status of the image as a kind of modern-day *School of Athens* – a classicising association with the intellectual life of cafés not restricted to Vienna (as indicated by the name of the later Café Nouvelle Athènes in Paris).

The *Kassierin*'s station in the Café Museum bears a close resemblance to that depicted in Katzler's print of the 'silbernen Kaffeehaus', which shows a reflection of the café's main entrance in the mirror behind the cashier. With its careful delineation of elegant men's clothing, this image also seems to confirm Loos's identification of the café with male dress. There is a certain amount of visual elaboration afforded by the mirror and food on the cashier's counter,

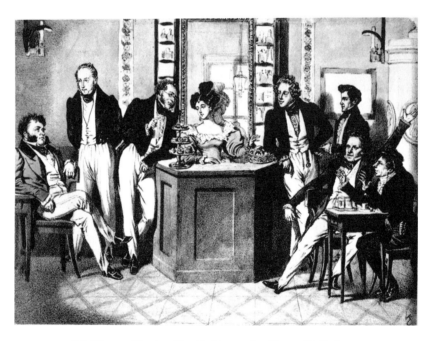

2.3 Vinzenz Katzler, *The Cashier at the silberne Kaffeehaus*,
colour lithograph, 1871. Copyright Wienmuseum.

but this is restricted to forming a kind of frame for the female figure of the cashier. It is the casually posed men with their dark jackets and slim trousered legs who set the tone for the bare walls and simple décor and furniture of the *Kaffeehaus*. Late nineteenth-century photographs of the Café Museum show a simple but elegant interior, like the photographs themselves it would seem, a study in monochrome. Photography sustains the idea of plain white walls, of surfaces stripped bare of ornament. In this stark, almost minimalist guise, the café seems to live up to its soubriquet of 'Café Nihilismus'.[15] Hevesi had pronounced approvingly: 'Etwas nihilistisch zwar, sehr nihilistisch, aber appetitlich, logisch, praktisch' ('Somewhat, perhaps even very, nihilistic, but tasteful, rational and practical').[16] Contemporary descriptions, however, rather complicate this apparently austere picture. Hevesi himself, in the May 1899 issue of *Kunst und Kunstwerk*, gave the following description:

> The whole café has English flock wallpaper in a kind of matt green colour, rather like the grain on blotting paper; the ceiling is, however, quite white, finished with a washable oil-based paint and is completely without ornament. The wainscot and large items of furniture (pay desk, billiard tables) are of dark mahogany with single inset strips ('arteries') of boxwood in a yellowy white colour.

His account draws attention to a variety of colours and textures, a reminder that Loos's eschewal of ornament went hand in hand with a penchant for dramatic use of materials in ways which were both visually and texturally rich.[17]

Like the Secession Building, now restored to a gleaming and pristine condition, the Café Museum too has been revamped with careful attention to the design of its original fittings and furniture. The Museum has undergone the extensive reconstruction and restoration recently lavished on other famous Viennese cafés such as the Central or the Griensteidl. However, the Café Museum's status, both as an iconic representative of the Viennese café and as a monument to Viennese modernism – an important example of Loos's polemic rendered three-dimensional – was well established long before its restoration in 2003. Photographs and written descriptions of the Café

Museum, with its billiard tables and its bentwood chairs, its marble-topped tables, newspapers and journals, have played a large part not only in recording the original appearance of the café but also in determining how we interpret it as a manifestation of turn-of-the-century Viennese modernity. But the Café Museum in 1899 did not consist solely of the L-shaped space now so familiar from the often-reproduced photograph. Adjacent to this, there were also smaller rooms: a *Gibsonzimmer* and an *Extrazimmer* as well as the *Spielzimmer*. The Gibson Room, its walls hung with framed pictures by the American illustrator Charles Dana Gibson (1867–1944), constitutes an intriguing feature of the original Café.[18] (Ill. 2/4) With its British and American flags and its sign for Dewar's Whisky, the room fits well with Loos's adulation of Anglo-Saxon culture. It underscores his claims concerning the importance of his American *Bildungsreise*.

At the same time, the inevitable association (for contemporaries) of Charles Dana Gibson with his most famous creation, the Gibson Girl, creates a strong feminine emphasis that might seem incongruous given Loos's equation (as in his 1898 essay 'Men's Fashion') of modernity with correctly dressed and tailored masculinity.[19] Although a relatively small and subsidiary space, the presence of the Gibson Room raises questions concerning exactly how modernity was manifested in and through the Café Museum. Prompted by the Gibson Room (which no longer exists in its original state in the current, newly refurbished café), this chapter takes the form of a series of speculations on the role of femininity in defining the modern in late nineteenth-century Vienna. In particular, the encounter of Loos's revamped Café Museum with the Secession will be reassessed with a view to problematising notions of a modernism based on simple binary oppositions: the plain versus the ornamental, the masculine opposed to the feminine.

Let us begin with Schölermann's assertion that 'for the Secession, tradition is nothing; for Adolf Loos everything.' Given Loos's admiration of the Biedermeier period, the Café Museum would seem to accord well with this pronouncement. But as we saw in Chapter 1, Biedermeier culture was also important for artists and designers affiliated with the Secession. In 1899, the year in which Loos's Café Museum opened, Gustav Klimt showed his painting *Schubert at the*

2.4 Wilhelm Gause, *Gibson Room at the Café Museum*,
pencil drawing, 1899. Copyright Wienmuseum.

Piano (destroyed 1945) at the fourth Secession exhibition. Like the Café Museum, this was a work conceived as a dialogue between '1800 and 1900', albeit, in the case of Klimt, a dialogue presented in rather more feminised terms. Alma Schindler recorded in her diary: 'his "Schubert" is wonderful [...]. Schubert sits at the piano, surrounded by ultra-modern young ladies singing.'[20] Klimt's choice of the Schubertian subject matter was timely: 1897, the centenary of Schubert, had seen a large Schubert exhibition at the Künstlerhaus along with associated musical events. As the Emperor Franz Joseph had pointed out at the opening of the exhibition, unlike so many other composers who had worked in Austria, Schubert was the only one to have been born in the Residenzstadt and thus to be 'authentically' Viennese.[21] By the late nineteenth century, a fully developed mythology of the composer was in place. This identified Schubert with what was seen as a convivial middle-class Biedermeier culture, epitomised by the *Hauskonzert*, smallscale concerts held in private homes. Such Schubertian imagery depicted middle-class domesticity as the site not only of sociability but also of high culture. To the extent that Klimt's painting of Schubert reinforced these ideas it was no doubt attractive to the affluent middle-class patrons of Secession art and design.[22] It is however perhaps more the femininity of its female figures than the *Gemütlichkeit* of the depicted *Hauskonzert* that predominates in Klimt's picture. But this too accorded with aspects of the Schubert legend, according to which the so-called '*Mädchencharakter*' of the Viennese composer's music was contrasted with the drama of Beethoven's compositions.[23]

The concept of tradition ('Biedermeier') in defining the modern was as important for the Secessionist painter as for Loos.[24] In the case of Loos, tradition signified a perfectly achieved and appropriate form which should be sustained (rather than needlessly altered); for Klimt, an authenticity in need of constant renewal and updating. Loos represented the concept of tradition through the constancy of male dress; Klimt, through the juxtaposition of the past with the empherality of fashionable femininity. For the Secession, the concept of modernity (the condition of being modern), was in certain ways linked to the idea of Austrian-ness. In the case of the Austro-Hungarian Empire in 1899 this was, it must be stressed, very much an idea (or ideal). There was,

on the one hand, the desire of certain ethnic groups to differentiate themselves from the political and cultural hegemony of German culture; on the other, the empire's need to formulate a concept of identity which would somehow unify a highly diverse population and appease (or at least hold in check) growing nationalist movements. The writer Hermann Bahr, a passionate supporter of the Secession, wrote as follows about Klimt's *Schubert* painting:

> I only know that I get cross if people ask me if I am a German. No, I say, I am not German, I am Austrian. But that isn't a nationality, they say. Austria has become a nation, I say, we are different from the Germans, we have our own identity. Define it! Well, how can one 'define' it? But you can see it in Klimt's painting of Schubert! That quiet, mild gaze, the radiance combined with bourgeois modesty – that is the very essence of our Austrian nationality![25]

Klimt, through both his work and his artistic persona, represented an Austrian artistic modernism, but this was a modernism identified as much with contemporary femininity as with Biedermeier masculinity.

The journalist Berta Zuckerkandl's account of a visit in 1902 by Klimt and Rodin to Vienna's amusement park, the Prater, is in this respect revealing. Klimt had apparently asked the orchestra to play music by Schubert. She describes the following scenario:

> Klimt and Rodin had seated themselves beside two remarkably beautiful young women – Rodin gazing enchantedly at them. Klimt had created an ideal of this type – the 'modern' woman, with a boyish slimness and a puzzling charm. [...] And, that afternoon, slim and lovely vamps came buzzing round Klimt and Rodin, those fiery lovers. [...] Rodin leaned over to Klimt and said: 'I have never before experienced such an atmosphere – your tragic and magnificent Beethoven fresco; your unforgettable, temple-like exhibition, and now this garden, these women, this music [...] and round it all this gay, childlike happiness [...]. What is the reason for it all?' And Klimt slowly nodded his beautiful head and answered only one word: 'Austria'.[26]

The Secession exhibitions included many important displays of art and design from abroad, but the institution's ultimate aim was to foster and promote an Austrian artistic avant-garde, a world-class art produced by 'geniuses' (such as Klimt) and epitomised by a new feminine physical ideal.

That ideal is demonstrated by Klimt's 1898 lifesize *Portrait of Sonja Knips*, described by Zuckerkandl as the 'sublimated essence of the modern type of woman'.[27] Here, as in Klimt's other turn-of-the-century female portraits, the physicality of the sitter is dispersed, dissolved almost, into the gauzelike tissue of a white (in the case of Knips, mother-of-pearl) gown. It was by virtue of being thin that the Klimt 'type' of woman defined a contemporary Austrian, or at least Viennese, femininity. This extreme slenderness was the subject of comment (and indeed ridicule) when Klimt's work was exhibited at the 1900 Paris Exhibition.[28] Prototypes of a slim and elegant Austrian femininity were by no means new, nor confined to the aesthetic realm. The Empress Elisabeth was renowned for her slender figure, achieved through rigorous dieting and exercise.[29] Her assassination in 1898 gave added impetus to the cult of Elisabeth; iconic images of Sissi (the diminutive version of her name) were produced and circulated at a mass level. Slenderness, however, signified more than physical self-discipline and restraint. It also connoted a kind of restlessness: woman's refusal to conform to, or be restricted by, the more traditional female roles. Elisabeth's many imperial residences, as well as her extensive travels across Europe, were perceived as indicative of her dissatisfaction with the constraints of court life, as an attempt to escape her position as imperial wife and mother. Klimt's upper-middle-class sitters included women engaged in a variety of professional, cultural and athletic activities. Rose von Rosthorn-Friedmann for instance, painted by Klimt in 1900–1, was a successful Alpine climber. Female physical prowess was not however interpreted merely as a matter of health. It could also be related to women's assertion of control, characterised either as passively self-destructive (as in the case of the Empress Elisabeth's anorexia) or more actively, as voracious. (Klimt's portrait of the slender Rosthorn-Friedmann, for example, was described as depicting a 'modern sphinx'.)[30]

For the Secession, the significance of this new female type was not restricted to the realm of portraiture. Several of Klimt's patrons had domestic interiors designed (often by the Secession architect Josef Hoffmann) around their female portraits. The painting of Sonja Knips was positioned centrally in a living room; that of Marie Henneberg (1901–2) above a marble fireplace, flanked by open showcases,

creating the effect of an altar.[31] Both pictures occupied a liminal space: the Knips painting was visible from the vestibule; Henneberg's portrait hung in the central reception hall. In each case, visitors were confronted at the home's entrance by an image which identified these haute-bourgeois dwellings not merely in terms of ownership, but also as the manifestation of a specifically Viennese modernism. This was a modernism construed as light and airy, as a stripped-down simplicity in tune with both the shimmering dress and the slenderness of the Klimtian female form. Hoffmann's designs carefully staged Klimt's portraits, emphasising the interiors not only as settings but also as extensions of this painted femininity. Secessionist figure type and interior were interrelated, establishing a difference from an earlier Viennese middle-class aesthetic, that of Hans Makart (1840–84). Makart, 'prince of the Ringstrasse', was renowned for his mid-nineteenth-century reinterpretations of lush, Venetian nudes as well as for inspiring well-padded interiors cluttered with plush pillowcases, velvet curtains, heavy draperies and dried palm branches, along with dark, solid old German-style furniture and historical ornamentation.[32] Although marking the aesthetic of a new generation (Secessionist versus Ringstrassen-era), Secession interiors could at the same time be seen as a continuity with the past. Here again the issue of femininity was central. One of Klimt's sitters has recently been referred to as a 'salon sibyl', a reference to the idea that Vienna's industrialist and liberal upper-middle class perpetuated the salon culture established by Austria's eighteenth-century aristocracy.[33] The aristocratic salon was often characterised in terms of the personality of its hostess, and so by implication, Secessionist interiors might be interpreted as a kind of feminised space, an acknowledgment of women's participation in artistic and cultural life, at least within the domestic sphere.

Both Loos and the Secessionists admired early nineteenth-century Biedermeier as a modern aesthetic of light-filled, pared-down simplicity. (Hoffmann was an admirer of Biedermeier cultural artefacts, which he collected.) These aesthetic values were however differently gendered. Loos's identification with the Biedermeier café and the male dress of this period emphasises the 'masculinity' of the Café Museum interior, not only in terms of its appearance, but also as a space for men's intellectual encounter and artistic creativity. As

suggested by Alma Schindler's response to Klimt's *Schubert* painting, the Secession offered something else: the possibility of figuring the modern through woman's fashionably dressed body. For Loos on the other hand, female fashion functioned as a term of disparagement. His essay on 'Ladies' Fashion' denounced women's fashion as wasteful in its pursuit of novelty and perverse in its function of provoking 'unnatural' sensuality in male viewers.[34]

Yet to a certain extent, the presence of the Gibson Room in the Café Museum can easily be explained by and assimilated to Loos's published arguments. Loos's Anglophilia is well known. For Loos, there were ways in which Anglo-Saxon culture could offer positive exemplars of a more progressive, modern femininity. He commented on the 'tendency' which emanates from England but was in fact 'that persuasion invented by the refined Greeks: platonic love. The woman may be no more than a good friend to the man.'[35] Loos related the potential for platonic friendship to the evolution of the woman's 'tailor-made costume', in his view perhaps a desirable alternative to the unhealthy erotic desire stimulated by more obviously fashionable women's dress. The turn-of-the-century American girl, as conceived by Charles Dana Gibson, embodied similar ideas. In the words of one commentator: 'They unite freedom of manner with modesty of behavior. [...] Probably the Greek girls in their highest development in the times of Phidias were never so attractive as the American girl [...].'[36] This new classical ideal usefully combined the modern with the timeless, the beautiful with the unerotic (and hence the unthreatening). Tall without being gawky, willowy but not lean, this female paragon 'bore her height with a sweet timidity that disarmed fear'; she was 'chastity personified'.[37]

While Loos's view of America as the land of the new Greeks was probably based more on an admiration of American engineering achievements than on a predilection for Gibson Girls, he would surely have appreciated that defining aspect of the Girl – her vibrant athleticism. In 'Ladies' Fashion', Loos commented positively on women cyclists, seeing in their liberated clothing the precursor of their economic independence:

2.5 Charles Dana Gibson, *Gibson Girl playing Golf*, illustration.

only in the last fifty years have women acquired the right to develop themselves physically. [...] the concession will be made to the twentieth-century female bicyclist to wear pants [trousers] and clothing that leaves her feet free. And with this, the first step is taken toward the social sanctioning of women's work.[38]

The Gibson Girl swam, played golf and cycled. (Ill. 2/5) Americans claimed her as a modern 'Goddess of the Wheel' (Loos was not alone in making the connection between cycling and a more progressive state of affairs for women): 'the new deity was a pretty American girl speeding joyously along on a bicycle. On that simple machine she rode like a winged victory, women's rights perched on the handlebars and cramping modes and manners strewn in her track.'[39]

In these ways Gibson Girls encapsulated not only American femininity but also the American modernity of the 1890s. How then should we interpret the significance of the *Gibsonzimmer*, that little piece of American modernity appended to the larger space of the Café Museum? The year 1895 had seen the opening in the Prater of the popular amusement 'Venedig in Wien'.[40] 'Venice in Vienna' was a reconstruction of Venice, the medieval city of canals imported into modern Vienna, the Vienna of the Ringstrasse and of fast-growing transport systems. Could we, by analogy, consider the Gibson Room as a kind of 'Amerika in Wien', as an exoticisation of the modern rather than of the past? We need to remember however that 'Venedig in Wien', itself a manifestation of Viennese modernity, was not merely an exercise in nostalgia for the past as preserved in a unique Italian city. It also constituted a kind of comment on Austrian society, which more than other European countries was still structured by the co-existence of the feudal with the modern. Similarly, far from being simply the supplement to a larger entity, the Gibson Room offers a vantage point from which to reconsider the modernity of the Café Museum.

The Gibson Girl was a kind of new classical ideal, a 'universal' type.[41] There was no 'original' Gibson Girl, she was a 'composite' (recognised as the Girl 'who was all things to all men').[42] These characteristics were less a consequence of late nineteenth-century classicism than of the technologies of representation. The Gibson Girl was a product of modern processes of mechanical reproduction. As

The Studio put it in 1896: 'But for process [...] Mr. Gibson would not be Mr. Gibson'.[43] Through her appearances in illustrated magazines, such as *Life*, the Gibson Girl was addressed to mass audiences (of men and women), to a vast reading public, both in the United States and abroad. She represented a democratic impulse, a secular icon to whom shrines were created in many homes. There were also Gibson Girl commodities, including wallpaper (deemed especially suitable for bachelors) and furnishings. The Gibson Girl was thus symptomatic of the processes of mass reproduction and consumerism which were transforming everyday life in the modern world. Gibson's illustrations were reprinted on a larger scale (in folio form) and it was framed examples of these which hung on the walls of the Café Museum *Gibsonzimmer*. On the face of it, the statuesque American woman invoked by the *Gibsonzimmer* constitutes both an adjunct to the inherent masculinity embodied by the Café Museum and a robust contrast to the slender and ethereal womanhood promoted by the Secession. In this sense, the Gibson Room effected an exoticisation of modern womanhood, proclaiming not only a femininity but also a modernity that was simultaneously elsewhere (in America) and in the future (for Austria).

It seems that some months prior to the opening of the Café Museum, Loos had enlisted the support of Peter Altenberg in promoting the Gibson Girl. The New Year's Day issue of the *Wiener Allgemeine Zeitung* in 1899 included Altenberg's essay 'Zwei anglosaxonische Künstler' ('Two Anglo-Saxon Artists'), mainly devoted to the work of Charles Dana Gibson.[44] Altenberg claimed that he had been invited by Loos to accompany him on a visit to an exhibition at Artaria to admire 'Anglo-Saxon Culture'. Altenberg obliged, both with an extended account of the Gibson albums on show at Artaria and by publishing a brochure on Gibson (a special offprint from the *Wiener Allgemeine Zeitung*). The pamphlet was inscribed by Altenberg 'For the "Gibson-Room" in the Café Museum printed in 10,000 copies'.[45] As the exponent of American (or 'Anglo-Saxon') culture, the imagery of the Gibson Girl was thus enhanced by the wit and insouciance of the *Kaffeehaus* literateur. It is however in its opposition to the Secession that Loos's conjunction of American femininity and Biedermeier masculinity reveals the parameters of a distinctively *fin-*

de-siècle Viennese modernity. In reality of course, Gibson's heavily idealised female figure was far from being an 'all'-American girl, particularly given the country's mixed and diverse population, which included immigrants from a great variety of national and ethnic backgrounds.[46] In the context of Vienna, the strapping (invariably WASP) Gibson Girl contrasted tellingly with the febrile femininity associated with the largely Jewish patrons and clients of the Secession. (Otto Weininger's anti-semitic tract *Sex and Character*, for example, referred disparagingly to the Secession's penchant for 'tall lanky women with flat chests and narrow hips'.)[47] Similarly, to identify the authentically modern with Biedermeier culture was to privilege a period prior to the largescale influx of Jewish immigrants to Vienna during the second half of the nineteenth century.[48]

As the component of a café refurbishment the *Gibsonzimmer* offers further reminders of the fact that, far from existing elsewhere, modernity had already encroached upon Vienna. The Viennese *Kaffeehaus* was a vital symptom of modernisation, intrinsically linked to urbanisation and to the expansion of the outer limits of the city. Since the Biedermeier period, cafés had proliferated in the city's new suburbs. In some cases, such as the Café Hohe Warte, first opened in 1841, they constituted destinations for day-trippers, offering splendid vistas of the city.[49] However, even when not so dramatically situated as the Hohe Warte, many cafés were designed – with glassed-in verandas and gardens, for example – to ensure varied views both for and of their customers. City-centre cafés often occupied a corner site, affording patrons views of two different streets. Located on a corner in the old inner city, the Café Museum (like so many other cafés) formed part of the visual spectacle constituted by this unceasing urban renewal. In the case of Viennese *Kaffeehäuser*, Loos's invocation of Biedermeier culture to connote continuity, uniformity and a slow rate of change in fact masked a quite different situation. Cafés were an important aspect of urban consumerism, and as with all forms of consumer culture, rapid change and differentiation of product were key elements in maintaining existing and in attracting new customers. Cafés reveal the extent to which the modernity of commercial architecture in particular involved not only new buildings but also the refurbishment of existing establishments. Viennese newspapers and

journals of the period were full of advertisements and announcements about such renewals, vaunting not only new amenities but also the latest designs. Indeed, employing a high-profile architect or designer to undertake such refurbishments was one means of raising the cachet of the business in question. Much like the modern female dress so disparaged by Loos therefore, the design of cafés could not escape fashion's relentless and accelerating rate of change, nor what Loos saw as the aim of women's fashion, the processes of differentiation in order to attract attention.

There were other ways too in which Viennese cafés problematised the idea of the *Kaffeehaus* as a bastion of 'masculine' intellect. Extensions of both home and office, cafés functioned as sites of communication, for discussion and as places to read and write. By the late nineteenth century, certain Viennese coffeehouses were renowned as meeting places of the city's intellectual elite. At the same time, coffeehouses were also identified with particular forms of literature, especially those aimed at mass audiences such as newspapers and illustrated journals.[50] These were the very types of reading and writing increasingly disparaged by certain critics as trivial and lightweight. Edmund Wengraf in 'Coffeehouse and Literature' (1891) pronounced that 'seriousness and thoroughness do not thrive in the atmosphere of the coffeehouse.'[51] And Alfred Polgar (1906) in an ironic description of Viennese *feuilleton* journalism as vacuous, proceeded by way of an extended feminised metaphor: 'the wishy-washy visage, winsomely set off by stylishly frizzled little curls'.[52] Mass culture brings with it, as Andreas Huyssen has argued, the spectre of 'feminisation' – the threatened erosion of high art and cultural values that have been positively characterised as masculine.[53] Despite Adolf Loos's denunciations of Austria's backwardness, by the 1890s the forces of modernisation were much in evidence: in the form of mechanical reproduction and industrial development as well as in the increased employment of women in offices and service industries.[54] Loos's privileging of male dress over female fashion can be read as a defensive insistence on the masculine nature of modernity in the face of a widespread perception of an insidious 'feminisation' of culture and society.[55] The consequences for women of such negative formulations of the 'feminine' were however far from straightforward.

In Vienna, as elsewhere in Europe, modernisation involved a proliferation of feminist and women's movements.[56] The presence of these 'new' women is often credited with provoking anxieties and misogyny in their male contemporaries. The masculine version of modernity promoted by Loos can be interpreted (at least in part) as the consequence of this prevalent misogyny. At the same time, Loos was admired by and produced work for exponents of various Viennese women's movements.[57] Women were interested in artistic avant-gardism (however apparently misogynistic in certain of its manifestations) not only as a means of engaging with the domain of high culture, but also for its potential to challenge and change contemporary society.

Recent architectural historians and theorists have characterised certain aspects of Loos's early twentieth-century work in terms of its interiority and mystery. They have pointed, for example, to the ways in which Loos's architectural façades function as a 'mask' for their building's interiors.[58] Here, early in his career, at the Café Museum, where Loos was responsible solely for the interior refurbishments, there was a quite different relationship of exterior to interior. Rather than defining any hard-and-fast boundaries, this café with its mirrors and windows (like many others in Vienna) constituted a tantalising interface between interior and exterior. At the Café Museum, the glittering mirrors of the *Sitzkassierin*'s 'throne' along with the large windows facing the street produced a scintillating interplay of transparency and reflection, a spectacle which was both an element, and an enhancement, of the dynamism of the urban street.[59] Such spatial complexities, along with the increasingly ambivalent cultural connotations of the *Kaffeehaus* around 1900, simultaneously connoting masculine intellect and feminine frivolity, rendered the café a problematic means of sustaining the kind of rhetorical arguments favoured by Loos. When articulated through reference to the *Kaffeehaus*, the binary oppositions so important to Loos's polemic are constantly threatened and undermined.

Commentators (including some recent historians as well as journalists of the period) may have acquiesced in the terms of Loos's critique of the Secession, but it has always been evident that the differences between the two were more rhetorical than real. The Secession shared, for example, Loos's disdain for Ringstrassen

historicism in art and architecture as well as his Anglophilia. The Biedermeier period was, as we have seen, admired by numerous members of the Secession as much as by Loos. The apparently different and contesting modernisms on offer in Vienna around 1900 were not only a matter of aesthetic debate, or even of professional jockeying for position and attracting clients, but also a product of the political tensions of the time, particularly in the ways that such conflicts were formulated in terms of race and gender. The presence of the *Gibsonzimmer* in Loos's Café Museum prompts a reconsideration of the encounter between café and Secession in ways which eschew the fixed, binary oppositions so often used in discussing the aesthetic discourse and practice of the period.[60]

Gibson's 'all-American Girl' is a useful point of reference in pondering the complex calibrations of 'femininity' and 'Austrianness' which characterised and helped shape late nineteenth-century Viennese modernisms. Instead of a series of confrontations between masculinity and femininity, or plainness and ornament, we are made aware that far from existing separately (across the street from each other, as it were) these were symbiotically linked terms which co-existed in a state of tension. Loos's Café Museum was an elegantly spare environment for the pursuit of serious, intellectual concerns. It was also a richly coloured and textured set of spaces identified with the ephemerality and 'frivolity' of journalism and literary *Kleinkunst*. (In the announcement of the Café's opening, the *Neue Freie Presse*, impressed by the colourful interiors, claimed it could be dubbed 'the Rainbow Café', and particularly remarked on the blue windowframes and reddish bentwood chairs.)[61] Similarly, the ostensibly more 'feminine' version of modernism promulgated by the Secession included an updated iconography of the femme fatale (as in the case of Rosthorn-Friedmann's portrait) shaped more by male anxieties than women's concerns. From the vantage point of the Gibson Room we are afforded further insights into the unstable and shifting relationships (between 'masculinity' and 'femininity,' between 'high' and 'low' culture) distinctive to Viennese modernisms at the turn of the century.

* * *

Loos's Café Museum reveals the extent to which Viennese coffeehouses constituted discursive as well as architectural and urban spaces. For Loos, the Café Museum functioned as a useful referent in lectures and essays long after its official opening in 1899. Quite beyond its professional significance for Loos however, at a wider level, the Café Museum was merely one of the many Viennese cafés through which the modernity of the city was proclaimed and represented. Like other cafés, the Café Museum appeared in the form of postcards. Caricatures of the well-known regulars of the Museum were published as postcards in 1907 and 1910, and two postcard views of the Gibson Room appeared in 1911. These functioned as a useful means of communication (and advertising), but more generally such postcards were also a means of representing the distinctiveness of Vienna as a modern city. Here Vienna was depicted as a modern metropolis characterised by its arts, but also by its vibrancy, wit and humour. The Viennese café signified the continuity of indigenous traditions (as epitomised by the Biedermeier *Kaffeehaus*). At the same time, the city's contemporaneity was asserted by its cafés' constantly updated architecture and refurbished interiors. In the ephemeral – but very pervasive – guise of the postcard the *Kaffeehaus* stood for Vienna metaphorically as well as metonymically.

However important, cafés were far from being the only kind of urban space to play a significant role in Viennese debates as to what defined the modern during the early years of the twentieth century. As we saw in Chapter 1, the domestic interior was similarly important in these debates. Like the café, the urban home (despite its associations with ideas of privacy and refuge) was also linked to the public and intellectual life of the city. Both as an inhabited and discursive space, the home was a vital site for the enactment and contestation of what should constitute 'modern life'. In 1903, Loos published two photographs labelled 'bedroom for my wife' in Peter Altenberg's journal *Kunst*. Chapter 3 explores the significance of the public appearance of this ostensibly most private room of the home, the bedroom (and in particular, the marital bedroom), not only for Loos but also for Viennese culture more widely at this time.

Notes

1 Janik and Veigl, *Wittgenstein in Vienna*, p. 57. There was a Café Secession; located in the Rothenthurmstrasse; it had opened on Easter Sunday 1899. See the advertisement on the front page of the *Wiener Allgemeine Zeitung*, 2 April 1899.
2 For a detailed account of the Secession Building, see 'The Secession Building: Multiple Truths and Modern Art' in Topp, *Architecture and Truth in Fin-de-Siècle Vienna*, pp. 28–62.
3 'Plumbers' (1898) in Loos, *Spoken into the Void*, p. 45.
4 These works included projects for the Viennese tailors Ebenstein (1897) and Goldman & Salatsch (1898–1903) and furniture for the apartment of Eugen Stössler (1898–9); see Rukschcio and Schachel, *La vie et l'oeuvre de Adolf Loos*, pp. 411–17.
5 Indeed David Frisby points out that at this period, the Karlsplatz was one of the most contested spaces in Vienna; see 'The City Designed: Otto Wagner and Vienna' in *Cityscapes of Modernity*, pp. 223–35. Perhaps because Loos's refurbishments for the Café Museum did not affect the building's exterior, it escaped much of the criticism and controversy directed at other, more substantial projects for the square.
6 'Als Aufrichtiger Nichtsezessionist gibt sich Adolf Loos in seinem "Café Museum". Nicht als Feind der Wiener Sezession, aber als etwas anderes, denn modern sind schliesslich beide' (Ludwig Hevesi, *Acht Jahre Sezession*, quoted in *Das Wiener Kaffeehaus Von den Anfängen bis zur Zwischenkriegszeit*, p. 49).
7 For details of Hoffmann's work in the years up to and including 1899, see Sekler, *Josef Hoffmann*. For Hoffmann's Secession exhibition designs, WV 14, 15, 16, 22,25, 26, 27 (pp. 255–7); furniture for Koloman Moser, W 17 (p. 253); Haus for Fernand Khnopff in Brussels, 1899–1900 (?), W 36 (p. 260); lobby and office of the Secession Secretariat, WV 24 (p. 256); Apollo Candle Factory, WV 1899 (p. 258); displays at the 1900 Paris Exhibition, WV37 (pp. 260–1), WV 38 (p. 261), WV 39 (pp. 261–2) and WV 40 (p. 262). See also Chapter 4 below, 'Viennese Modernism', n. 7.
8 On Peter Altenberg, see Chapter 1 above, 'The Inner Man'. For an account of Hugo von Hofmannsthal's 'discovery' at the Café Griensteidl, see Zweig, *The World of Yesterday*, p. 47.
9 Carl Moll, 'Osterstimmung im Wiener Kunstleben', *Osterbeilage der Wiener Allgemeinen Zeitung* (1898), reprinted in Bisanz-Prakken, *Heiliger Frühling: Gustav Klimt und die Anfänge der Wiener Secession 1895–1905*, p. 211 (cited in Johnson, 'Athena goes to the Prater', p. 65).
10 'My Building on Michaelerplatz' (1911) in Loos, *On Architecture*, p. 105.

11 Rukschcio and Schachel, *La vie et l'oeuvre de Adolf Loos*, p. 66, who cite Loos's lectures (1912–13) at the Schwarzwaldschule; see also Kurt Lustenberger, *Adolf Loos*, p. 24.

12 Loos, 'My Building on the Michaelerplatz', p. 105.

13 *Das Wiener Kaffeehaus*, p. 32. On the implications of gender in connection with the British coffeehouse, see Cowan, 'What was Masculine about the Public Sphere? Gender and the Coffeehouse Milieu in Post-Restoration England'; also Cowan, *The Social Life of Coffee*.

14 For details of this print, see catalogue no. 100 in *Das Wiener Kaffeehaus*, p. 79.

15 Rukschcio and Schachel, *La vie et l'oeuvre de Adolf Loos*, p. 67.

16 Hevesi, *Acht Jahre Sezession*, quoted in *Das Wiener Kaffeehaus*, p. 50.

17 Hevesi, quoted in Lustenberger, *Adolf Loos*, p. 42. Detailed information concerning the original appearance of the furniture, materials and colours was presented by the exhibition *Das Café Museum von Adolf Loos* (March–May 2000) at the Kaiserliches Hofmobiliendepot, Vienna, in collaboration with the Graphische Sammlung Albertina. I am most grateful to Markus Kristan and Eva B. Ottilinger for subsequently sharing with me their extensive research for this exhibition.

18 On Charles Dana Gibson, see Downey, *Portrait of an Era*.

19 'Men's Fashion' (1898) in Loos, *Spoken into the Void*, pp. 11–14.

20 Beaumont, *Alma Mahler-Werfel Diaries 1890–1902*, Tuesday 23 May 1899, p. 143. Klimt's careful selection of the women's dress for *Schubert at the Piano* is discussed in connection with his *Portrait of Serena Lederer* (also 1899) in Natter and Frodl (eds) *Klimt's Women*, p. 88.

21 See Messing, 'Klimt's Schubert and the Fin-de-Siècle: 'But we can proudly call him ours: Vienna especially can call him one of its greatest sons' (p. 3).

22 Klimt's *Schubert at the Piano* was commissioned for the music room of Baron Nicolaus Dumba. See Natter, 'Baron Nicolaus Dumba: geboren, um Mäzen zu werden'. The painting achieved a wide popularity, and is said to be Klimt's most reproduced work. Both Hermann Bahr and Altenberg owned reproductions of the painting; see Messing, 'Klimt's Schubert'.

23 'The Schubertian *Mädchencharakter*, a term coined by Robert Schumann in 1838 to indicate Schubert's music was more "feminine" than Beethoven's, still exerted its cloying influence sixty years later' (Messing, 'Klimt's Schubert', p. 11).

24 The relationships between concepts of tradition and modernity which characterized Viennese artistic practice and theory at this period is a widely discussed issue. See Chapter 1 'The Inner Man', n. 31.

25 Natter, 'Princesses without a History? Gustav Klimt and "The Community of All who Create and All who Enjoy"' in Natter and Frodl (eds), *Klimt's Women*, p. 67.

26 Comini, 'The Three Stages of Life' in Natter and Frodl (eds), *Klimt's Women*, p. 242.

27 Natter in Natter and Frodl (eds), *Klimt's Women*, p. 84.

28 See the caricature illustrated in Natter and Frodl (eds), *Klimt's Women*, p. 23.

29 For a biography, see for example, Sinclair, *Death by Fame: A Life of Elisabeth Empress of Austria.*

30 Hevesi, who drew attention to the figure's 'gleaming' teeth; quoted in Natter and Frodl (eds), *Klimt's Women*, p. 92.

31 See Natter and Frodl (eds), *Klimt's Women*, pp. 96–7 (Henneberg house on the Hohe Warte, built in the early years of the last century) and pp. 86–7 (Hoffmann's later 1924–5 home for Knips in the Nusswaldgasse, Wien XIX).

32 See for example, the exhibition catalogue *Hans Makart Malerfürst (1840–1884).*

33 Natter in Natter and Frodl (eds), *Klimt's Women*, p. 71.

34 'Ladies' Fashion' (usually dated 1898) in Loos, *Spoken into the Void*, pp. 99–103. On the significance (and dating) of this essay see Janet Stewart, *Fashioning Vienna*, pp. 112–24.

35 'Ladies' Fashion' in Loos, *Spoken into the Void*, p. 100.

36 Downey, *Portrait of an Era*, p. 190.

37 Downey, *Portrait of an Era*, pp. 194 and 206.

38 'Ladies' Fashion' in Loos, *Spoken into the Void*, pp. 102–3. On the vogue for cycling in Austria during the late nineteenth-century, see Roman Sandgruber, 'Cyclisation und Zivilsation. Fahrradkultur um 1900' in Ehalt et al. (eds), *Glücklich ist, wer vergisst?*, pp. 285–303.

39 Downey, *Portrait of an Era*, p. 252.

40 See, for example, Ursula Storch, 'Venedig in Wien' in *Das Pratermuseum*, pp. 64–6; Janet Stewart, *Fashioning Vienna*, pp. 146–8. On the cultural significance of the Prater more generally at this time, see Mattl et al., *Felix Salten.*

41 J.M. Bulloch, 'Charles Dana Gibson,' *The Studio*, vol. 8, 1896, p. 78.

42 Downey, *Portrait of an Era*, pp. 211 and 195.

43 Bulloch, *The Studio*, vol. 8, 1896, p. 80.

44 Peter Altenberg, 'Zwei anglo-saxonische Künstler', *Wiener Allgemeine Zeitung*, no. 6250, 1 Jan. 1899, p. 4.

45 The cover to the brochure on Charles Dana Gibson, as inscribed by Altenberg, is illustrated in Rukschcio and Schachel, *La vie et l'oeuvre de Adolf Loos*, p. 67.

46 On images of American femininity, see Banta, *Imaging American Women.*

47 Weininger, *Sex and Character*, p. 73; quoted in Cernuschi, *Re/casting Kokoschka*, p. 97.

48 Cernuschi analyses the anti-semitism, implicit as well as explicit, in the pronouncements of Adolf Loos and his circle; see, for example, *Re/casting Kokoschka*, pp. 178–9.

49 On the Café Hohe Warte, see *Das Wiener Kaffeehaus*, pp. 76 and 103. After closure of the earlier café, a renovated version was opened in 1860.

50 See for example, Segel, *The Vienna Coffeehouse Wits.*

51 Edmund Wengraf, 'Coffeehouse and Literature' (1891) in Segel, *The Vienna Coffeehouse Wits*, p. 386.

52 Alfred Polgar, 'The Viennese Feuilleton' (1906) in Segel, *The Vienna Coffeehouse Wits*, p. 248.

53 'Mass Culture as Woman: Modernism's Other' in Huyssen, *After the Great Divide*, pp. 44–62 and 225–7.

54 On women's employment, see Appelt, 'The Gendering of the Service Sector in Austria at the End of the Nineteenth Century'.

55 On the 'feminisation' of Viennese society, see Le Rider, *Modernity and the Crises of Identity*.

56 Anderson, *Utopian Feminism*. It has been argued however that feminist movements in Vienna were not as strong as in other countries at this period.

57 Loos was asked to design the interiors for the Viennese Wiener Frauenclub (1900), his 'Ladies' Fashion' was published in the feminist journal *Dokumente der Frauen* (1902) and he had connections with Eugenie Schwarzwald, an energetic promoter of women's education. On Schwarzwald, see Streibel (ed.), *Eugenie Schwarzwald*. There was also considerable feminist admiration for the Secession. For details, see Anderson, *Utopian Feminism*.

58 Colomina, 'On Adolf Loos and Josef Hoffmann'; 'The Michaelerplatz Building, an Honest Mask' in Topp, *Architecture and Truth*, pp. 132–68.

59 In his gloss to Karl Gutzkow's 1842 *Briefe aus Paris*, Walter Benjamin comments: 'The way mirrors bring the open expanse, the streets, into the café – this, too, belongs to the interweaving of spaces, to the spectacle by which the flâneur is ineluctably drawn.' Gutzkow described the mirrors as 'reflecting rows of merchandise right and left'. 'Mirrors' in Benjamin, *The Arcades Project*, p. 537.

60 On the rhetorical implications of such binary oppositions, see Cernuschi, *Re/casting Kokoschka*, pp. 189–93.

61 *Neue Freie Presse*, 20 April 1899, p. 6.

3 Haptic Homes: Fashioning the Modern Interior

The first issue of the lavish, upmarket Viennese journal *Kunst: Halbmonatschrift für Kunst und alles andere* appeared in autumn 1903 edited by the poet Peter Altenberg. Concerned with both literature and the visual arts, *Kunst* (whose full title translates roughly as *Art: Bimonthly Publication for Art and Everything Else,* or *Art and All the Rest*) was accompanied by a supplement edited and written by Adolf Loos, *Das Andere: Ein Blatt zur Einführung Abendländischer Kultur in Österreich* (usually translated as *The Other: A Journal for the Introduction of Western Culture in/to Austria*). It was however *Kunst* – and not the more provocatively titled *Das Andere* – that featured two photographs of a room designed by Adolf Loos and entitled 'Das Schlafzimmer meiner Frau' ('My Wife's Bedroom').[1] (Ill. 3/1) Active for some years as a cultural journalist and interior designer, Loos (then 32) had married the nineteen-year-old aspiring actress Lina Obertimpfler in July 1902, moving to a flat in Vienna's First District at 3 Giselastrasse (now Bösendorferstrasse) later that year. The photographs of his wife's bedroom in *Kunst* are clearly self-promotional. Along with the editorship and authorship of *Das Andere*, they can be seen as part of Loos's attempts to establish his identity and practice as an architect in early twentieth-century Vienna. Here the 'architect's home' functions not merely as the means of soliciting further clients, but also (like his refurbishment of the Café Museum in 1899) as the visual and spatial manifestation of Loos's ongoing journalistic critique of Austrian design as backward and outdated.

As the image of an appropriately modern bourgeois domestic interior however, Loos's bedroom presented a somewhat unusual appearance. The room was enveloped in white textiles; not only the windows but also the dressing table, walls and cupboards were swathed in this fabric. The floor carpet was almost entirely covered by a vast white furry angora rug, which climbed up the bedstead to meet the mattress. Although the bedroom itself no longer survives,

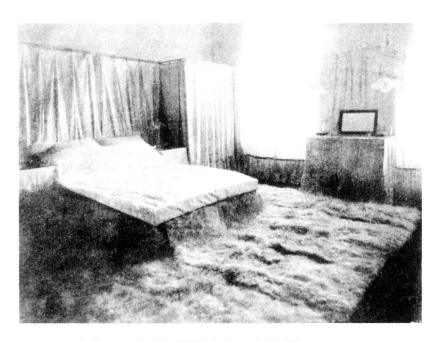

3.1 Photographs, 'My Wife's Bedroom', Adolf Loos apartment
as illustrated in *Kunst*, 1903, no. 1. Wienbibliothek im Rathaus.

representations of Loos's design retain their power to provoke a startled response. Reviewing the 1989 exhibition of Loos's work in Vienna, the architectural historian Alan Crawford described a reconstruction of the bedroom as 'the most eccentric exhibit':

> there was nothing in this white shrine, shrouded in white drapes, except a low white slab of a bed rising from a sea of shaggy white angora; was it for sex or for sacrifice? Better to think of Loos's sitting room [...] with its inglenook, its Windsor chairs and its sweeping copper firehood it makes you think of Raymond Unwin, Gustav Stickley, and other such healthy things.[2]

For Crawford, it was not possible (or more accurately perhaps, not desirable) to represent Loos through this bedroom. His recoil from an implied morbid Viennese sensuality, along with the relieved turn to a 'healthy' Anglo-Saxon environment (the more recognisably Arts and Crafts appearance of Loos's sitting room), parallels Loos's own mission to introduce 'Western culture' into Austria. Almost a hundred years earlier, in 1898, Loos had used his series of articles for the liberal newspaper the *Neue Freie Presse* to vaunt the accoutrements of American and British everyday life as the means of bringing Austria up to date. He particularly admired English men's tailoring, contrasting this with what he saw as the unhealthy eroticism of women's fashion. This prompts questions concerning the significance of the photographs in *Kunst*. As we have seen, Loos's redesign for the interiors of the Café Museum involved an urban space, the *Kaffeehaus*, which was generally construed as a masculine terrain. Archetypally Viennese, cafés were recognised as important sites of public encounter and communication. Domestic bedrooms on the other hand were conventionally gendered as 'feminine,' and identified as one of the most private spaces of the house. Loos himself advocated the need to protect and maintain the privacy of the bedroom.[3] What then was involved here, in Loos staking a claim for male professional identity through making public the most intimate and feminised room of his own home?

Prior to his marriage, and in part due to his financial circumstances, Loos had not resided at any permanent address and would sometimes cite hotels or cafés as his *poste restante*. As we have seen in the previous two chapters (and particularly in the case of figures such as

Peter Altenberg) these were precisely the urban locations associated with certain forms of artistic identity. Throughout his memoirs, *My Youth in Vienna*, Arthur Schnitzler associates the Viennese café with both work and leisure, the place to while away happy hours playing billiards, but also a retreat in which to write. The café was recognised as a sphere of male sociability where masculinity could be publicly celebrated in terms of a flamboyantly bohemian lifestyle. Schnitzler describes a nocturnal café encounter:

> I had come upon him one night at the Café Central, with a glass of absinthe on the table in front of him, staring with glazed eyes into a mirror, and he had responded to a question of mine, or perhaps only a look, with the words, 'I want to see what a fellow looks like who has made love five times (he used a more colloquial expression) and drunk two bottles of champagne'.[4]

The artist's studio too was construed as a site for socialising as well as for work. It is revealing that in 1903, the year in which the Wiener Werkstätte were founded, its co-founder and financial backer Fritz Waerndorfer proposed a fullscale redesign of Klimt's studio by Werkstätte designers.[5] Waerndorfer clearly felt that the project would entail good publicity for the new organisation. Although Klimt fiercely guarded his work space (on this occasion he refused Waerndorfer's proposal), certainly since the time of Makart, 'the Prince of the Ringstrasse', artists' studios were considered an important means for painters to present a professional identity in public. (Written accounts of a visit to an artist's studio had indeed become a kind of journalistic and literary genre.) Like the café environment, Klimt's studios were identified with 'undomesticated' forms of male sexuality. There were descriptions of Klimt in his artist's smock surrounded by naked female models, whom he had instructed to move naturally about the studio.

The publication of the photographs of Loos's wife's bedroom in *Kunst* is obviously different from such contemporary conventions for depicting male professional identities. (This was especially the case given the fact that unlike other rooms such as dining or living rooms, the marital bedroom was not widely recognised as a 'representational' domestic space – a means of establishing one's public status.) At the same time, the publication of these two photographs accorded neither with Loos's views on the photographic representation of interiors, nor

with his disparagement of architectural publication more generally. Loos often expressed disapproval of photographed interiors. In an essay on 'Architecture' (1910), for example, he pronounced:

> a true building makes no impression as a picture reduced to two dimensions. It is my greatest pride that the interiors I have created are completely lacking in effect when photographed; that the people who live in them do not recognise their own apartments from the photographs […].[6]

Loos claimed to prefer his domestic interiors to be viewed *in situ*, as three-dimensional spatial experiences, on visits preferably carried out under his own guidance. He invited colleagues to accompany him to Viennese apartments he had redesigned and in December 1907 he organised two 'Guided Tours to Apartments' for members of the public. These tours were guided by Loos, although not in person (he was apparently on holiday in the Alpine resort of Semmering at the time) but through an exquisite small brochure he had written and designed. Here again he announced:

> One aim of these tours is to halt the relapse into a mishmash of old styles which has already become widespread. I will, I know, be accused of self-advertisement. Perhaps I can meet the accusation by pointing out that the apartments on which I collaborated have never appeared in art magazines […] it was never my habit to cackle whenever I laid an egg.[7]

Loos was vituperative about what he considered to be the negative and insidious effect of arts magazines, claiming that this 'mass of slick publishing ventures has poisoned our urban culture'.[8] This was a two-pronged polemic, an argument against the arbitrary recycling of historicist styles and a condemnation of architecture which lacked proper three-dimensional, spatial coherence. According to Loos, arts magazines encouraged architects to become 'knights of the drawing board,' producing works in any style to order, interiors and buildings that were attractive in reproduction as opposed to good to live in.[9]

Loos relished public polemic, adopting a confrontational stance in order to delineate his ideas on contemporary architecture and his identity as an architect. (Strategic use of criticism to bolster career and reputation was characteristic of Viennese cultural politics at this time. Hermann Bahr's compilation of attacks on Klimt, for example, was

published as *Gegen Klimt* in 1903.) In his newspaper journalism, guided visits and, increasingly, in his public talks and lectures, Loos adopted a stance of the misunderstood outsider not only in order to mount his attack on Austrian backwardness but also to position himself vis-à-vis institutions of Viennese culture. His complaint that he was denied the more usual platforms of making public his architecture and ideas, such as exhibitions and teaching posts, was directed as much at certain sectors of the Viennese avant-garde as against the more conservative bastions of Viennese culture. As we have seen, Loos had fallen out with members of the Vienna Secession in 1898 when Josef Hoffmann refused his request to design the meeting room for the group's journal *Ver Sacrum* in Olbrich's newly built Secession building. Thereafter Loos often formulated his own views in opposition to the Secession and its members, with regular diatribes against Hoffmann in particular. But Loos's negotiation of a position within the Viennese arts world involved references to the past as well as to the present, to his own work as well as that of others. The photographs of his wife's bedroom in *Kunst* should therefore be considered in relation to such strategic positionings, as a component of the discursive network through which ideas about modern architecture and design were being debated in early twentieth-century Vienna.

Loos's career as an architect got off to a slow start. On his return to Vienna in spring 1896 from a visit of several years to the United States and a shorter trip to Britain, he earned his income largely from journalism and interior design. Always aiming for more important commissions, Loos denied his refurbishments of Viennese shops and apartments the status of architecture. At one point he compared such work to his temporary job as a dishwasher while in America.[10] Nevertheless, at a polemical level, the interiors played an important role, both as the materialisation of the views expressed in his journalism and subsequently, as subjects for his articles and lectures. The year 1903 was Loos's most prolific as an interior designer, and although he was eventually able to concentrate more on commissions for building private houses, references to interiors from the earlier part of his career occur frequently in his published writings right up until his death in the early 1930s.[11]

At one level then, the photographs of his wife's bedroom form part of Loos's ongoing public dialogue with his own work and its reception. He frequently referred back to his first high-profile interior refurbishment, for the Café Museum in 1899, a year after his rejected proposal for the *Ver Sacrum* room at the Secession. Loos claimed that despite the fact that they remained largely unpublished, his Café Museum interiors had exerted considerable influence. He undoubtedly relished the confrontational geographical position of the café and its implied critique of Secessionist ornament (as 'Café Nihilismus') as a means of identifying his own practice. At the same time, he claimed that the café's simplicity had had a profound, albeit undesirable, impact on Secession design. Loos asserted that 'Ever since the café was opened, all apartments have been as bare as a café.' Nor, according to him, was this influence confined to architecture and interior design:

> Since then [...] the decoration for vases and fruit bowls has been based on sewer gratings. That was not what I intended. If I hadn't done the Café Museum then, the whole decorative trend of Olbrich, van der Velde and Hoffmann would have collapsed from over ornamentation. My café showed them new but mistaken ways [...].[12]

These assertions appeared in the 1907 guide to Loos's interiors, the walking tours clearly intended as a remedy to such 'misunderstandings' about design for the domestic, as opposed to more public, interiors.

Loos's own apartment did not feature in the 1907 tours of his interiors. Like those visits however, the two photographs in *Kunst* can be construed as a public statement on the modern home. His concern was not merely with the appearance (or style) of domestic interiors, but rather with the kinds of physical experience that apartments embodied. Loos advocated a domestic architecture of intimate, cosy rooms as opposed to what he claimed were the cold, highly stylized interiors 'imposed' on clients by Secession architects: 'A room must look cozy, a house comfortable to live in.'[13] Cosiness and comfort were related to the quality of materials, and especially to the sense of touch: 'precisely what I want is for people in my rooms to feel the material around them, I want it to have its effect on them, I want them to be aware of the enclosing room, to feel the material.' The

inhabitants of a Loosian interior were to 'see it, touch it, to perceive it sensually [...].'[14] His essay 'The Principle of Cladding' (published in 1898) related this tactile experience of architecture to textiles:

> Say the architect is to create a warm, cozy room. Carpets are warm and cozy, so he decides to spread one over the floor and hang up four to make the four walls. [...] Both floor and carpets need a construction to keep them in place. Designing this construction is the architect's second task.[15]

More than a definition of domestic cosiness, this is an acknowledged paraphrase of and tribute to Gottfried Semper's theory on the origins of architecture. Playing on the German word *Decke* (cover, blanket, ceiling), Loos continues: 'In the beginning we sought to clad ourselves [...]. We sought to cover ourselves. Originally consisting of animal furs or textiles, this covering is the earliest architectural feature.'[16] The photographs of his wife's bedroom could be read almost as an illustration to 'The Principle of Cladding', a demonstration that architecture is to be worn (or unfolded) as much as it is inhabited.

Notions of cladding as the link between architecture and dress are evident both in the arguments of Loos's lectures and writing and in the careful cultivation of his personal appearance. Loos emphasised men's dress, particularly the unobtrusive tailored suit, as the ultimate icon of modernity. In his essay on 'Architecture' (1910) he sought to convince those who doubted the validity of comparing tailoring and architecture by asking 'have you never noticed the remarkable correspondence between people's appearance and that of buildings?'[17] Equally telling is his account late in life (1931) about an encounter with Josef Hoffmann. In what was obviously a favorite anecdote, Loos describes how early in his career he had invited Hoffmann to view his redesign of Eugen Stössler's apartment, undertaken in 1898: 'It was only after I had shown Hoffmann the first apartment I had done that he started to dress in a European style. He rushed straight out of my apartment to my tailor and threw [away] his jacket [...].'[18] Suitably enlightened by the encounter with Loos's design, Hoffmann's ostensible response was not architectural but vestimentary.

But this Hoffmann anecdote had as much to do with constructing Loos's professional identity as with demolishing the reputation of the

Secessionist architect. Loos's tailors, Goldman & Salatsch, were one of his most important clients – according to Loos, partly in an attempt to reduce his tailoring bill. For them he designed commercial interiors and shop fittings in 1898 as well as prestigious new premises opposite the Hofburg in 1909, the controversial Michaelerhaus. In an essay published in 1898 ('Underwear') Loos credited Goldman & Salatsch with introducing to Vienna a new type of shop 'already standard in other cities: the *tailors and outfitters*'.[19] A gentlemen's outfitter, according to Loos, was responsible to its buyers for the correctness of its stock, with 'a duty to select the best'; 'errors of judgment should be unthinkable'.[20] Both at the level of consumption and production therefore, tailoring functioned as a privileged metaphor for Loos's work as an architect. Particularly with respect to his refurbishments of Viennese apartments, where he mainly bought in furniture by other designers, Loos presented his skills of correct choice as analogous not only to the well-dressed urban man but also to those of the tailor as outfitter.

The photographs in *Kunst* seem to bear little relation to Loos's paeans to elegantly tailored masculinity. Indeed, Loos went out of his way to identify the draped textiles on the windows and walls of his wife's bedroom as '*batiste rayée*' (striped cambric), a fabric used – as he did not fail to point out – to make women's blouses.[21] The draped lengths of this material do not conform to the ideal of the well-cut, carefully fitted man's suit. Whereas the suit defines a crisp outline and discrete form, the evanescent white of the *batiste rayée* absorbs walls and furniture into a continuous flow of folds. Although Loos criticised what he saw as the reign of the 'upholsterers' in interior design, in the context of a 'lady's room', he obviously felt it appropriate, on occasion, to create a heavily textilian environment.[22] In the case of his refurbishment of the Turnovsky apartment in 1900 for example, photographs of the *Damenzimmer* show not only a pale-coloured fur rug, but also a peculiar lampshade constructed of ruched textiles – almost dresslike in shape. Despite the reference to *batiste rayée* blouses however, Loos would not have wished to identify the flowing drapes of his wife's bedroom with women's fashion, so often deployed in his writings as a term of disparagement. Indeed, Loos was not alone in condemning the heavily corseted, fashionable female body in terms

of an 'unhealthy sensuality'.[23] Stefan Zweig in commenting on dress of this period, pointed out the extreme artifice of women's hair and clothing: 'The more of a "lady" a woman was to be, the less was her natural form to be seen.' The result of such artifice Zweig claimed, was not 'decency' but rather the 'minutely provocative revelation of the radical difference between the sexes'.[24]

Loos would no doubt have preferred the flowing folds of the *batiste rayée* to connote a 'timeless' as opposed to a fashionable femininity.[25] In particular, the fluidity and movement of the folds could suggest a classicising female body, as in the case of Isadora Duncan's 'classical' dances. Duncan was widely admired in Vienna (including Loos among her many fans) and had performed at the Secession in 1902. By comparison with other forms of dance, such as the ballet, Duncan's dancing was commended as being more 'natural' and unstylised, ostensibly a return to a period which marked the origins of Western art and civilization. Such unencumbered movement of the female form, 'liberated' from its corset, functioned not merely as a reference to the past, but also as an image of the modern body. Altenberg, to take just one instance, often referred to new, experimental forms of dance and physical movement as a quintessential attribute of modernity.[26] But flowing folds could also be feminised by reference to the past in the context of interior design. Historians of furniture have related Loos's bedroom to early nineteenth-century women's bedrooms, in which textiles were used to create tentlike interiors.[27] Loos was of course a self-proclaimed admirer of Biedermeier, but compared to such earlier designs, his use of textiles is distinctive in its dissolution of boundaries. Furniture becomes part of the wall; the bed appears to merge with the floor. This lack of differentiation seems exacerbated by the 1903 black-and-white photographs, which lack a strong tonal contrast. Rather than interpreting this as a failure of photography to reproduce its subject clearly however, we might more fruitfully consider the images in *Kunst* as a dynamic encounter between photography and interior, between textiles and paper – a productive as much as a reproductive process. In the context of Loosian discourse, there were perhaps ways in which this interior in particular was well suited to the medium of photography.

A crucial factor, common to both interior and photographs, was the colour white. Loos's caption in *Kunst* described the predominantly white colour scheme: 'weisse Tünche, weisse Vorhänge, weisse Angorafelle' ('white distemper, white curtains, white angora'). Newly married to a young bride, Loos's emphasis on the whiteness of his wife's bedroom might be read as a reference to virginal purity. Indeed, the association of female virginity with white textiles was a longstanding convention (and not only in the case of wedding dresses). Arthur Schnitzler wrote about his infatuation during the 1880s with the 'young girl' Helene Herz: 'the most virginal in appearance and personality; and looking back, I can't see her slender, delicate, well-proportioned figure dressed in any other way but in airy white tulle, neck and shoulders bare – a swaying, untouched apparition.'[28] The significance of whiteness for Loos however transcended any such literal or biographical references to virginal femininity. In the context of Loos's writings, whiteness and purity were often invoked to suggest an absence, his commitment to banish 'unnecessary' surface ornament. Indeed it was the eradication of such ornament that signalled the advances of modern culture:

> A drinker of the seventeenth century was happy to drink out of a tankard with a Battle of the Amazons carved on it, an eater had strong enough nerves to cut up his meat on a Rape of Proserpina. We cannot do that. We cannot. We moderns.[29]

Loos was in no doubt that 'We prefer to eat off a white base.'[30] White, the desirably plain and unornamented surface, signifies purity not as the virginal prelude to marriage but as the erasure of eroticised woman. Such erasure does not, however, necessarily produce an absence. As Mark Wigley and Irene Nierhaus have argued, modernist white 'blank' surfaces are in fact highly representational.[31] This is particularly true here where the representation of the white room has been mediated by the photographic plate.

Loos claimed that there were architects 'who design interiors not so people can live in them, but so they will look beautiful in the photographs.' He argued that 'these designs 'with their mechanical combination of light and shade, correspond most to a piece of

mechanical equipment, in this case the darkroom.'[32] This was no doubt partly a reaction against Secession interiors, well known for their white and pale pastel colour schemes, along with their distinctive black-and-white decorative motifs. Such interiors were frequently illustrated and (as Loos pointed out) reproduced well in arts magazines. In its exhibitions and in the journal *Ver Sacrum*, the Secession energetically promoted European Symbolist art as well as the aestheticised interior. They much admired the tonal qualities of Whistler's pictures and, in 1900, a white room ensemble by Charles Rennie Mackintosh and Margaret MacDonald was displayed at the eighth Secession exhibition. In a review of Klimt's portraits of women in 1903, Ludwig Hevesi referred to the painter's penchant for pale colours, both in his sitters' dresses and in his palette, as a 'wallowing in white'.[33] Hoffmann, extensively involved with designing exhibition installations for the Secession shows, was also much in demand for domestic design and refurbishments. The fact that on numerous occasions he was commissioned to design interiors around the owners' portraits by Klimt no doubt enhanced the sense that these elegant, delicately coloured interiors constituted the architectural extension of a modern, stylish femininity. (Hence Loos's provocation that Hoffmann and his Secessionist colleague Koloman Moser were better suited to being dress designers than architects.)[34] For the Secession as well as for Loos, the white (or pale-coloured) room signified the modern interior, but this modernity was differently expressed. In the case of Hoffmann, the appeal of whiteness was predominantly visual, explicitly linked to images of the fashionably-dressed Viennese woman. But femininity was crucial for Loos too in the elaboration of his ideas about the interior. The materials of his white bedroom were an invitation to the sense of touch, suggesting an environment of tactile experiences.

The medium of photography was of particular significance in the context of the publication of Loos's wife's bedroom in *Kunst*. In the introduction to this first issue of the journal, Altenberg (that enthusiastic proponent of photography) had referred to 'the tender human hand' which wields the Kodak and collaborates with nature, the greatest 'Künstlerin' (female artist) of all. Further on in the issue, Altenberg included two photographs of a woman's hand labelled 'The Hand of

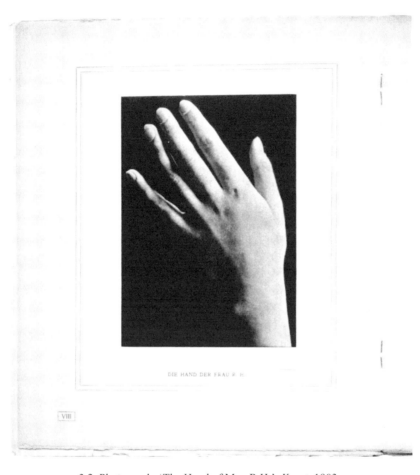

DIE HAND DER FRAU R. H.

VIII

3.2 Photograph, 'The Hand of Mrs. R.H.', *Kunst*, 1903,
no. 1. Wienbibliothek im Rathaus.

Mrs. R.H.'. (Ill. 3/2) These were photographs taken by Altenberg of the 25-year-old Risa Horn (another version, inscribed by Altenberg 'The Hand of the Sweet Mrs. Risa Horn' hung in his room at the Hotel Graben).[35] At a more literal level, the two photographs of hands can be seen as illustrations of Altenberg's 'tender' photographing hand, but at the same time they draw attention to the sense of touch, stressing the indexical character of photography as a medium. Altenberg's feminisation of photography was not so much to do with the gender of the photographer, as with the passive, reactive nature of the medium. The two photographs proved controversial, with one journalist demanding to know which other parts of Mrs R.H.'s body the readers of *Kunst* might expect to see in future issues. In this journalistic response, photographic corporeal fragmentation is lewdly interpreted, implying a fetishistic dismemberment of the female form. Photography operated rather differently in the case of the *Kunst* photographs of Loos's wife's bedroom. Rather than fragmentation, these involved a kind of rematerialization of the female body: the sublimation of femininity. (Loos himself claimed that 'Photographs *dematerialize* reality [...].')[36] Here woman is not so much banished (as in the case of the white dinner plates) but rather dispersed across the surfaces of domesticity, the *batiste rayée* fabric along with the angora rug representing not only feminine accessories but also those physical attributes of femininity embodied by textiles – silkiness and softness.

This emphasis on the sense of touch was perhaps part of an attempt to convey a 'warm' domestic architecture and may to some extent explain the focus on a 'wife's bedroom'. According to Otto Weininger (whose *Sex and Character* was published to much controversy and acclaim in 1903), touch was a 'feminised' sense, more developed in women than in men.[37] Similar conceptions may well underlie the portrait convention of depicting women in conjunction with animal-skin rugs, as with the photographs of the young Alma Schindler (who married Gustav Mahler in 1902).[38] Loos seems to have engaged with and reinforced such contemporary codes of femininity, not only through the publication of designs for his wife's bedroom with its dramatic expanse of angora rug, but also in the implicit contrast of these illustrations with those in *Das Andere*, the accompanying supplement to *Kunst*. Here (in *The Other: A Journal*

for the Introduction of Western Culture in/to Austria), Loos included an advertisement for gentlemen's tailors Goldman & Salatsch. (Ill. 3/3) This shows a man, dressed in a nautical-style suit, holding a pair of binoculars, a perfect illustration of Loos's preoccupation with well-dressed masculinity. Loos's wife's bedroom appears as both the means and the product of a differentiation carried out across these two linked publications, an apparently emphatic separation of masculine from feminine, of touch (angora and fabric) from sight (the binoculars). Where Altenberg characterised photography as 'feminine' in order to stress the passive receptivity of his own artistic stance, for Loos, the binoculars are clearly identified with a more 'masculine' dynamic and proactive sense of looking. At the same time however, there were ways in which the nineteenth-century iconography of the bourgeois bedroom undermined and problematised such ideas of difference.

Loos's wife's bedroom is sometimes interpreted as his response to the rooms by Otto Wagner exhibited at the Jubilee Exhibition of 1898.[39] These rooms (a bedroom and bathroom) received an overwhelmingly positive critical and popular response; Loos himself had praised Wagner's designs in his essay on interiors in the *Neue Freie Presse*.[40] Photographs of the rooms were published in *Ver Sacrum* and the ensemble was again exhibited at the 1900 Paris Exhibition. Intended for a new block of moderately priced apartments in the Köstlergasse designed by Wagner, the rooms were light and airy, with pale colour schemes. The bedroom was dominated by a cherry-blossom motif, the bathroom decorated more abstractly with black and white tiles (on the floor) and a white, violet-striped fabric covering the floor and walls. In his review, Loos wrote approvingly not only of the design, but also of the fact that these rooms were intended for Wagner's own apartment in the new block. As a statement of artistic identity through the exhibition and publication of his home, Wagner's project might well be seen as the precursor to the photographs of Loos's wife's bedroom in *Kunst*. Wagner's domestic spaces also involved a tactile dimension, particularly in the bathroom, where not only the dressing gown but also the large, floor-length rug and wall-covering were made of terrycloth. (Ill. 3/4a & b) Here was a room that suggested a secluded refuge from the public life of the city:

Beilage zur „KUNST" WIEN 1903 Nr. 1

DAS ANDERE

EIN BLATT ZUR EINFUEHRUNG ABENDLAENDISCHER KULTUR IN OESTERREICH: GESCHRIEBEN VON ADOLF LOOS 1. JAHR

TAILORS AND OUTFITTERS
GOLDMAN & SALATSCH

K. U. K. HOF-
LIEFERANTEN
K. BAYER. HOF-
LIEFERANTEN

KAMMER-
LIEFERANTEN
Sr. k. u. k. Hoheit des
Herrn Erzherzog Josef
etc. etc.

WIEN, I. GRABEN 20.

HALM & GOLDMANN

ANTIQUARIATS-BUCHHANDLUNG
für Wissenschaft, Kunst und Literatur

WIEN, I. BABENBERGERSTRASSE 5

Großes Lager von wertvollen Werken aus allen
Wissenschaften.

Einrichtung von belletristischen und Volksbiblio-
theken.

Ankauf von ganzen Bibliotheken und einzelnen
Werken aus allen Zweigen des Wissens.

Übernahme von Bücher- und Autographen-
auktionen unter kulantesten Bedingungen.

COXIN das neue Mittel zur Entwicklung
photographischer Platten, Rollfilms

ohne DUNKELKAMMER

bei Tages- oder künstlichem Licht ist in allen
einschlägigen Geschäften zu haben.

COXIN ist kein gefärbter Entwickler. — COXIN
erfordert keinerlei neue Apparate und kann immer
benutzt werden.

COXIN-EXPORTGESELLSCHAFT
Wien, VII/2. Breitegasse 3.

3.3 Cover of *Das Andere: ein Blatt zur Einführung abendländischer Kultur in Österreich: geschrieben von Adolf Loos*, 1903. Wienbibliothek im Rathaus.

112

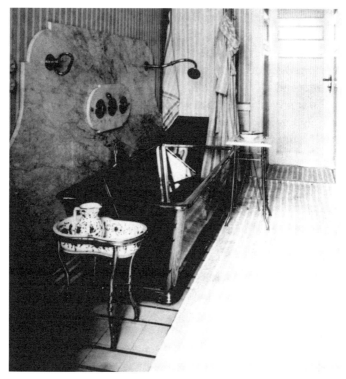

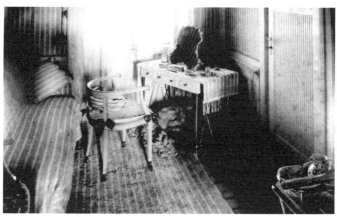

3.4 Photographs, Otto Wagner, Apartment, 1899. Austrian National
Library, picture archives, Vienna. (a) bathtub [Pk 2.539,755]
(b) dressing table [Pk 2.539,756].

a muffled environment, a warm and comforting terrycloth wrap for the bather. These designs evoked a multi-sensory response (of touch as well as sight) in their depiction of domestic spaces to house the body in its most private and vulnerable moments.

At one end of Wagner's bathroom stood a toilet table which involved a highly elaborated assemblage of textiles: the violet-striped terrycloth appeared on the floor beneath the table, as a fringed cloth covering the table and (tied with ribbons) as a cushion on the chair. Immediately below the table lay a white bearskin rug. (This pairing of mirror and bearskin may well have been a furnishing convention. It occurs in an even more dramatic form in Wagner's 1886 design for a bedroom in the Heckscher apartment.)[41] Toilet tables suggest an interface between the public and the private; the preparation at home for self-display in public. The conjunction of furry rug with mirror, repeated in Loos's wife's bedroom, draws attention to the interaction between sight and touch which is fundamental to the processes of making oneself up. This interaction of the senses was also dramatically manifested by Wagner's spectacular glass and nickel bathtub which combined the tactile sensations of water and glass with pleasure in looking. Earlier in the century with his 'Painter of Modern Life', Baudelaire had praised make-up – and by implication the rituals of the toilette – for the virtue of artifice.[42] In the case of Loos, who (like Altenberg) claimed to abhor artifice, the *Schminktisch* (toilet table) and angora rug suggest something rather more problematic than Baudelaire's quasi-ironic formulation of the modern.

Loos's close friend and intellectual ally Karl Kraus famously pronounced:

> Adolf Loos and I, he literally, I in the sphere of language, have done nothing more than show that there is a difference between an urn and a chamber pot, and that it is only by maintaining this difference that there is any scope for culture.[43]

It has been suggested that Peter Altenberg and Loos undertook their joint publishing project in emulation of Karl Kraus's success with his polemical journal *Die Fackel* (1899–1936). Despite his much-vaunted hostility to publishing his work in arts journals, Loos may well have

felt that the collaboration with Altenberg offered the means of presenting a written and visual polemic on terms he could control. The involvement of Altenberg with *Kunst* and Loos with its supplement was, however, brief. Loos produced only two issues of *Das Andere*, but these occurred at a crucial point in his career, when he was establishing his professional identity, as an architect and as a writer on modernity. The first issues of *Kunst* and *Das Andere* are in this respect revealing. The simultaneous publication of his wife's bedroom in *Kunst* and the man's suit in *Das Andere* can be seen as Loos's elaboration of a modernism formulated earlier by Otto Wagner. Otto Wagner too had praised the man's suit as an icon of modernity in his treatise *Modern Architecture*, first published in 1896.[44] The photographs in *Kunst* show a double bed and were captioned 'My wife's bedroom', separating out the conception and design of the room (by the male architect) from its physical experience (by the female inhabitant). This differentiation by gender was a continuation of Loos's earlier rhetoric, where on the one hand he had condemned the 'dreadful perversions and unbelievable vices' of women's fashion while at the same time praising the properly dressed man: 'What use is a brain if one doesn't have the decent clothes to set it off?'[45] The publication and success of Weininger's *Sex and Character* in 1903 seemed to confirm (and legitimate) a style of rhetoric based on the binary opposition of gender, with the female term consistently negatively valued. At the same time, as we have seen, Loos's preoccupation with ideas of architecture as something to be worn made such oppositions unstable and difficult to sustain.

Apparently differentiated by gender as well as by medium of reproduction, what the publication of his wife's bedroom and the man's suit reveals is that Loos's formulation of modernity in fact undermines a rigid system of binary oppositions, between the haptic and the visual, between femininity and masculinity. Something of the instability of such categories is suggested, it might be argued, by Loos's strange bedroom design, with its apparently contradictory connotations: the allusion to untouched virginity (whiteness) coupled with the implication of an intensely haptic and sensual experience. Loos's marriage to Lina was short-lived (they divorced in June 1905). Like Otto Wagner, Loos never lived primarily in the city-centre

apartment he had designed. These interiors functioned more as showcases for their identities and ideas as architect-designers than as homes. In the context of its publication in *Kunst* the significance of Loos's 'wife's bedroom' had to do less with its status as an inhabited domestic environment or 'model' home than as a component of Loos's polemic on modernity in Vienna. Recently, scholars have drawn attention to the complexities of Weininger's *Sex and Character* as a critique of modernity. David Luft, for example, has argued that Weininger used a 'grammar of gender' as a strategy to attack bourgeois culture.[46] As Luft (along with others such as Chandak Sengoopta) have shown, although *Sex and Character* is at one level about sexuality as it pertains to men and women, it is also a study where gender constitutes a symbolic territory through which modernity is explored.[47] This is not to endorse the condemnation of femininity and womanhood found in the writings of Loos and Weininger, but rather to speculate as to what might be revealed if the gendered codes and stereotypes which they deployed were addressed in a somewhat less literal – and in the case of Loos, less biographical – way as critiques of modern life in Vienna.

For example, let us compare with the images in *Das Andere* and *Kunst,* an anonymous, unpublished photograph showing Loos and Lina, taken apparently in 1903 before the renovations on their Giselastrasse apartment were completed. (Ill. 3/5) The photograph shows not the bedroom, but the sitting room, the room which Alan Crawford (and other recent commentators) have described as the more Anglo-Saxon ('healthy') aspect of Loos's design for the marital home. The recently married couple are seated like firedogs either side of the chimneypiece, gazing pensively into the flames of a roaring fire. The image suggests both contrast and harmony. On the one hand, there are the flowing lines of Lina's white, loose-fitting dress, on the other the crisp outlines of Loos's smartly tailored dark suit – the two irrevocably separated both by the fire and the dramatic chimney hood. At the same time, it is possible to see the male and female figures as a couple, the personification of marriage as signified by the double bed featured in *Kunst.* The photograph is classically composed in the form of a symmetrical triangle, balancing and giving equal weight to the two figures, male and female, light and dark.

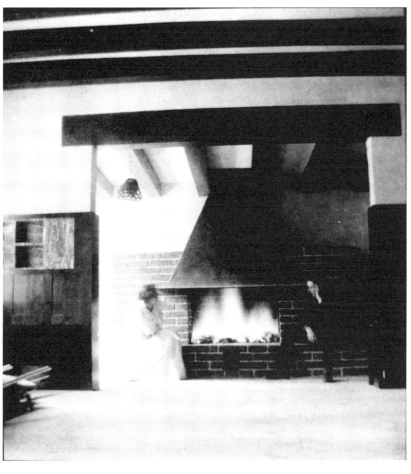

3.5 Photograph, Adolf and Lina Loos sitting around the fireplace in their
Vienna apartment, 1903. Albertina, Vienna.

This composition presents the shimmering white dress and the dark suit not only as opposites, but also as foils, the one a necessary component of the other. The apparently informal *mise-en-scène* of the unfinished apartment frames an image of marital harmony, the ostensible *raison d'être* for this carefully redesigned home. In addition to its significance as a marital portrait however, we can also consider the imagery of the black suit and the white dress in the context of Loos's polemic on modern urban interiors, and indeed his arguments on modern living more generally. Like Weininger, Loos's rhetorical deployment of binary oppositions formulated in terms of gender formed an important aspect of his condemnation of Viennese modernity. Far more than merely a concern with modern design or lifestyles, Loos was, like Weininger, centrally concerned with the definition of an appropriately modern self. Whether construed in terms of Loos's own meticulously cultivated personal appearance, or through his publications and lectures, this was a self which would appear to be unequivocally masculine. At the same time (as this photograph can remind us) a closer reading of Loosian discourse reveals that modern subjectivities result not so much from the separation of apparent 'opposites', nor indeed from the transcendence of one by the other, of the feminine by the masculine (as postulated by Weininger); they involve rather an interdependence and interaction between the two.[48]

* * *

Unlike Moll's 1903 painting of Anna Moll at her writing desk, the photographs published in *Kunst* did not involve a figurative depiction of Lina Loos. Nevertheless, for Loos as much as for the Secession, femininity was crucial in formulating ideas on the appropriately modern interior. In Vienna, questions of gender were clearly centre stage in the debates on modernity and modernism. The complex ways in which culturally-determined stereotypes of masculinity and femininity were enacted, problematised and renegotiated in the interests of articulating a public, artistic self are further examined in the subsequent two chapters. Here attention shifts from the claustrophobic ambiance of Loos's wife's bedroom to an apparently more expansive,

outdoor milieu. Thus far we have considered different instances of 'the home' located in and around Vienna: both in the more domestic sense (Moll's Hohe Warte villa and Loos's inner city apartment) and as the counterpoint to such marital and family domesticity, 'the home away from home', as with Altenberg's hotel rooms and the Viennese café. The next chapter investigates the importance of images of Gustav Klimt and the fashion designer Emilie Flöge, on holiday at the Attersee, for their Viennese-based practices. As we shall see, although the annual event of the *Sommerfrische* involved a departure from home, such visits to the countryside did not necessarily constitute a break from the social networks and professional concerns of the city.

Notes

1 On the *Kunst* and *Das Andere* publishing project, see '*Kunst* and other catastrophes' in Barker, *Telegrams from the Soul*, pp. 94–106.

2 Crawford, 'Ausstellung Adolf Loos, Vienna, 1 December 1989–25 February 1990'.

3 'The bedroom, Lerle, is the most private, most sacred thing – no stranger may profane it' (Claire Loos, *Adolf Loos privat*, 1936, as quoted in Gravagnuolo, *Adolf Loos*, p. 104, n. 1). Gravagnuolo cites Massimo Cacciari's comments in *La Vienna di Wittgenstein* in 'Nuova Corrente', Milan, 1977, pp. 72–3. On the gendering of rooms, see Kinchin, 'Interiors: nineteenth-century essays on the "masculine" and the "feminine" room'. Kinchin discusses the 'womb-like muffling' produced by the 'layers of curtains, carpets and fluffy rugs, frilly lampshades, cushions and padded upholstery' as well as the 'protective cocoon of textiles' in those rooms conventionally associated with women (p. 21). On the British reform movement which targeted such interiors as the object of necessary change, see 'Feminine Taste and Design Reform 1830–1890' in Sparke, *As Long as It's Pink*, pp. 15–69.

4 Schnitzler, *My Youth in Vienna*, p. 97.

5 Noever (ed.), *Der Preis der Schönheit*, p. 53.

6 'Architecture' (1910) in Loos, *On Architecture*, p. 78.

7 'Guided Tours of Apartments' (1907) in Loos, *On Architecture*, p. 55.

8 'Architecture' in Loos, *On Architecture*, p. 76.

9 'Glass and China' (1898) in Loos, *Ornament and Crime*, p. 70.

10 Loos, in a reply in *Das Andere* to a reader's enquiry (quoted in Adolf Opel, 'Introduction' to Loos, *Ornament and Crime*, p. 6), observed: 'I will continue to do interior designs for business premises, cafés, and apartments […]. You were kind enough to call my work so far in Vienna "architectural". Unfortunately it is not, though we do live in times when every wallpaper designer calls himself an architect. […] But interior design for apartments has nothing to do with architecture. I have made a living through it because I am good at it. Just as for a time in America I kept body and soul together by washing dishes […].'

11 See Kristan, *Adolf Loos Wohnungen*.

12 'Guided Tours of Apartments' in Loos, *On Architecture*, pp. 55–6. Here, with the description of the characteristic Secessionist grid motif as a 'sewer grating', Loos in fact pre-empts the insult levied a few years later at his controversial building on the Michaelerplatz.

13 'Architecture' in Loos, *On Architecture*, p. 84.

14 'On Thrift' (1924) in Loos, *On Architecture*, p. 178.

15 'The Principle of Cladding' (1898) in Loos, *On Architecture*, p. 42.

16 Ibid. For a discussion of Semper, see McLeod, 'Undressing Architecture', pp. 38–84.

17 'Architecture' in Loos, *On Architecture*, p. 82.
18 'On Josef Hoffmann' (1931) in Loos, *Ornament and Crime*, p. 193. (Also, Loos, *On Architecture*, p. 196.) Stössler's apartment has been preserved; see my Conclusion, n. 4.
19 'Underwear' (1898) in Loos, *Ornament and Crime*, p. 116.
20 Ibid., p. 117.
21 'Guided Tours' in Loos, *On Architecture*, p. 58: '8th district: 24 Wickenburggasse, mezzanine. Dr. T.'s Apartment. Dining room in cherrywood, consulting room in mahogany, bedroom in *batiste rayée* (fabric for ladies' blouses). After my wife's bedroom, which appeared in the magazine *Kunst.*'
22 'Interior Design: Prelude' (1898) in Loos, *Ornament and Crime*, p. 52: 'And thus began the rule of the upholsterer, a reign of terror that still gives us nightmares. Silks and satins, plush and "Makart bouquets" of peacock feathers and dried grasses, dust and a lack of light and air, door curtains and carpets and so on – thank God it's over now.'
23 'Ladies' Fashion' (1898/1902?) in Loos, *Ornament and Crime*, pp. 106–11: 'Ladies' fashion! What a horrible chapter of our cultural history, laying bare mankind's secret lusts' (p. 106).
24 Zweig, *The World of Yesterday*, p. 73: 'At first glance one is aware that a woman, once she is encased in such a toilette, like a knight in armor, could no longer move about freely, gracefully and lightly. Every movement, every gesture, and consequently her entire conduct, had to be artificial, unnatural and affected in such a toilette' (p. 72).
25 Gen Doy has analysed the cultural significance of drapery in *Drapery: Classicism and Barbarism in Visual Culture* (I.B. Tauris: London and New York), 2002.
26 Altenberg admired, and was in correspondence with, contemporary 'modern' dancers such as Bessie Bruce (who became Loos's long-term companion around the time Lina Loos left him) and Grete Wiesenthal (who performed with her sisters Elsa and Berta). A letter to Grete Wiesenthal in 1918 promises to partner her on the occasion of his sixtieth birthday. Photographs of dancers featured prominently in his extensive collection. See, for example, 12/13/32, *Traum und Wirklichkeit Wien 1870–1930*, pp. 324–5.
27 Ottilinger, *Adolf Loos: Wohnkonzepte und Möbelentwürfe*, pp. 109–13.
28 Schnitzler, *My Youth in Vienna*, p. 178. At the time of its exhibition, Whistler's 1862 painting *The White Girl (Symphony in White Number 1)*, depicting a young woman in a white dress standing on a bearskin rug, was interpreted as implying the morning after the wedding night.
29 'Surplus to Requirements (1908) (The German Werkbund)' in Loos, *Ornament and Crime*, p. 155. For a study of ornament and gender in the context of Viennese Expressionism, see Simmons, 'Ornament, Gender and Interiority in Viennese Expressionism'.
30 'Pottery' (1908) in Loos, *Ornament and Crime*, p. 148.

31 Wigley, *White Walls, Designer Dresses*; Nierhaus, 'Text + Textil. Zur geschlechtlichen Strukturierung von Material in der Architektur von Innenräumen' in Bischoff and Threuter (eds), *Um-Ordnung*, pp. 84–94.

32 'On Thrift' in Loos, *On Architecture*, p. 178: 'I am against photographing interiors. The results are always different from the original.'

33 Natter and Frodl (eds), *Klimt's Women*, p. 98.

34 'Josef Veillich' (1929) in Loos, *On Architecture*, p. 185: 'In the year the *Wiener Werkstätte* was founded: I said, "That you have a certain talent one cannot deny, but it lies in quite a different area from the one you think. You have the imagination of a dressmaker. Make dresses."'

35 Lensing, 'Peter Altenberg's Fabricated Photographs'.

36 'On Thrift' in Loos, *On Architecture*, p. 178.

37 Nierhaus, 'Text + Textil', p. 88: 'Eine natürlich-magische Koppelung zwischen Weiblichkeit und allem Stofflichen tauchte um 1900 vielerorts auf, wie 1903 in *Geschlecht und Charakter* bei Otto Weininger in Zusammenhang mit dem Haptischen als dem bei Frauen angeblich ausgeprägtesten Sinn.' For another account of contemporary associations of femininity with the sense of touch, see Johnson, 'From Brocades to Silks and Powders'.

38 As reproduced in Natter and Frodl (eds), *Klimt's Women*, p. 29 (Alma Schindler and her sister Grete), and in Beaumont, *Alma Mahler-Werfel Diaries 1898– 1902*, plate 18 'Alma 1899 ("the picture with the bear")'.

39 Asenbaum et al., *Otto Wagner*, pp. 162–81.

40 'The Interiors in the Rotunda' (1898) in Loos, *Ornament and Crime*, pp. 57–62.

41 See Asenbaum et al., *Otto Wagner*, pp. 130–1.

42 'XI. In Praise of Make-Up' in 'The Painter of Modern Life' (1865) in *Baudelaire: Selected Writings on Art and Artists* (Penguin Books: Harmondsworth, Middlesex), 1972, pp. 424–8.

43 Timms, *Karl Kraus: Apocalyptic Satirist*, p. 120.

44 Otto Wagner's *Modern Architecture* was published in 1896, with further editions in 1898, 1902 and 1914.

45 'Men's Fashion' (1898) in Loos, *Ornament and Crime*, p. 39.

46 Luft, *Eros and Inwardness in Vienna*, p. 3.

47 Sengoopta, *Otto Weininger*.

48 Similarly, in connection with her account of Alois Riegl's influential ideas on the optic versus the haptic (particularly as formulated in his *Die spätromische Kunstindustrie*, 1901 and 1927), Laura Marks stresses that these two concepts involve not so much a dichotomy as a slide of one into the other, a dialectical movement between (for example) far and near; see Marks, *Touch: Sensuous Theory and Multisensory Media*, pp. xii and 3.

4 Viennese Modernism: A New Look

Loos used his discussions of dress and clothing to dissociate *Mode* (fashion) from *die Moderne* (the modern) with regard to design and architecture. In particular, he identified women's fashion with the unstable and the fast-changing, for Loos highly pejorative terms. Equally culpable, from his point of view, was what he saw as the role of women's dress in attracting attention and arousing an erotic desire in male viewers. By contrast he advocated the constancy of men's clothing, arguing that the man's frock coat had changed little since the early nineteenth century. Along with many other of his Viennese contemporaries, Loos admired the Biedermeier period and it was specifically the Biedermeier café that he cited as an inspiration in his refurbishment of the Café Museum in 1899. However, as we have seen in connection with the refitting of Vienna's coffeehouses more generally, keeping up to date in terms of architectural design was often considered a commercial necessity and therefore just as much a part of fashion's relentless imperative for change as women's dress. Perhaps it was precisely because a certain amount of Loos's earlier commissions involved work for commercial clients – the redesign of shop interiors as well as cafés – that he was so keen to disparage other designers and architects, particularly those associated with the Vienna Secession such as Koloman Moser and Joseph Hoffmann, as being better suited to fashion design.[1]

The Secession's own aesthetic preoccupations however were not always expressed in terms so different from that of Loos. We saw in Chapter 1 that Joseph August Lux, an active supporter of the Secession and Wiener Werkstätte, condemned recent villas as façade architecture, too concerned with ostentation and 'masquerade' – language very similar to that of Loos. By contrast with such artifice, in his book *Das Moderne Landhaus* Lux described Biedermeier design as being 'style-less', having evolved organically, 'almost like the dogroses behind the house' ('so organisch wie die Rosenhecken hinten

am Haus').[2] Lux's advice was to seek out this genuinely Austrian culture – according to him best preserved in more rural areas, including the hilly landscapes comprising the Vienna Woods – for the purposes of artistic inspiration. (This again was in tune with Loos's own views.) Here, Lux claimed, was to be found the inspiration of nature as well as culture. Landscape painters could admire the same views that had earlier so inspired Biedermeier artists. In the case of architecture, he identified Hoffmann's Hohe Warte villas as a prime instance of modern architecture successfully embodying Biedermeier values.[3]

For Lux, the Hohe Warte villas were an expression of timeless indigenous values but also so new that their significance as 'eine gute heimatliche Tradition' ('a good indigenous tradition') was not yet widely understood or appreciated. As we have seen in Chapter 2, a key difference between Loos and the Secession in their shared concern to promote Biedermeier as an inspiration for design and architecture in the modern period was the Secession's more positive emphasis on women's dress. In 1906 the journal *Hohe Warte* (edited by Lux along with other Secession members and sympathisers) opened a special issue with an extended quote from William Morris entitled 'Die Heiligkeit des Heims' ('The Sanctity of the Home') and went on to include features on Biedermeier women's clothing. This focus on feminine apparel coincided with an interest in design for commercial premises. The same issue of *Hohe Warte*, for example, included a full page devoted to illustrations of 'Altwiener Geschäftsläden' ('Old Viennese Shops').[4]

Carl Moll's work as an artist reveals that not only publications, but also Secession paintings were instrumental in promoting a Biedermeier ethos. Wilhelm List's 1903 picture *Rosenzeit*, is another instance. Its title replicates that of Ferdinand Georg Waldmüller's 'Biedermeier' masterpiece painted almost exactly forty years earlier. (Ill. 4/1) Where Waldmüller's *Rosenzeit* takes the form of a rustic idyll, showing the romantic encounter between a young man and woman, List's painting gives lyrical expression to Biedermeier values in a more domesticated form. It celebrates the spontaneity and cosiness which formed the heart of a happy home – as extolled in *Das Moderne Landhaus*. List depicts a mother and child posed next to a climbing

4.1 Ferdinand Georg Waldmüller, *Die Rosenzeit*, oil on panel, 1862. Copyright Wienmuseum.

rose, the same motif deployed by Lux (the rosebush clinging to the side of the house). In the case of the painting, it is the maternal figure as well as the rosebush that express the desirably 'organic'. Woman embodies the 'natural' both in her guise as mother and in her attire, clad in an airy, flowing gown. This is not the woman about town, encased in a tightly corseted dress, but an informally dressed mother. The loose-fitting dress is reminiscent of the kind of clothing worn by women at home or on holiday, in a private and domestic setting as opposed to in public. At the same time it recalls the styles of earlier, Biedermeier dress.[5] A rustic setting is implied by the garden as well as by the white walls which form the background of the painting, suggesting perhaps a farmhouse or country villa. The red and white stripes of the woman's dress connect the female figure both to the natural motif of the rosebush as well as to the architecture of the building. The gentle domesticity and relaxed informality of this imagery bear little resemblance to Loos's caricature of Secessionist design in 'The Poor Little Rich Man' where he describes clients imprisoned in the claustrophobic and intractable environment of Secession interiors. But if women's dress offered the Secession a way to promote its aims and values, this was not simply through a straightforward affiliation of women with nature. Important too were the ways in which femininity could be associated with culture and with commerce. The latter was of course especially important at a point when Secession artists and Werkstätte designers were increasingly relying on private commissions and on the commercial market.[6]

The commercial sphere offered artists and designers the means of securing a financial income, but also possibilities for establishing professional reputations both in Austria and abroad.[7] An example of how this might operate at the international level is demonstrated by the arts journal *Deutsche Kunst und Dekoration* whose volume 19 (October 1906–March 1907) prominently featured the work of Gustav Klimt. The magazine reproduced two of the artist's paintings (*Malerei auf Pergament*, now known as *Waterserpents* (1904–7), and a *Damen-Porträt*, the portrait of Margarethe Stonborough-Wittgenstein (1905)), as well as ten photographs of the fashion designer Emilie Flöge, shown outdoors in what appears to be the countryside wearing a series of loose, flowing gowns.[8] (Ill. 4/2) Flöge was by this date a well-known

126

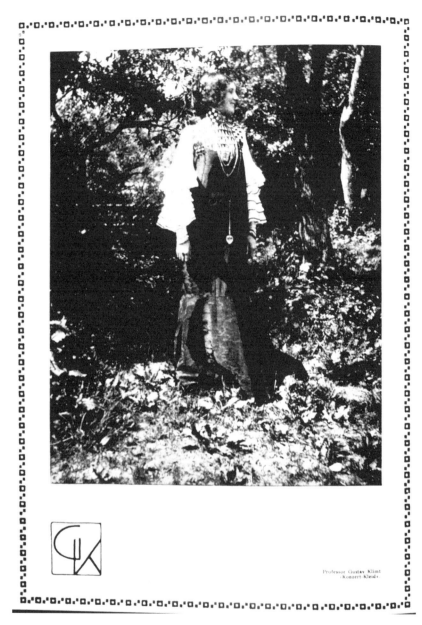

4.2 Photograph, Emilie Flöge posing outdoors by the Attersee, published in
Deutsche Kunst und Dekoration, vol. 19, 1906–1907.

designer, who along with her two sisters ran the successful fashion house Schwestern Flöge in Vienna. Here, however, she appears as model rather than author.[9] She is unidentified, but the designs for the dresses in the photographs (like the two paintings) are attributed to 'Professor Gustav Klimt' and the execution of these 'various outfits' to the 'Atelier der Schwestern Pflöge' [sic].[10] Klimt's reputation too was well established by this date and the visual coverage of paintings and photographs provided an indicative cross-section of Klimt's work at a new stage in his career.

In April 1905 Klimt had made a formal request to the government to be released from his controversial Faculty paintings project for the University of Vienna; 1905 was also the year in which the 'Klimt Group' left the Vienna Secession.[11] Often characterised in terms of a withdrawal from the public sphere, Klimt's work after this date was primarily sustained by the commercial market and private commissions.[12] He was represented by the Galerie Miethke in Vienna, and maintained close affiliations with the Wiener Werkstätte, founded in 1903.[13] *Deutsche Kunst und Dekoration* presented the artist's practice as dominated by feminine themes: female nudes and portraits (both genres for which Klimt was well known) along with, perhaps more surprisingly, fashion design. Although Klimt's portraits of women reveal an intense interest on his part in the sitter's fashionable apparel, he was not known as a dress designer. (The Wiener Werkstätte only opened their fashion department in 1911.)[14] In this arts journal, subtitled *Illustrierte Monatsheft für moderne Malerei, Plastik, Architektur, Wohnungskunst und künstlerische Frauenarbeiten* (*Illustrated Monthly for Modern Painting, Sculpture, Architecture, Interior Design and Artistic Women's Work*), Klimt's work defines the modern through femininity construed in both a timeless and a more contemporary guise, as the nude figure and as the fashionably dressed urban woman.

Klimt appeared in *Deutsche Kunst und Dekoration* as part of a wider promotion of Viennese modernism. The magazine was based in Darmstadt, and edited by Alexander Koch. In *Deutsche Kunst und Dekoration*, as well as in his other publications, Koch was an energetic supporter of Viennese painting, applied arts and architecture.[15] Volume 19 included an article by Franz Blei on the Wiener Werkstätte and

extensive photographic coverage of the group's designs across a wide range of media. Koch's publications were an important means of presenting Viennese modernist art and design to international audiences. (The impact of this promotion was not limited to the German-speaking countries. In 1906, a special summer issue of *The Studio* on 'The Art Revival in Austria' credited Koch, as editor of *Deutsche Kunst und Dekoration,* for permission to reproduce the photographs of Wiener Werkstätte work.)[16] A substantial number of the illustrations to volume 19 are of architecture, in particular of Josef Hoffmann's recently executed designs for the 'artists' colony' on the Hohe Warte. This appearance in a German arts journal is indicative of the prominent polemical role assigned to the Hohe Warte villas. A founder member of the Wiener Werkstätte, Hoffmann worked with other members, conceiving the Hohe Warte houses as a harmonious ensemble, both in terms of their relationship of interior to exterior and through the visual unity of the architectural group as a whole. Built for well-off middle-class members, supporters and clients of the Wiener Werkstätte, the Hohe Warte houses were (as we have seen in Chapter 1) not only a highlight of Hoffmann's own career as an architect and designer, but also an important demonstration of the Werkstätte's ideal of reforming all aspects of everyday life.[17]

Like Klimt's female portraits, the Wiener Werkstätte designs were aimed at an urban elite of affluent patrons and clients who wished to demonstrate their social and cultural status through the modernised accoutrements of a sophisticated lifestyle. (What was referred to in German as *Wohnkultur*, or as in the subtitle of *Deutsche Kunst und Dekoration*, 'Wohnungskunst'.) In Vienna as elsewhere, many of these consumers derived their wealth from the industrialisation, commerce, finance and banking which constituted the forces of modernity reshaping the city at the turn of the century. What is striking in the coverage of Viennese modernism in volume 19 of *Deutsche Kunst und Dekoration* however, is the identification of this totalising aesthetic with the countryside, or rather, with a withdrawal from the city into the country. The photographs were taken in the summer of 1906 in Litzlberg, where Klimt and the Flöge family were spending their summer holidays, or *Sommerfrische*.[18] (For most summers between 1900 and 1916, Klimt joined the Flöges in the

beautiful Salzkammergut countryside around the Attersee, a popular holiday destination.) They show Emilie Flöge posed in a series of rustic settings: in a farm garden, next to a meadow, in front of a farm building, as well as on the shores of the lake itself.[19] More than simply family photographs or souvenirs (as indicated by their publication in an arts journal), these striking fashion photographs were for their time unusual in being posed outdoors in an ostensibly bucolic setting. Similarly, the Hohe Warte (today a desirable leafy suburb of Vienna), appeared in *Deutsche Kunst und Dekoration* as the setting for country villas. The captions to the houses for Fräulein Hochstätter and Ing. Brauner referred to them in each case as 'Landhaus'. (The third house illustrated was that for the Wiener Werkstätte designer Koloman Moser.)[20] Indeed, when the young Alma Schindler moved to the house designed by Hoffmann for her mother and stepfather Carl Moll in September 1901, she described this in her diary as a form of exile from the city: 'The first night on the Hohe Warte. St. Helena. I cried in the train – couldn't stop myself. The house is really nice – it would be even nicer if it were closer to the city centre.'[21]

In the context of early twentieth-century Viennese modernism, these culturally determined retreats into the countryside on the part of urban inhabitants – whether in the form of the permanent move to a country house or of the ritual annual *Sommerfrische* – were often represented as a means of re-energising an artistic practice as much as refreshing body and mind. In contrast to the noise, bustle and grime of Vienna's city streets, the countryside offered solitude, peace and fresh air. Away from the urban centre, it seemed possible to escape (or at least, to distance) the pressing demands, schedules and deadlines of daily professional life. In the case of Klimt on the Attersee or of the villa owners of the Hohe Warte, however, this seclusion from city life did not constitute a break from artistic practice; quite the opposite, indeed. We have already seen how inhabitants of the Hohe Warte, such as Moll, continued to work and maintain professional contacts from their new houses. According to his own account, Klimt adhered to a rigorous daily regime of work on the Attersee, and regularly exhibited in Vienna the landscape paintings he produced there.[22] (Ill. 4/3) This was not so much a matter of withdrawal from public life, as a displacement and extension of it. In each case the retreat to the

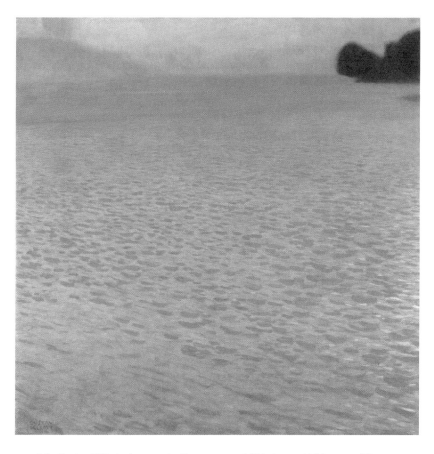

4.3 Gustav Klimt, *Attersee I*, oil on canvas, 1901. Leopold Museum, Vienna.

countryside was a carefully staged aspect of a practice: a crucial means of defining and giving meaning not only to the artistic practice itself, but also to the works produced, whether in or out of the city. Far from fortuitous, the shared 'country' motif of Klimt's fashion photographs and of the Hohe Warte houses in volume 19 of *Deutsche Kunst und Dekoration* was symptomatic of a modernity (and an artistic modernism) that was specifically Viennese. This chapter examines artistic retreat into the countryside as both the product and reinterpretation of contemporary ideas about the relationships between city and country, between past and present. It explores the ways in which femininity, particularly as evoked by female dress, was important in the Secession and Wiener Werkstätte promotion of a comprehensive aestheticization of everyday life.

What was at stake – aesthetically, as well as professionally and commercially – in the photographic conjunction of Hoffmann's villas with Flöge's dresses in *Deutsche Kunst und Dekoration*? And how exactly did this pairing of architecture with women's fashion relate to an aesthetics of the modern? In order to answer these questions, we need to consider in more detail the trajectories of looking evoked by women's fashion on the one hand, and fashionable villas on the other. This returns us to the Vienna Woods, and to Hoffmann's villas on the Hohe Warte. The name of the location is itself telling, explicitly invoking processes of looking. 'Warte' is a watch-tower or observatory and Hohe Warte thus suggests a gaze from above. The hilly Vienna Woods to the west of the city had for some time been a destination for city dwellers on day excursions from the city.[23] There are, for example, numerous early nineteenth-century depictions and caricatures of *parties de campagne*. These outings offered not only a temporary wooded refuge from city life, but also the opportunity to admire views from on high – a 'mini-Alpine' experience, as one author has put it.[24] The most spectacular view on offer from such vantage points however was that constituted by the city itself, only recently forsaken. The distant view (or *Fernblick*) of Vienna from an elevated *point de vue* was a popular subject for paintings, prints and drawings.[25] These depictions often included parts of the Vienna Woods: forests, fields and vineyards acted both as the counterpoint to and as the frame for the sweeping urban vista. The

preoccupation with such distant views (both in the form of trips and paintings) can be seen in terms of the city admiring itself; or indeed, as showing itself off to other non-Viennese audiences. Paintings of this type were exhibited throughout the Austro-Hungarian Empire as well as abroad.[26]

It is no coincidence that the artistic preoccupation with such views gathered momentum throughout the nineteenth century, a period of dramatic modernisation. The views of Vienna from the Belvedere Palace (and particularly from the Upper Belvedere), built in the early eighteenth century as the summer residence of Prince Eugene of Savoy, are reminders of his role in thwarting the Turkish invasion of the city in 1683. (He had commanded the Austrian army that successfully repelled the Turks.) Here, architecture and gardens offer panoramic views as a monument to conquest. The pictures painted from the vantage point of the Vienna Woods throughout the nineteenth century were testimony to a rather different, and more successful invasion – that of industrialisation. They regularly included factories and factory smokestacks, as well as (later in the century) evidence of the regularisation of the Danube River through canalisation. Industry and new forms of transport were modernising and reshaping the city, simultaneously a source of civic pride and nostalgia. Framing urban views with vignettes of the Vienna Woods was thus also at least in part an invocation of the more 'natural' landscapes rapidly disappearing as the result of such modernisation. The growing interest in preserving the Woods as an amenity for the inhabitants of the city was a further expression of this sense of actual and threatened loss, not only of nature itself, but also of a 'simpler' (pre-industrial) life. The Vienna Woods thus increasingly came to occupy a liminal space: as a boundary between country and city – a reminder of the differences between past and present – but also as the century advanced, as an extension of the city itself.

The building of a villa colony on the Hohe Warte was one indication of the city's expansion and improved transport links. It also serves as a reminder that in connection with the Vienna Woods, processes of looking involved more than merely a series of views outwards from the hills, across the city. Such panoramic views derived their meaning partly through the ways they were framed by their vantage point. An

immersion in the woods, with all their changing and culturally produced meanings, was part of the process of contemplating the city. The woods were, in other words, both the means and the object of an urban gaze. In this sense, the Vienna Woods did not provide an alternative or opposition to modern life; they too were a product of the powerful forces so identified with urban modernity. Similarly, the Hohe Warte colony presented the Wiener Werkstätte aesthetic as simultaneously retreat and spectacle. At a distance from the city centre (with its bombastic Ringstrassen historicist buildings), Hoffmann's architecture stood as an exemplar of a 'simpler' style, based on various sources, such as vernacular building as well as British Arts and Crafts and Biedermeier architecture. English architecture was often associated with country houses and living, as well as with a love of gardening. The Biedermeier period too, as we have seen, was known for its cultivation of smallscale domestic gardens. Biedermeier art and design was much admired by the Wiener Werkstätte as a specifically Austrian, simpler (or rather, pre-historicist) aesthetic.[27] Like the *fin-de-siècle* a period of growing industrialisation and urbanisation, Biedermeier had come to represent a time when society sought refuge in the joys of domesticity and nature.

As Lux and others were keen to point out, the Hohe Warte villas were designed to incorporate the natural surroundings of the Vienna Woods not only in terms of views but also in the form of gardens and terrace – elements characterised (like the buildings and their interiors) by geometric motifs. Hoffmann's villas demonstrated the reform and aestheticisation of everyday domestic life on a larger scale than anything to be seen in central Vienna. The natural setting, which gave something of a utopian quality to the project, could be seen as underscoring ideas of art's rejuvenation through contact with nature. Here, the secluded woodland setting was clearly foil to and subject of the designs. Motifs from nature appeared both on the exterior and in the interiors. Decorative conceits, such as the delicate floral frieze running under the eaves of the Henneberg villa (1900–1), along with judicious use of potted plants – for example, the two trees flanking the raised terrace of this villa – reinforced the impression that Hoffmann's architecture had sprung up almost organically from this wooded terrain. (Ill. 4/4)

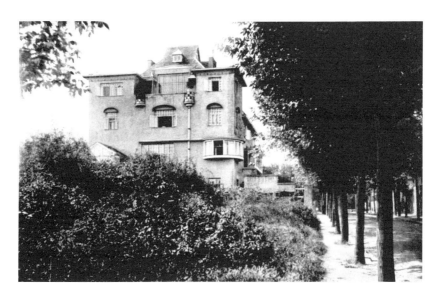

4.4 Photograph, Josef Hoffmann, Dr Hugo Henneberg House, Hohe Warte,
Vienna, *Die Kunst,* 1904. Wienbibliothek im Rathaus.

Far from connoting simply the idea of architecture's subjection to its natural surroundings however, the Hohe Warte designs demonstrated a more complex, symbiotic relationship between culture and nature. The distinctive stylisation (often involving square, cubic shapes or spherical forms) which shaped both gardens and architecture was not only a means of linking interiors to exteriors. It also revealed the extent to which nature, and indeed life, had been transformed by 'art'.[28]

For readers of *Deutsche Kunst and Dekoration*, the photographs of Emilie Flöge in the countryside around the Attersee would obviously have conveyed a somewhat different set of connotations. In this case the setting was apparently rustic rather than woods or villa gardens, the juxtaposition of a sophisticated Viennese woman with the countryside clearly a transient event as opposed to the more permanent presence of Hoffmann's new architecture on the Hohe Warte. Here again however the reader might infer a domestic context, the intimacy of family life relaxed into the informality of a holiday away from the city. (The seasonally recurring event of the *Sommerfrische* involved the annual removal of more or less the entire household to the countryside, usually to a rented flat or villa.) Yet the depiction of these carefully posed outfits outdoors in a natural setting was not merely the random by-product of a summer holiday. The conjunction of countryside with the loose and unconstrained forms of clothing defined a particular set of interactions between 'art' and nature. The connection of the dresses with art was signalled through the attribution of their design to 'Professor Klimt', and also by the Wiener Werkstätte jewellery (apparently gifts from Klimt) which Flöge displays prominently in the photographs.[29] As 'artistic dress' they present nature refashioned by art. At the same time, the uncorseted loose forms of the gowns suggest a more unfettered, 'natural' type of clothing. In their implication of a two-way relationship between art and nature, the dresses played a similar role to that of the gardens on the Hohe Warte. Like the geometricised flower beds, paving and planters adjacent to Hoffmann's villas, these dresses existed on the cusp of artifice and nature. It is not surprising therefore to find similarly styled dresses by Schwestern Flöge (identified as '*Reformkleider*') reproduced in an early issue of the *Hohe Warte* journal.[30]

136

Today, there is little consensus concerning the photographs published in *Deutsche Kunst und Dekoration*. Commentators disagree about the exact site on the Attersee where they were taken, and even more about the authorship of the dresses themselves. The attribution to Klimt is accepted by some, and it has been argued that the dresses – like the Wiener Werkstätte jewellery which adorns them – were an expression of Klimt's love for Flöge. Others have rejected the idea and consider the designs to be by Flöge herself.[31] Considerable attention has been devoted to the personal relationship between Klimt and Flöge, which most authors characterise as unconventional for the time. Beginning in 1891 with the marriage of Helene Flöge to Klimt's brother Ernst, the two enjoyed a long friendship, with Klimt famously calling for Emilie to be present at his deathbed. At the same time, Klimt had several affairs and a number of children by his mistresses.[32] Klimt and Flöge never married and some commentators speculate on whether the relationship was ever sexually consumated. In terms redolent of the period's own stereotypes, Flöge's personality has been described as nervous and highly strung as the result of sexual frustration.[33] What is clear, however, is that Klimt and Flöge regularly appeared together, both in public life at events in Vienna and in the greater intimacy of family summer holidays on the Attersee. The publication of these photographs in *Deutsche Kunst und Dekoration* with its prominent coverage of the Wiener Werkstätte, can be construed as a further instance of such joint public appearances. Rather than addressing questions of authorship or personal history, let us turn instead to a further consideration of the functions performed by these photographs.

The Attersee photographs are generally ascribed to Klimt himself, on the basis of his keen amateur interest in photography and the fact that by this date he had sometimes made and used photographs as part of his practice as a painter. Recent research has revealed the extent to which Klimt relied on visual prosthetic devices, particularly during his summers on the Attersee when he devoted himself to the painting of landscapes. Along with opera glasses and a telescope, he regularly used a cardboard viewfinder to help him compose and frame landscape views.[34] The camera could thus be considered one more such tool of his visual artistic exploration. There

are analogies too with other aspects of Klimt's working practice. Whereas he apparently painted very slowly, he drew quickly. In cases where he was working on female portraits, he often produced large numbers of drawings relating to the sitter's apparel and accessories. (Numerous scholars have attested to Klimt's fascination with female dress.) The Attersee photographs (like the drawings) could thus be seen as rapidly executed impressions of feminine ensembles.[35] What then was the status of these photographs as published in *Deutsche Kunst und Dekoration*? Their appearance accords with the interest of certain German artists and audiences in reform dress. (The journal had previously published essays on reform clothing, by Henry van de Velde in 1902 and by Anna Muthesius in 1904, for example.) On the other hand, it has been claimed that the reform clothing movement was not as strong in Vienna as in Germany, and that a concern with dress was more in the nature of a private preoccupation on the part of a few artists than a public manifesto. Similarly, it has been asserted that the dresses modelled by Flöge were never intended to appear on the streets of Vienna, deemed suitable only for the privacy of the home or as casual wear in the more relaxed atmosphere of the countryside.[36]

In assessing the significance of the photographs, we might move beyond identifying them simply as Klimt's representations and consider them instead as the encounter between two mutually inflected professional practices. More than a passive figure framed by the viewfinder of the camera, Flöge's smiling acknowledgement of the photographer (along with her carefully struck poses) suggests an artful and knowing performance. She appears as the active participant in – rather than merely the object of – the photographic encounter. Revealingly, the *Deutsche Kunst und Dekoration* photographs also played a part in her work as a fashion designer. They were included in a photographic album on display in the Schwestern Flöge fashion salon.[37] Here clients were invited to leaf through the album as part of their visit and consultations at the Salon. Indeed in this context, the photographs became part of complex circuits of looking which make it difficult to identify the dresses depicted as being aimed straightforwardly at either the public or the private sphere. The premises of Schwestern Flöge, located on the Mariahilferstrasse, had been

4.5 Photograph, Wiener Werkstätte, Schwestern Flöge Fashion Salon, interior, 1904.

extensively redesigned in 1904 by the Wiener Werkstätte, primarily under the direction of Josef Hoffmann and Koloman Moser. Five full-page photographs of the revamped salon appeared in volume 16 of *Deutsche Kunst und Dekoration*, along with an essay on 'Die Moderne in Wien' and numerous illustrations of other designs by the Werkstätte.[38] Like the villas on the Hohe Warte, Schwestern Flöge was an exercise in producing a *Gesamtkunstwerk*, in which all aspects of the interiors and furnishings were carefully coordinated and harmonised. Located amidst the hustle and bustle of a well-known Viennese shopping street, the salon, unlike the Hohe Warte, did not involve a geographical retreat to the countryside. Nor, given its concern with up-to-date fashion, did it obviously invoke relationships of past to present. And yet, closer examination reveals that for the fashion salon as much as the villa colony such concerns were central to articulating a specifically Viennese modern aesthetic.

In certain senses, Schwestern Flöge did entail a form of withdrawal: a move from the everyday life of the city into the realm of fashion. The sensation of having stepped over a threshold was created both by the self-contained design of the Werkstätte environment and by the wall-to-wall grey carpeting which created the feeling of warm and muffled interiors, cocooned from the outside world.[39] Emilie Flöge's affiliations with the world of high art, both personally and professionally, would undoubtedly have enhanced the cachet of her designs. For the customers as much as the dress designers at Schwestern Flöge, the salon interiors signalled their participation in a larger aesthetic project – that of Viennese modernism as epitomised by the Werkstätte and its affiliated artists. Fittings could be scrutinised in the specially designed full-length pivoting mirrors which formed part of the Werkstätte ensemble. (Ill. 4/5) For customers gazing at their reflections in these mirrors, the Werkstätte interiors were not merely a backdrop but also the verification of the modern status of such outfits. A contemporary photograph reveals the full visual impact of this scrutiny. Facing mirrors provided front and back views of the customer, but also these same views repeated in a *mise-en-abîme*. Indeed it could be argued that it was this dramatic display of endlessly reflected dresses that constituted the final element of the salon as *Gesamtkunstwerk*.[40] Far more than was the case with the Hohe Warte,

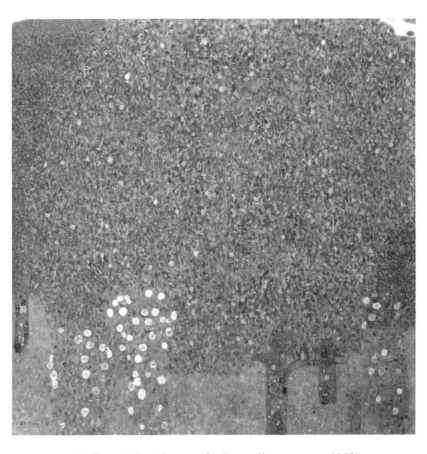

4.6 Gustav Klimt, *Roses under Trees*, oil on canvas, c. 1905.
Musée d'Orsay, Paris. Photo RMN.

the fashion salon was an explicitly feminine environment in which female fashion played a key role in identifying what was modern. This raises further questions however as to exactly how Flöge's fashions defined this modernity.

Flöge's clients were engaged in a process where fashionable urban outfits were designed through consultation of a diverse range of sources: the 'artistic' dresses photographed at the Attersee, a collection of textiles and artefacts and also, designs from other important fashion centres (Emilie made regular trips to Paris and also visited London). In addition to the photograph album, visitors to the salon would have been able to look at display vitrines containing Flöge's collection of ethnic textiles, drawn from both the Far East and constituent countries of the Austro-Hungarian Empire.[41] Flöge's interest in such textiles was symptomatic of wider aesthetic and political preoccupations with 'folklore', in Vienna as well as in the growing nationalist movements of the empire. On the occasion of a Viennese exhibition of 'Österreichische Hausindustrie und Volkskunst' in 1905, for example, Ludwig Hevesi wrote approvingly of the vivid colours of the artefacts on display. He identified these variously with the primitive, the Oriental and with the rustic ('farmers' wives').[42] For Werkstätte practitioners such as Hoffmann, who admired the simplicity and geometry of folk arts and the vernacular, such preoccupations formed a crucial part in formulating a modern aesthetic. So too with Klimt; the rustic settings of the Attersee photographs reappeared as the stylised subject matter of his landscape paintings, as rural gardens, orchards and flowering meadows. (Ill. 4/6) Dresses designed by Flöge in some cases literally incorporated fragments of Hungarian or Slovak folk textiles, a tangible demonstration of modern design articulated in terms of non-urban artefacts. In the case of Vienna, this was not simply a matter of nostalgia for a lost past. The imperial *Residenzstadt* was the showcase for an exoticism which, far from being 'outre-mer' (as with other European empires), emanated from territories within its own imperial boundaries. (There was of course Metternich's famous pronouncement that the Orient began at Vienna's Landstrasse.) Outfits from Schwestern Flöge thus constituted the 'modernised' counterpoint to the rustic and national dress from the Austro-Hungarian Empire which formed part of the daily spectacle of Vienna's streets.

At this period, there were also other ways in which femininity could signify modernity as the presence of the past in the present. In 1907, *Die Hetaerengespraeche des Lukian*, Lucian's *Conversations of the Hetaera*, translated into German by Franz Blei (author of the essay on the Wiener Werkstätte in volume 19 of *Deutsche Kunst und Dekoration*), was published in Leipzig.[43] Printed in a run of 450 numbered copies, the folio volume was available by private subscription only and included fifteen illustrations – mainly drawings of the female nude – by Klimt. The book was given a more public profile in the form of an exhibition at the first graphic exhibition of the Deutsche Künstlerbund at the Deutsche Buchgewerbemuseum in Leipzig in 1907.[44] Max Brod, writing in *Die Gegenwart*, saw a clear connection between Klimt's drawings and the antique. The publication was well received in Vienna, where Hermann Bahr wrote to Blei that he was 'entzückt über dieses Werk' ('enchanted by this work').[45] In the context of Vienna, 'that Athens on the Danube', Brod's reference to a 'Frauenkult' was timely.[46] Here, particularly in the circle of Karl Kraus, the cult of the hetaera (courtesan) was enthusiastically celebrated in terms of a youthful 'pagan' femininity, uninhibited in matters of sexuality.[47] Kraus's young mistress, the actress Irma Karczewska, was referred to as a 'miracle of a Dionysian girl'.[48]

Klimt's nude drawings (some of them, it seems, executed prior to the *Hetaerengespraeche* commission) do not link in any very explicit way to the text of Lucian's *Conversations*, but this did not stop commentators such as Brod seeing their relevance to the contemporary cult of the hetaera. Now recognised as the manifestation of shared male erotic fantasies, the cult denounced the inhibitions of bourgeois sexuality, claiming that modern-day women were forced to live against their true nature.[49] Women, in particular young women, were encouraged to act out the role of the *Kind-Weib*, to become 'late-born' Greeks and adopt a 'freer' sexuality. As for men, Kraus's dictum was 'never marry'.[50] The identification of Klimt, through his drawings for Blei's translation of Lucian, with such Viennese cults does not imply that Flöge in any sense played out the role of hetaera in relation to Klimt. More mature than the young women idolised in the Kraus circle, Flöge was an independent practitioner, not merely the muse to Klimt's practice as a painter. (Although even today this is not

always acknowledged; relatively recent studies of this relationship persist in referring to Flöge as Klimt's 'muse'.) It is perhaps more productive to see the Klimt–Flöge relationship in terms of mutual enhancement of their professional identities and here again, notions of femininity were crucial. If Flöge's designs benefited from association with Klimt's reputation as a painter, then his artistic identity as a painter was also to a certain extent closely linked to the kinds of femininity evoked by Schwestern Flöge clothing. The *Deutsche Kunst und Dekoration* photographs of flowing dresses in a country setting suggest an unconstrained femininity that would have accorded with contemporary representations of the hetaera. Like the hetaera, such clothing suggested a womanhood in tune with nature, an escape from the restrictions of bourgeois society. Such connotations of a less conventional femininity might well have appealed too, in different ways, to various sectors of Flöge's well-off clientèle, a number of whom had connections with the arts.[51]

In the case of both Klimt and Flöge, their lifestyle (and images of that lifestyle) were intimately linked to the promotion of the Wiener Werkstätte, not only in aesthetic but also in commercial terms. Women customers were an important target.[52] Flöge's personal adornment (the fact she regularly wore Wiener Werkstätte jewellery), like the design of the salons for Schwestern Flöge, was a useful means for the Werkstätte to solicit the attention and custom of female clients. Such links with a feminine clientèle were signalled too by the subjects of Klimt's portraits, who sometimes wore outfits and/or lived in interiors designed by the Werkstätte.[53] Klimt and Flöge appeared together in public, in Vienna and on the pages of *Deutsche Kunst und Dekoration*, but their relatively more private moments on holiday at the Attersee also formed part of social and artistic networks. Here, the two were regularly photographed together, Klimt wearing long, full-length smock-like garments, Flöge a variety of artistic dresses. Posing together on a rowing boat on the lake was a recurrent motif.[54] (Ill. 4/7) Klimt regularly wore smocks when working in his Vienna studio; their appearance on Lake Attersee signalled not only the greater informality of the *Sommerfrische*, but also (given his practice of working there *au plein air*) the fact that the Salzkammergut landscape now functioned as an extended studio environment. These holidays can thus be considered

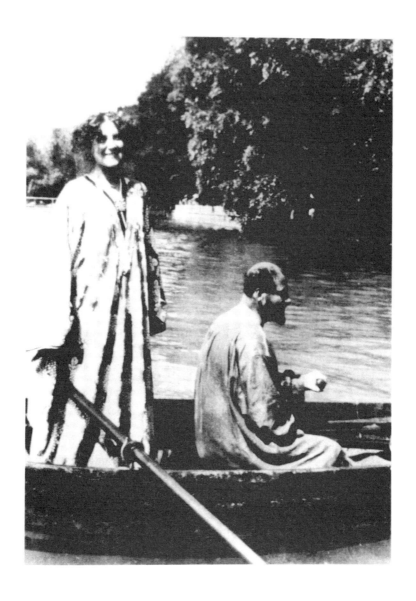

4.7 Photograph, Gustav Klimt and Emilie Flöge in a rowing boat, Attersee, c. 1905. Copyright Wienmuseum.

considered as part of a wider set of activities in which both clothing and photography played a vital role in the production of professional identities. In the case of Klimt, although he no longer undertook official commissions, it remained important to maintain a high-profile public image in order to sustain his reputation – and commissions – as a portrait painter and collaborator on Wiener Werkstätte projects.[55]

The Attersee photographs showing Flöge and Klimt together seem to reinforce a conventionally gendered identification of woman with nature and man with art. Such stereotypes are however complicated by other, more formal portraits by well-known professional photographers showing Klimt and Flöge in their respective Viennese working environments. The carefully posed photographs of Klimt in his painter's smock, taken in 1910 by Moritz Nähr, show him in the garden adjacent to his studio in the Josefstädterstrasse. Madame d'Ora, the famous Viennese society photographer, produced a number of photographs of Flöge in her salon, showing her elegantly dressed in streetwear, complete with elaborate hat. Josef Hoffmann was involved in the redesign of both Klimt's studio and Salon Flöge, but in the case of Nähr's photographs of Klimt, Hoffmann's design is not used as a backdrop.[56] Klimt is photographed outdoors, in the informal garden he so carefully cultivated. In these photographic portraits, the sitters are linked to 'art', but where femininity (the woman designer) appears in the context of artifice, masculinity (the male painter) is identified with nature. The image of Klimt suggests the practice of art as a form of liberation from more conventional social constraints. The full-length artistic male smock was not unusual at this period. Since the later nineteenth century, such garb played a role in the defining the male artist as a prophet, whether of unconventional sexual mores (Hermann Bahr) or of a more 'advanced' aesthetic (Joséphin Péladan).[57] In Klimt's case, his artistic identity seemed to involve more than simply one possibility. Subsequent commentators have characterised him as a combination of the classical and the biblical, as a modern-day satyr and ascetic (Tietze) or Pan and St. Peter (Gütersloh).[58] Partly due perhaps to the controversial nature of his female nude figure paintings, partly to what may have been known of his private life, Klimt's robed figure has often been associated with unbridled male sexuality.[59] Like

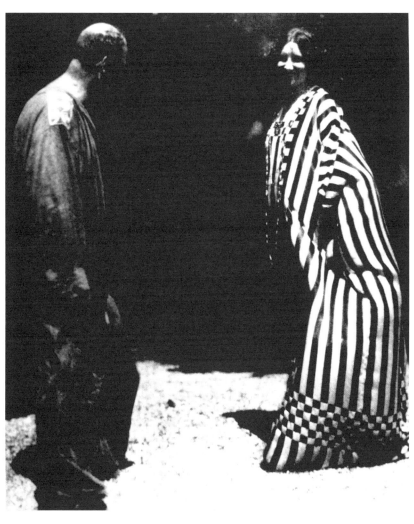

4.8 Photograph Gustav Klimt and Emilie Flöge.
Austrian National Library, picture archives, Vienna, Pf 31.931:E(2).

the much-lauded hetaera, Klimt could signify the retrieval of 'lost' sexual freedoms in the midst of early twentieth-century Vienna.

A photograph by Nähr dated around 1905 or 1906 shows Flöge and Klimt together in the Josefstädter garden, he in his smock, she in a boldly patterned kimono-like garment whose geometric patterning is reminiscent of Wiener Werkstätte design. (Ill. 4/8) Here they appear almost as if dancing together, their physical acknowledgment of each other suggesting the aesthetic interconnectedness of two practices. Photographic images of clothing, whether of those produced by Salon Flöge or of Klimt's smock, played an important role in defining the characteristics of a specifically Viennese modernism. Here the modern was defined not so much as an abandonment of the past, but rather as a set of relationships between past and present. The partnership (if we can call it that) enacted between Klimt and Flöge through individual and joint performances, to camera as in their social appearances, is an indication of the inherent theatricality of the *Gesamtkunstwerk* as conceived by the artists and designers affiliated with the Wiener Werkstätte. Nor did this strategic self-staging cease when Klimt died in 1918. Following the painter's death, Flöge set up a special room in her salon dedicated to his memory. It included not only drawings by Klimt carefully housed in folders and drawers, but also the artist's blue smock, displayed on a dummy.[60] None of this is to deny any genuine feeling and affection between the two, but rather to emphasise the significance of their relationship at the level of representation.

Blei's essay on the Wiener Werkstätte in *Deutsche Kunst und Dekoration* commented on the relatively recent establishment of the group, while at the same time stressing Vienna as the oldest continuous German *Stadtkultur* (urban culture).[61] The photographs of Flöge at the Attersee in this volume of the journal, along with the illustrations of the Hohe Warte, indicate the importance of a retreat into nature in the formulation of this distinctively modern urban culture. (The subtitle to Lux's *Hohe Warte* journal, with its stated aim of cultivating 'artistic education and urban culture', had made explicit this symbiotic relationship between city and country, art and nature.)[62] Such associations also functioned at a more metaphorical level. Like the *Sommerfrische*, for example, a Werkstätte *Gesamtkunstwerk* signified the renewal of everyday life. Here it is important to recognise, however,

that neither the Salzkammergut nor the Hohe Warte implied nature simply as a direct contrast or alternative to the city. Since the Biedermeier period, these locations had been popular destinations, both for leisure trips and for landscape artists to paint. The Hohe Warte and the Attersee were thus recognised not merely as nature but rather as *Kulturlandschaften*, sites which revealed the symbiotic inter-relationships between nature and culture. In this context, women played an important role, and not merely as potential customers. Simultaneously the completion and embodiment of modernised interiors (whether domestic as in the case of the Hohe Warte, or professional as with Schwestern Flöge) they conveyed the 'new look' of the Wiener Werkstätte. Schwestern Flöge demonstrates the extent to which women's dress – as the embodiment of ambivalences between artifice and nature, past and present – constituted a particularly effective means of purveying the aesthetic of the Werkstätte. These fashionably dressed Viennese women demonstrated Viennese modernism not simply as a break with the past, but as its continuous renewal. At the same time, Emilie Flöge's active participation in the staging of her professional identity and dress designs reveals the role of women within Viennese Modernism as more than simply demonstrations – passive objects – of 'reform'. Whether outdoors on the streets of Vienna, or indoors at home or at work, women were as much the bearers as the objects of this new look.

* * *

In Chapter 5 I again deal with circuits of looking, returning to the motif of the panoramic gaze with which this book opened. The case of the Hohe Warte, which gave its name both to the villa colony and to the arts journal, reveals the importance accorded to an elevated viewing position in contemporary discourses on Viennese modernity. (Tellingly, a watch-tower motif formed the logo of the publisher, Verlag Hohe Warte, who produced Lux's magazine.) In Chapter 5, however, the vantage point in question is not, as with the Hohe Warte, the Vienna Woods but rather the Alpine views afforded en route to and from Semmering, the fresh-air resort located a short train journey from Vienna. Like the Attersee, Semmering offered opportunities for

physical and mental recuperation by escaping the city, but even more than the Salzkammergut lake, Semmering was associated with the Austrian institution of the 'Kur'. Hence Semmering offered not only a return to health, but also possibilities of transformation. Then as now, there was a powerful allure in the promise of physical improvement coupled with improved lifestyle – in short, the prospect of a somehow better self.

For Klimt and Flöge, the Attersee was the *mise-en-scène* for producing a jointly articulated artistic identity to audiences both in Vienna and abroad. Similarly, Peter Altenberg deployed his stay on the Semmering in 1912 to elaborate images of his public self. But while the idea of the couple, the relationship between man and woman, was crucial in the formulation of individual artistic identities for Klimt and Flöge, Altenberg was more concerned with a kind of psychic merger between masculinity and femininity. As we have seen in Chapter 1, this merger was effected symbolically through Altenberg's idiosyncratic form of visual poetics: in his inscribed photographs and postcards as well as in published books of verse and picture collections. Chapter 5 shows how Semmering was uniquely suited to Altenberg's project of producing both a modern form of poetry and a reformed masculine physique. Semmering's Alpine panoramic views provided the ideal setting for the expressions of unfulfilled longing which ostensibly motivated Altenberg's poetry.

Notes

1 It was in 1903, the year in which the Werkstätte was founded, that Loos recommended Hoffmann and Moser should give up more serious work and turn their attention to dress design. See Chapter 3 'Haptic Homes', n. 34.

2 'Biedermeier ist ein Wort, das eine spätere Zeit erfunden hat für etwas, das ursprünglich auch keinen Stil hatte. Für etwas, das da gewachsen war, fast so organisch wie die Rosenhecken hinten am Haus [...]' (Lux, *Das Moderne Landhaus*, pp. 46–7).

3 'Ganz nach der Art der Menschen von damals, die sichs bequem und gemütlich einrichteten und darum in ihren Ausdrucksformen so unbekümmert waren, so treuherzig and bieder' (Lux, *Das Moderne Landhaus*, p. 47).

4 *Hohe Warte: Halbmonatschrift zur Pflege der künstlerischen Bildung und der städtischen Kultur*, vol. II, 1905–6, p. 216. Five volumes of *Hohe Warte* appeared between the years 1905 and 1909, published by Verlag Hohe Warte. As well as Joseph August Lux, the front cover of the journal also cited the involvement of Cornelius Gurlitt, Joseph Hoffmann, Alfred Lichtwark, Koloman Moser, Hermann Muthesius, Paul Schultze-Naumburg and Otto Wagner.

5 On 'reform dress' in Austria, see Houze, 'Fashionable Dress and the Invention of "Style" in Fin-de-Siècle Vienna'. List's painting *Rosenzeit* (1903) is reproduced in Becker and Grabner (eds), *Wien 1900*, p. 61.

6 On issues to do with commerce and the Wiener Werkstätte, see Siegfried Mattl, 'Stil als Marktstrategie' in Noever (ed.), *Der Preis der Schönheit*, pp. 13–21.

7 See, for example, Leslie Topp's discussion in 'Josef Hoffmann' and 'Moments in the Reception of Early Twentieth-Century German and Austrian Decorative Arts in the United States'.

8 *Deutsche Kunst und Dekoration: Illustrierte Monatshefte für moderne Malerei, Plastik, Architektur, Wohnungskunst und Künstlerische Frauenarbeiten*, Verlagsanstalt Alexander Koch, vol. XIX, October 1906–March 1907. The illustrations of Klimt's work appear on pp. 62 and 63, the photographs of Emilie Flöge on pp. 65–73. There are eight full-page and two half-page photographs. They are reproduced in Fischer, *Gustav Klimt & Emilie Flöge*. According to Fischer (p. 95), the photographs were commissioned by Koch for publication in the journal.

 Emilie Flöge's estate (unknown until then) was discovered in 1981. Along with about 400 letters and postcards from Klimt to Flöge over a period of twenty years, the estate includes twenty photographs, fifteen of them with their negatives. Material from the estate formed part of the exhibition 'Emilie Flöge und Gustav Klimt: Doppelporträt in Ideallandschaft', held at the Hermesvilla, Vienna between 1988 and 1989; see also *Inselräume: Teschner, Klimt & Flöge am Attersee*.

9 On the fashion salon Schwestern Flöge, see Fischer, *Gustav Klimt & Emilie Flöge*, esp. chs III and IV.

10 In 1906, Klimt was designated an honorary member of the Königlich Bayerische Akademie der bildenden Künste, Munich. He was subsequently referred to as 'professor' in the German press. Bailey, *Gustav Klimt*, p. 205.

11 For a detailed chronology of Klimt's career, see Bailey, *Gustav Klimt*.

12 On the argument regarding Klimt's withdrawal from the public to the private sphere, see 'Gustav Klimt: Painting and the Crisis of the Liberal Ego' in Schorske, *Fin-de-Siècle Vienna*. Also the relevant sections on Klimt in Natter and Hollein (eds), *The Naked Truth*.

13 On the Galerie Miethke, see Chapter 1 above 'The Inner Man', n. 23. For the Wiener Werkstätte: Schweiger, *Wiener Werkstaette*; Kallir, *Viennese Design*; Noever (ed.), *Der Preis der Schönheit*; Brandstätter, *Wonderful Wiener Werkstätte*.

14 It is now widely acknowledged that 'fashion played a central role in Klimt's vision of modernity'; see the discussion of the paintings that form 'a group of fashion subjects' in Bailey, *Gustav Klimt*, pp. 119 and 121. On Klimt's interest in women's fashion, see also Brandstätter, *Klimt & die Mode*; Partsch, *Gustav Klimt: Painter of Women*; Angela Völker, 'Gustav Klimt and Women's Fashion' in Natter and Frodl (eds), *Klimt's Women*, pp. 43–9. For the Wiener Werkstätte fashion department, see Völker, *Wiener Mode + Modefotografie*.

15 Artistically, there were close links between Darmstadt and Vienna at this time. The Secession architect Joseph Maria Olbrich (1867–1908), who was originally responsible for the villa projects on the Hohe Warte, was called to Darmstadt in 1899 by Ernst Ludwig, Grand Duke of Hesse. There he built a number of houses (including his own) on the Mathildenhöhe.
 Deutsche Kunst und Dekoration was founded in 1904. Alexander Koch's other journals included *Innendekoration: Die Gesamte Wohnungskunst in Bild und Wort* and *Stickerei u. Spitzen Rundschau, Darmstadt. Das Blatt der Schaffenden Frau.* He also published a series of volumes (including *Das Vornehm-Bürgerliche Heim*) under the rubric of 'Neuzeitliche Wohnkultur'.

16 *The Art Revival in Austria*, special summer number of *The Studio*, 1906: 'The work of the Wiener Werkstaette appearing in this volume is reproduced by kind permission of Herr Hofrat Alex. Koch, Editor of "Deutsche Kunst und Dekoration", Darmstadt.'

17 See Sekler, *Josef Hoffmann*. On the Hohe Warte villa colony, see Chapter 1 above 'The Inner Man', n. 17; on notions of the *Gesamtkunstwerk*, n. 15 of the same chapter.

18 Fischer claims the photographs were made in Weissenbach, Attersee, and that the photographs as well as the dress designs were by Klimt (Fischer, *Gustav Klimt & Emilie Flöge*, p. 95). *Inselräume* claims that the location was 'in unmittelbarer Umgebung des Brauhofs Litzlberg, bei der kleinen Kapelle und im Garten des Braugasthofes' and that 'die Flöge-Schwestern trugen – erprobten sozusagen – Mode aus ihrem Wiener Salon' (p. 15).

19 See 'The Fashion Photographs' in Fischer, *Gustav Klimt & Emilie Flöge*, pp. 95–105.

20 The house for Helene Hochstetter (1906–7) was undertaken five years after Hoffmann had designed her city apartment (Sekler, *Josef Hoffmann*, cat. 111, pp. 315–16). The house for Alexander Brauner (1905–6) was the fifth Hohe Warte villa (Sekler, cat. 101, pp. 295–6).
 The Koloman Moser house (1900–1) (Sekler cat. 52, pp. 266–7) forms part of a visual unit with the (larger) house for Carl Moll (1900–1) (Sekler, cat. 53, pp. 267–8). A second Hohe Warte villa was built for Moll in 1906–7 (Sekler, cat. 112, pp. 316–17). Also from this period are the houses for Dr Hugo Henneberg (1900–1) (Sekler, cat. 54, pp. 269–70) and Dr Friedrich Victor Spitzer (1901–2) (Sekler, cat. 63, pp. 273–5).

21 Beaumont, *Alma Mahler-Werfel Diaries 1898–1902.* p. 434.

22 Natter and Frodl (eds), *Carl Moll*; Koja (ed.), *Gustav Klimt Landscapes.*

23 See *G'schichten aus dem Wienerwald: Vom Urwald zum Kulturwald.*

24 'Ein alpines Gipfelerlebnis im Kleinen' in 'Landschaft als Vergnügen' in *Wiener Landschaften*, p. 120.

25 See *Wiener Landschaften* and *G'schichten aus dem Wienerwald.*

26 Such images could be deployed to vaunt the modernity of the Austro-Hungarian capital. For example, the 1906 Jubilee Exhibition in Bucharest included a room devoted to paintings of Vienna and its environs. This included pictures commissioned by the city for the exhibition, such as Karl Ludwig Prinz's *Der Leopoldsberg von der Eisernen Hand* (1905). The aim of the display was to present the civic improvements (such as the creation of the Wald- und Wiesengürtels and new water supplies) by Mayor Dr Karl Lueger, who visited Bucharest at the time of the exhibition. *Wiener Landschaften*, p. 28.

27 See Waissenberger, *Vienna in the Biedermeier Era 1815–1848*; Robertson and Timms (eds), *The Austrian Enlightenment and its Aftermath*; Erickson (ed.), *Schubert's Vienna.* And, on gardens, *Gartenkunst: Bilder und Texte von Gärten und Parks.*

28 In 1906, the Wiener Werkstätte mounted an exhibition on gardens and garden design, 'Ausstellung von Entwürfen kleinerer und grösserer Gartenanlagen. Architekten: Oskar Barta, Karl Brauer, Robert Farsky, Josef Hoffmann, Franz Lebisch, Paul Roller'; see Schweiger, *Wiener Werkstaette*, pp. 64–8. See also Chapter 1 above 'The Inner Man', n. 19.

29 For illustrations of Klimt's gifts of Wiener Werkstätte jewellery to Flöge, see Fischer, *Gustav Klimt & Emilie Flöge*, esp. p. 71. Fischer also illustrates a number of other Werkstätte artefacts from Flöge's estate. The design of the two necklaces shown in the Attersee photographs is attributed to Josef Hoffmann (see Sotheby's 1999 sale catalogue *Gustav Klimt & Emilie Flöge*). I am grateful to Evangelia Avloniti at Sotheby's, New Bond Street, London for sending me a copy of this catalogue.

30 *Hohe Warte*, vol. II, 1905–6, p. 78. The accompanying text reads: 'Das Reformkleid. Die Idee des heutigen Reformkleides entsprang einer natürlichen und künstlerischen Notwendigkeit. – Das Reformkleid ist künstlerisch durch die

richtige Konstruktion und die erfinderische edle Handarbeit. […] Ausführung sämtlicher Kleider durch den Salon Schwestern Flöge, Wien' (reproduced in *Emilie Flöge und Gustav Klimt*, p. 13). Hoffmann was interested in dress design; in 1898 he published 'Das individuelle Kleid' and he also designed dresses. See Wigley, *White Walls, Designer Dresses*, p. 74. Moll painted his wife wearing reform dresses at home on the Hohe Warte: *Bei Der Anrichte* (c. 1903) and *Mein Wohnzimmer (Anna Moll am Schreibsekretär)* (1903); see Natter and Frodl (eds), *Carl Moll*, plates 26 and 32.

31 The attribution of the dresses to Klimt is accepted by Fischer (see n. 18 above) and Völker, 'Kleiderkunst und Reformmode im Wien der Jahrhundertwende' in Pfabigan (ed.), *Ornament und Askese*, pp. 142–155. Like *Emilie Flöge und Gustav Klimt*, Renate Vergeiner and Alfred Weidinger claim that the dresses were probably not by Klimt. They discuss Flöge's experimentation with her own body via fashion; see 'Das Reformkleid – Eine Erfindung der Sommerfrische' in *Inselräume*, pp. 28–36.

32 On Klimt's affairs and children, see Fliedl, *Gustav Klimt 1862–1918*; Fischer, *Gustav Klimt & Emilie Flöge*; Brandstätter, *Gustav Klimt und die Frauen*; Partsch, *Gustav Klimt: Painter of Women*.

33 Frau Hedwig Langer, née Paulick (described as Flöge's last employee) in a 1982 interview: 'Emilie and Gustav – they were never really lovers! Never! This is the only explanation I have for Emilie's lifelong extremely nervous disposition […]!' (Fischer, *Gustav Klimt & Emilie Flöge*, p. 128). The transcript of the entire interview appears on pp. 170–2.

34 See Koja (ed.), *Gustav Klimt Landscapes*, in particular Anselm Wagner, 'Klimt's Landscapes and the Telescope', pp. 161–71.

35 See Natter and Frodl (eds), *Klimt's Women*, in particular Marian Bisanz-Prakken, 'Klimt's Studies for the Portrait Paintings', pp. 198–219.

36 On Viennese reform dress, see references in notes 5, 30 and 31 above; also, 'Reformmode' in *Emilie Flöge und Gustav Klimt*, pp. 12–14. Vergeiner and Widinger maintain that: 'Diese Kleider wurden zwar hergestellt, zum Teil sogar am Attersee – vorhandene Schnittmuster beweisen dies – konnten sich aber im Wiener Strassenbild nie durchsetzen. Es wurde so notgedrungener Ausdruck einer künstlerischen Freiheit. Die Reformkleider trug Emilie nur am Land, hier am Attersee, weit weg von Wien. Sowohl das Kleid als auch die Sommerfrische mit Klimt sind wie die ungewöhnliche Beziehung, die niemals in irgendeiner Richtung legalisiert oder definiert wurde, Ausdruck einer Reform des bis dato doch recht reglementierten und traditionsbehafteten Beziehungsschemas Mann/Frau' (*Inselräume*, p. 35). On the interest in reform dress on the part of architects and designers, see Wigley, *White Walls, Designer Dresses*, esp. ch. 5 'The Antifashion Fashion', pp. 128–53.

37 See 'Der Salon "Schwestern Flöge"' in *Emilie Flöge und Gustav Klimt*, pp. 34–48, and Fischer, *Gustav Klimt & Emilie Flöge*.

38 *Deutsche Kunst und Dekoration*, vol. XVI, April 1905–September 1905, pp. 522–6. The *Bureau* and *Probier-Räume* [office and fitting rooms] (pp. 522 and 523) are attributed to Josef Hoffmann, the *Empfangsraum* [reception room] (pp. 524–6) to Koloman Moser.

39 Sekler, *Josef Hoffmann*, cat. 89, p. 290: 'the floor is covered with dark wall-to-wall carpeting.' Fischer quotes Herta Wanke, 'Even then all the floors were covered wall-to-wall with light grey felt.' Fischer comments: 'The phrase "even then" […] is used because until the late 1950s the Viennese expected floors to be covered with parquet […]. Felt or fitted carpets were something quite unusual, "new-fangled", "English" or "American".' (*Gustav Klimt & Emilie Flöge*, p. 29).

40 There has been a reluctance on the part of historians to credit fashion with the same status as other forms of design. For example, whilst acknowledging the interest of Werkstätte designers in dress as part of a total environment, Kallir sees the opening of the fashion department as part of 'a growing trivialization of art, an increased involvement with all sorts of *Kleinigkeiten*'. This later phase of the Werkstätte is described in terms of a 'gradual artistic decline'. Kallir, *Viennese Design*, p. 89.

41 On Flöge's collection, which included textiles and Wiener Werkstätte artefacts, see 'Emilie, ihr Boudoir und ihre Sammlung' and 'Kunst und Folklore' in *Emilie Flöge und Gustav Klimt*; also Fischer, *Gustav Klimt & Emilie Flöge*.

42 'Man sehe nur die Farben, die diese Primitiven von selber im Handgriff haben. Die tschechischen, ruthenischen, rumänischen, kroatischen Bäuerinnen […], je weiter nach Osten, desto mehr blüht die Farbe auf, der Orient flicht augenfällig seine Sonnenstrahlen durch jeden Faden der Stickerin' (Ludwig Hevesi, quoted in *Emile Flöge und Gustav Klimt*, p.82).

43 The 1907 publication proclaimed that: 'Die Hetärengespräche des Lukian wurden für Subskribenten herausgegeben und gedruckt von der Offizin W. Drugulin in Leipzig in einer Auflage von 450 Numerierten Exemplaren. Die Zeichnungen von Gustav Klimt sind in Facsimile-Lichtdruck wiedergegeben. Die Einbandzeichnung wurde besorgt von Gustav Klimt'. Nebehay claims that the drawings were not made specifically for the book; Nebehay, *Gustav Klimt Dokumentation*, p. 359.

44 Strobl, *Gustav Klimt: Die Zeichnungen 1904–1912*, vol. 2, p. 14. Strobl suggests that the drawings were probably executed during the years 1904–6. She points out that as there was no catalogue to the Leipzig exhibition in February 1907, it is impossible to know whether it was the original drawings or the book itself which was put on show.

45 Hermann Bahr to Franz Blei (quoted in Nebehay, *Gustav Klimt Dokumentation*, p. 379). See also Fischer, *Gustav Klimt & Emilie Flöge*, p. 126: '[I] drink to Klimt, the bright heathen […]. He is the only one who brought back a truly pagan vision.' Max Brod observed: 'Sie wird einem ganz klar, diese südliche genuszüchtige Linie des Frauenkults und der angenehmen Dinge' (quoted in Strobl, *Gustav Klimt*, p. 86).

46 'Introduction by Fritz Wittels: Wrestling with the Man' in Timms (ed.), *Freud and the Child Woman*, p. 1. Vienna was sometimes referred to as the third modern-day Athens, along with Paris and Berlin.

47 On Kraus and the cult of the hetaera, see Timms, 'The "Child-Woman"'; Timms, 'Editor's Preface' to *Freud and the Child Woman*. On the Kraus circle more generally, see Wagner, *Geist und Geschlecht*. According to Timms, 'The cult of the "courtesan" ("Hetäre") was actually launched in *Die Fackel* by Karl Hauer, in an article of November 1905 entitled "Lob der Hetäre", published under the pseudonyn Lucianus' (*Freud and the Child Woman*, p. 168, n. 9).

48 Timms, *Freud and the Child Woman*, p. 58.

49 A paper on 'Die grosse Hetäre' was delivered by Fritz Wittels to the Viennese Psychoanalytic Society in May 1907. Timms sees this not as a serious contribution to psychoanalysis but rather as a product of 'turn-of-the-century erotic cults and fantasies' (*Freud and the Child Woman*, p. 170, n. 8). Freud himself said, 'the ideal of the courtesan [Hetäre] has no place in our culture' (quoted in Timms, *Freud and the Child Woman*, p. 169, n. 7). Somewhat later, in his book *Sigmund Freud: His Personality, His Teaching, and His School* (1923, p. 212), Wittels presented a somewhat different view on the subject: 'The hetaera-cult of our day was no less homosexual than was that of classical Greece. What a man loves in the hetaera is the other men who have lain and will lie in her arms. Since the homosexual impulse is unconscious, it cannot manifest itself in the form of direct love for another man' (quoted in Timms, *Freud and the Child Woman*, p. 175, n. 16).

50 Timms, *Freud and the Child Woman*, p. 55.

51 For example, Fischer reproduces a Schwestern Flöge invoice for the painter Broncia Koller (*Gustav Klimt & Emilie Flöge*, p. 36). For further information on this artist, see *Broncia Koller Pinell*. Koller also bought from the Wiener Werkstätte; see illustrations of receipts in Fischer, *Gustav Klimt & Emilie Flöge*, pp. 38 and 39. See also the portrait of Koller (1907) wearing a necklace by Koloman Moser illustrated in Schweiger, *Wiener Werkstaette*, p. 69. On Josef Hoffmann's work for Koller and her husband, see Matthias Boeckl, 'Raumkünsterlische Fragmente' in *Broncia Koller Pinell*, 1993, pp. 25–34.

52 Vergeiner and Weidinger (*Inselräume*, p. 35) point out that Schwestern Flöge offered the Wiener Werkstätte its first opportunity to market goods to a specifically female clientèle. The Werkstätte received formal permission to run a fashion department in March 1911. According to Kallir (*Viennese Design*, p. 90), Schwestern Flöge may have executed Werkstätte designs prior to this date, a view reiterated by, for example, Wigley who claims that Hoffmann and others in the Werkstätte were designing dresses since its foundation in 1903 (*White Walls, Designer Dresses*, p. 74).

53 The relationship of Klimt's female sitters to the Wiener Werkstätte is addressed by Fischer, *Gustav Klimt & Emilie Flöge*; Brandstätter, *Gustav Klimt und die Frauen*; Natter and Frodl (eds), *Klimt's Women*.

54 Although ostensibly informal, the photographs function as a further dimension to the careful self-presentation of Flöge and Klimt, not least through their dress. These photographs have been extensively exhibited and reproduced since the discovery of Flöge's estate in the early 1980s.

55 It was during this period, for example, that Klimt worked with Hoffmann and the Wiener Werkstätte and produced his famous murals for the Palais Stoclet in Brussels.

56 Josef Hoffmann produced furnishings for Klimt's studio in 1904–5; see Sekler, *Josef Hoffmann*, cat. 96, p. 292.

57 Klimt's working smock is now in the collections of the Wien Museum. On the robed and besmocked attire of male authors and writers at this period, see 'Arbeitskittel und Priestergewand' in *Emilie Flöge und Gustav Klimt*, pp. 15–21; Fischer, *Gustav Klimt & Emilie Flöge*, p. 90.

58 A.P. Gütersloh's description of Klimt as having 'the mysterious countenance of Pan beneath the beard and hair of St. Peter' is quoted in the Foreword to Bailey, *Gustav Klimt*. In the words of Hans Tietze: 'Ein altmeisterlicher Revolutionär, ein verfeinerter Naturmensch, ein Gemisch von Satyr und Asket, von Weltmensch und Mönch; ein grossmütiger Egoist, mächtigen Instinkten und äusserstem Raffinement hingeben' (quoted in Brandstätter, *Gustav Klimt und die Frauen*, p. 10).

59 As well as characterisations of Klimt as 'pan' or 'satyr', there are also implications of a feminisation of the artist. Tietze when writing on Klimt's representation of women, for example, claimed: 'He has projected himself into every contour of her body, her dress, every smile and every movement' (quoted in Fliedl, *Gustav Klimt*, p. 204). Fliedl describes this as 'man's feminisation in the woman's image', pointing out that such empathetic modes of experience were identified as feminine (p. 206).

60 Flöge's Klimt memorial room is described by Herta Wanke; see Fischer, *Gustav Klimt & Emilie Flöge*, p. 171.

61 'Man müsste sich wundern, dass unter den ähnlichen Vereinigungen die der Wiener Werkstätte zeitlich die jüngste ist. Denn die Wienerische Kultur ist nicht nur die älteste deutsche Stadtkultur, sondern war auch die längstlebende; sie blieb eigentümlich bis in den Vormärz. Berlin war ein Provinzstädtchen, und das kulturelle München ist eine junge Monarchenschöpfung von gestern' (Franz Blei, 'Die Wiener Werkstätte', *Deutsche Kunst und Dekoration*, vol. 19, 1906–7, p. 42).

62 The full title was *Hohe Warte: Halbmonatsschrift zur Pflege der künstlerischen Bildung und der Städtischen Kultur.*

5 Panoramas of Desire: The Visual Poetics of Peter Altenberg

As we have seen, the panoramic view was a recurring motif in staking a claim to greatness, whether intellectual or political. In a letter written at the turn of the nineteenth and twentieth centuries, Freud mused on his future reputation as the founder of psychoanalysis from the vantage point of the Cobenzl, with its sweeping vistas of Vienna. Around the same period, Carl Moll's largescale painting for the ceremonial Kaiserpavilion of Otto Wagner's Stadtbahn showed a pair of eagles floating above a city newly modernised through a comprehensive metropolitan railway system. (Ill. Frontispiece) For both Freud and the Emperor Franz Josef, the urban panoramic view was implicitly linked with the imposition of order: for Freud, through the interpretation of dreams, in the case of the emperor, through modern transport. With Arthur Schnitzler's memories of his youth however, the scene has changed to the countryside – the mountains that dominated the Semmering region to the south of Vienna:

> it was here, in Reichenau, at the foot of the Schneeberg and Rax Mountains, that a loftier mountain panorama than I was accustomed to seeing in the distance from the environs of Vienna manifested itself to me for the first time, and the mystery of great heights and distances overwhelmed me; all of which probably sufficed to bring on a mild euphoria.

Here, the perspective of the great man of letters is linked less to processes of rationalisation than to the 'mystery' of a landscape. This was a setting that Schnitzler associated with the overwhelming passions of erotic desire, 'a magical framework for an adored beloved.'[1] In all three instances however, the panoramic vista functions as more than simply a rhetorical device or backdrop for the representation of 'the great man'. The turn-of-the-century panoramic view involved culturally shared ways of thinking as much as a type of visual experience on the part of certain individuals.[2]

This chapter examines in more detail the ways in which such references to the panoramic constituted the means for realising modern forms of masculinity. It returns to the figure and work of Peter Altenberg, as with the case of Klimt and Flöge at the Attersee, another exemplary instance of how a dynamic between city and country operated to produce artistic identities. The focus is on Altenberg's Semmering 1912 project, which consisted of a book of prose poems and literary sketches entitled *'Semmering 1912'*, published in 1913, and also the picture album 'Semmering 1912', subsequently compiled by Altenberg during the years 1915 and 1916.[3] Both ostensibly record Altenberg's extended stay in the Alpine resort of Semmering, which like the Attersee was a popular holiday destination for the Viennese bourgeoisie, in particular the city's artists and intelligentsia. The album, now housed in the Wienbibliothek im Rathaus (formerly the Wiener Stadt- und Landesbibliothek), consists primarily of picture postcards and some photographs slotted, rather than glued, onto each page. Altenberg was thus able to reorder the sequence of images, using the album as a flexible mechanism for recollection, recapitulating both his visit and his writing. (Ill. 5/1) The facsimile edition of the entire album, edited by Andrew Barker and Leo Lensing, was published in 2002 and brings to public view the diverse range of postcard imagery of the holiday resort in the years just before World War I.[4] As in the case of the photographs of Emilie Flöge, Altenberg's 'Semmering' album provides valuable insights into the significance of mass-produced visual imagery for the Viennese avant-garde of this period.

Leafing through the pages of Altenberg's album, the initial impression is of a collection of postcards of mountain landscapes and Alpine flora. along with holiday snapshots. Images of nature seem to predominate over, or at least rival, Altenberg's more usual preoccupation with teenage and pre-pubescent girls. There are hardly any photographs focusing on feminine limbs, such as that of the 'ideal legs' of a thirteen-year-old (mentioned in the Introduction to this book). With his 'Semmering' album, Altenberg appears to have shifted his 'botanizing on the asphalt' from the streets of Vienna to a more literal botanizing on the Alps. Closer scrutiny reveals however that in the mountain landscapes of Semmering as much as in Vienna, this is 'botanizing' in the sense deployed by Walter Benjamin – of

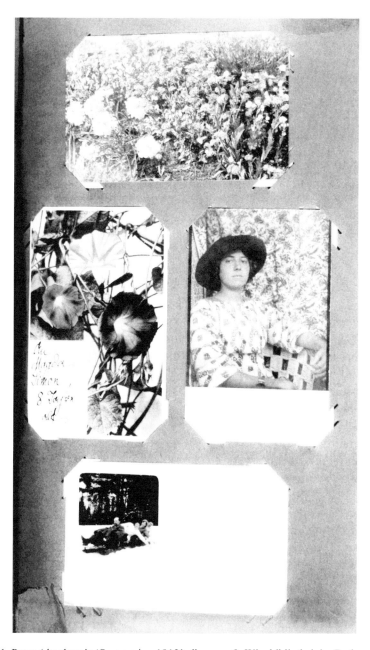

5.1 Peter Altenberg's 'Semmering 1912' album, p. 9. Wienbibliothek im Rathaus.

collecting as a form of recontextualisation.[5] Nearly all the postcards and photographs are inscribed by Altenberg, and his incriptions, along with the composition of the album, recast the meanings of these ephemeral images in a variety of ways. Here, as in his book of Semmering poems and literary sketches, Altenberg's concern with reformulating interactions between the visual and the written has to do with articulating a sense of self. As much as the carefully contrived bohemian persona he paraded in the cafés and streets of Vienna, Altenberg's practice as a poet and collector was always fundamentally concerned with fabrications of himself.

Altenberg's choice of the Semmering motif accorded well with his notion of inscribed postcards as a form of modern poetics. A well-known holiday and spa resort, Semmering epitomised the quintessential picture-postcard view. It was intimately associated with looking, in particular with the rapt contemplation of natural beauty. (Ill. 5/2) According to a recent cultural history by Wolfgang Kos, the resort virtually materialised out of its principal *points de vue*, with grand hotels and villa colonies perched on the hillsides facing the Schneeberg and Rax mountains.[6] A popular summer and winter destination for tourists from the different parts of the Austro-Hungarian Empire, especially between 1900 and 1914, Semmering was in effect an extension of the Ringstrassen society which frequented its largescale expensive hotels and commissioned architect-designed 'rustic' villas.[7] It was easily accessible by rail from Vienna (completed in 1854, the Semmering line from Vienna's Südbahnhof was Europe's first Alpine railway and itself a tourist attraction), and a walk along Semmering's Hochstrasse involved many of the same rituals, discussions and individuals as the Viennese afternoon *Korso*. Schnitzler, Adolf Loos and Freud were among the many well-known Viennese visitors. In the words of one commentator, in order to avoid encountering Viennese society, it was necessary to avoid Semmering.[8]

The resort was not only identified with, but also the product of, a variety of panoramic experiences. Semmering's special relationship to the panoramic ensured that sojourns in the resort on the part of urban visitors inevitably involved a symbiotic relationship between city and country. As a longstanding Alpine pass and pilgrimage route, Semmering offered a series of dramatic views of the surrounding

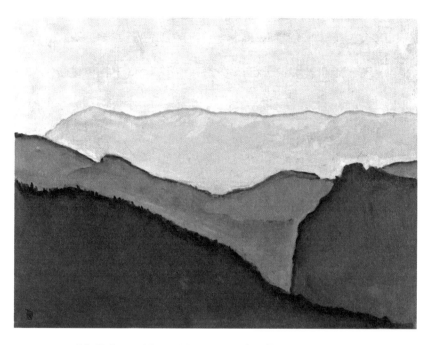

5.2 Koloman Moser, *Mountain Peaks*, oil on canvas, 1913.
Leopold Museum, Vienna.

countryside on which hotels, pensions and spas could capitalise in accommodating the growing tourist trade of the late nineteenth and early twentieth centuries. But the thrill of the panoramic view did not so much commence as climax upon arrival in Semmering. The train journey from Vienna was itself a form of panoramic experience, particularly from Gloggnitz onwards, when the Alpine railway snaked upwards through the mountains, often on a series of dramatically situated viaducts. (Ill. 5/3) The construction of the railway, which took several years, was considered one of the great engineering feats of the century.[9] Accounts of the building work were widely reported, and the railway line with its twists and turns and its bridges was – both in reality and in reproduction – a vital component in the panoramic vista. Views of the railway in its Alpine landscape appeared in lithographs, and subsequently in photographs and postcards, often issued as a sequence of images following the trajectory of the rail journey. (Ill. 5/4) Panoramic views of the Semmering region were thus in extensive circulation at the level of mass reproduction. The trip from Vienna to Semmering marked not only a transition from city to country, but also the ways in which encounters with the countryside were themselves formed as part of urban experience, a product of culture as much as an 'escape' into nature.

Semmering offered a productive social and cultural context for Altenberg's '1912' project. As in Vienna, Altenberg resided in a hotel, the Hotel Panhans. (Ill. 5/5) Unlike the down-at-heel Viennese establishments which he frequented, the Panhans was a largescale luxury hotel. Altenberg, however, had one of the cheaper rooms, facing the woods at the back of the hotel rather than out towards the spectacular mountain scenery. In Semmering, Altenberg continued his presentation of a bohemian and anti-bourgeois artistic persona to a predominantly haut-bourgeois audience. This individualistic stance grew out of, and indeed required, a wider social setting. Tellingly, the title of Altenberg's prose poems is contained within quotation marks, *'Semmering 1912'*, implying a place at a particular point in time, shared memories and associations. Although at one level the date refers to the occasion of the poet's own visit, *'Semmering 1912'* explicitly invokes a specific social and historical milieu to recount what are ostensibly the poet's most private feelings and experiences.

164

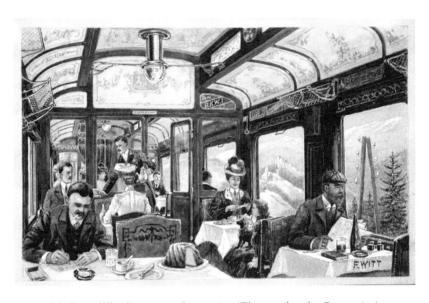

5.3 Franz Witt, *En route to Semmering* (*Elegant über den Semmering*),
watercolour, c. 1900. Technisches Museum Wien, archive.

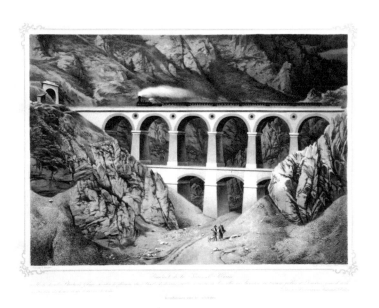

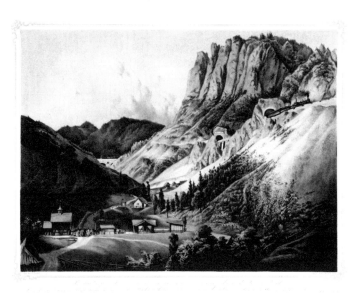

5.4 Emerich Benkert, *Views of the Semmering Railway*, lithographs, 1854.
Technisches Museum Wien, archive.

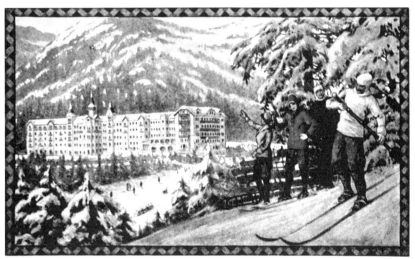

Semmering (Austria), Hotel Panhans, Wintersportplatz und Höhenkurort ersten Ranges.

5.5 Postcard, Hotel Panhans, Semmering, c. 1912.

167

With his Semmering project, Altenberg extended his practice as an urban poet by simultaneously engaging with and reworking a set of cultural relations to nature. This is not to deny that he was highly sensitive to natural beauty in the form of landscapes and flowers. Unlike Schnitzler, who deployed Semmering's Alpine grandeur as a form of backdrop to his erotic encounters, an intense communion with nature was at the very heart of Altenberg's '1912' project. Altenberg repeatedly characterised Semmering as a 'paradise,' more specifically a 'lost paradise' (*verlorenes Paradies*). The citation to the year 1912 is of both personal and historical relevance. Altenberg identified Semmering with his childhood and hence with loss. Like many others of his generation, Altenberg had regularly holidayed in the region as a child. This nostalgic sense of the passage of time is underscored in *'Semmering 1912'* with (for example) the prose sketch 'Nachwinter' where the poet refers to his fifty-third birthday. Another dimension of poignancy emerges with the picture album, compiled during World War I, where the sense of a *'verlorenes Paradies'* acquires wider, historical connotations. Such allusions to a society's past childhood suggest a state of harmony with nature, a form of prelapsarian innocence. At one level therefore, his own return to Semmering – through his visits, his poetry and his picture collections – represents an adult's attempt to recapture this vanished childhood world of edenic and innocent bliss.

As we saw in Chapter 1, Altenberg's poetic celebration of and longing for childhood involved not only an appreciation of the qualities of childhood but also the desire to somehow become a child, and in particular a female child. (Ill. 5/6) His writing is permeated with a powerful wish to identify – even to merge – with young womanhood, a wish fulfilled at the symbolic level through his choice of *nom de plume*. 'Peter', the nickname of the thirteen-year-old Bertha Lecher with whom he had been infatuated as a young man, in effect memorialised a summer spent in the Danube village of Altenberg. The fabrication of the poet's identity was thus connected both to a switch in gender and to the invocation of a holiday, an interlude away from 'everyday' life in the city. In this respect, Semmering (another holiday destination) offered Altenberg a poetically rich setting and subject matter, not only in its evocation of a 'lost childhood' but also in its

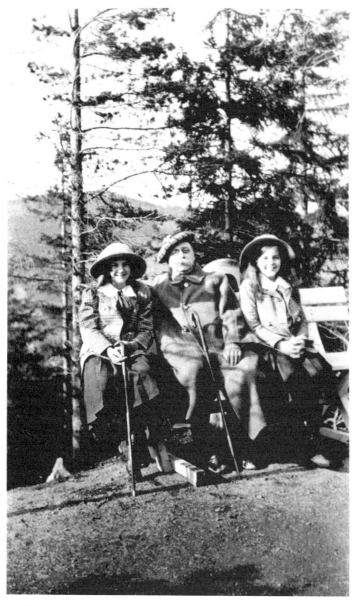

5.6 Photograph, Peter Altenberg and the Hansy Sisters, Semmering, 1912.
Copyright Wienmuseum.

particular conjunction of nature and culture. This was a place of artifice where, to quote Kos, Alpine glories could be admired in evening dress over a glass of champagne.[10] Vienna-in-Semmering brought with it not only all its urban glamour and intellectual sophistication, but also its aesthetic concerns and social strictures. Altenberg (like many other contemporary Viennese artists and writers) venerated youth both as a metaphor for, and the means of effecting, a new art. In the case of Altenberg, as with Kraus, a modern aesthetic was construed in terms of the pre-pubescent and adolescent girls rather than of the mature woman.[11] Where Altenberg was distinctive was the extent to which this new aesthetic was articulated through public performances of 'himself', both through his personal appearance and behavior and through his writing, which extensively narrativised his suffering as the result of his infatuations with young girls. At the literary level, this related to earlier works such as Johann Wolfgang von Goethe's story *The Man of Fifty*, which deals with the ultimate failure of an older man to develop a sexual relationship with a younger woman.[12] Altenberg's stance was particularly provocative however in the context of 1912, the year in which Egon Schiele was put on trial for his relationships with young, under-age models.[13]

Like much of Altenberg's other writing, '*Semmering 1912*' is presented in an apparently autobiographical, confessional mode. Illicit love must remain forever secret and unspoken, Altenberg proclaims, while at the same time openly announcing his various young inamorata, and in particular Klara Panhans, the hotel proprietor's twelve-year-old daughter. (Although not the only object of Altenberg's affections in 1912, Klara's name appears most frequently in his Semmering project.) According to Altenberg, it was precisely the anguish caused by this socially prohibited, physically unconsummated form of love, which made him a poet. (In Austria the legal age of consent at this period was fourteen.)[14] '*Semmering 1912*' often deals with unfulfilled love, but just as important are the means whereby, and the ends to which, such desire is expressed. Altenberg's obsession with femininity involved an explictly and intensely narcissistic self-preoccupation. His sketch 'Psychologie' proclaims: 'My interest in a woman concerns my relation to her, not her relation to me.'[15] As with his person (where Altenberg's idiosyncratic style of dress ensured that whether in

Semmering or in Vienna he was impossible to overlook), far from adopting a flâneurial anonymity, Altenberg's poetic stance constantly invited the regard of the reader. Similarly with the many picture postcards of his '1912' album, whatever they ostensibly depict, they are variously inscribed to address their author's most pressing subject – himself. It is in this sense appropriate that photographs of Altenberg appear prominently, both in the various early editions of *'Semmering 1912'* – the frontispiece shows Altenberg clad in a thick plaid overcoat, posed on the Semmering Hochstrasse with his walking stick – and in the Semmering picture album, where he features seventeen times.[16]

'Semmering 1912' reveals the ways in which Altenberg used this well-known location to draw attention to, and recast, representations of a desiring masculine self. He often refers, for example, to Semmering's role as a spa (*Kurort*), or more precisely, a *Nachkurort*. A eulogy on the *Nachkur* – 'after cure' is a literal, if not altogether satisfactory translation – forms the subject of one of the prose poems.[17] The cure itself, this proclaims, involves suffering and discomfort; the real benefits of such a regime can only be enjoyed subsequently, at the stage of the *Nachkur*. References to the cure returned Altenberg to a favourite theme: his own ill health.[18] Since 1910 he had frequented a series of sanatoria for physical and mental health problems (including alcoholism), and his treatments as well as his own bizarre health remedies often appear as the subject of his poetry and prose sketches. (This recurring literary preoccupation prompted several contemporaries to dismiss Altenberg as a neurotic and hypochondriac; more recently he has been referred to as a *Leidensvirtuose* – a virtuoso of suffering.)[19] In the context of *'Semmering 1912'*, the motifs of spa and health are deployed in various ways. On the one hand, they enabled the poet to dwell on the corporeality of his body in order to emphasise an almost childlike fragility and vulnerability. On the other, his alcoholism could be represented as a social barrier between himself and the object of his love.[20] As we saw in Chapter 1, both in photographs of Altenberg and in his writing, the poet's body figures as an expression of an ostensibly improved masculinity, reformed on the model of youth (he took particular pride in maintaining a slim figure). Altenberg's public pronouncements of agonised love as well as his carefully tended physique formed part of this personification of 'new'

manhood. In the poet's own terms, this was a masculinity construed both as critique and as utopian ideal: idealised love as opposed to what he saw as the sexual hypocrisy of the bourgeoisie, the adult male who not only protected but also identified with childhood innocence.[21]

Altenberg drew on the Alpine spa's reputation for the cultivation and care of the body in a beautiful natural setting in order to create a highly personalised landscape of desire. Semmering's renown (then as today) as a *Höhenluftkurort*, its altitude of 1000 metres vaunted as a health-giving attribute, was particularly significant in this respect. A short prose poem entitled 'Berghotel-front' vividly transcribes the fresh air motif into a characteristically Altenbergian *mise-en-scène*.[22] It is six in the morning, a foggy dew-sodden morning. All the hotel windows are shut, with the exception of that belonging to the room of a young tuberculosis sufferer. (Tubercular patients at this period were advised to leave their windows open to provide healing fresh air for their lungs.) Reciting the names of the young girls he admires, 'Klara, Franziska, Sonja – – –,' Altenberg invokes the beloved inhalations he imagines but cannot hear, almost as though the incantation of girls' names will bring his own breathing into rhythm with theirs. The poem's title 'Berghotel-front' corresponds with a typical postcard view.

The 'Semmering' album gives some indication of how Altenberg deployed the postcards themselves to elaborate his poetic themes, both through their inscription and their layout on the page. On page 27, for example, are mounted four postcards: the Kurhaus Semmering, Semmering in Winter, an illustration of pussywillows (inscribed 'to Evelyne Horner, 9 Jahre alt') and a card of the Hotel Panhans. The verso of the Hotel Panhans card has an extended text proclaiming Altenberg's love for Klara Panhans. He does not know which is her window, her door, her room; he knows only that under the roof of the enormous hotel he breathes along with her. Through his open window at night, perhaps he drinks in her beloved breath out of the mountain air. Both poem and album rework the motif of the *Höhenluftkurort* as a site of physical recuperation through a quasi-religious language (incantation, communion). The rehabilitation of the *Kur* and *Nachkur* is fantasized as a reform of aged masculinity through an almost mystical union with youthful femininity, the gloom and melancholy of winter assuaged by the promise of spring.

In Altenberg's work, expressions of a masculine identification with femininity are crucially dependent on sustaining a sense of distance, suggesting (like the inscribed photograph of a thirteen-year-old's legs) the dynamics of fetishism. Fetishistic voyeurism in this sense however does not provide an altogether satisfactory explanation for the Semmering 1912 project with its profusion of landscape and nature imagery. 'Berghotel-front' reveals Altenberg's appropriation of the standardised views and formulaic compositions of Semmering postcards as a means of sustaining the distancing effect of his poetic discourse. The 'Semmering 1912' picture album contains several instances of postcard views used to enunciate the gap between reality and that which is desired. A card showing the Fürstliechtensteinstrasse and Raxalpe is inscribed 'Hier mit Dir zu fahren, geliebtes Kind, Klara P.! Aber es wird nie sein!' ('To drive here with you, beloved child, Klara P.! But it will never be!')[23] Such fabrications might seem to undermine the more usual function of postcards as souvenirs or means of establishing contact. However, as Susan Stewart has pointed out, the very status of the souvenir is dependent on its distance in time and place from that to which it refers.[24]

The imagery of the seasons, a recurring theme in Altenberg's Semmering project, plays an important role in expressing this dynamic of desired closeness and necessary distance. In the poem 'Winter auf dem Semmering', Altenberg claims to have added snow to his countless unhappy loves.[25] Far from using the snow for wintersports, the poet wishes merely to gaze upon it for hours on end, to absorb it into his soul, as a means to escape from the world of reality into a magical realm. He expects no gratification, merely wishing to contemplate the snow in perpetual love, melancholy and wonder. In the 'Semmering' picture album, the many landscape and flower pictures are laid out in ways which seem to reproduce conventional associations of winter with age and spring with youth. (There are, too, a number of photographs of Altenberg taken in winter.) But rather than simply distinguishing age from youth, the snow in 'Winter' functions rather to signify both old age (in its barrenness) and virginal youth (in its untouched purity). Through its scenario of contemplative distance, the poem stages identification of age with youth, and by implication, of masculinity with femininity. Seasonal motifs persisted in Altenberg's

work well after 1912. For example, his inscription of around 1915 on a photograph of himself reads: 'I am old, and you, Albine, are young; but in our souls, exists the same, perpetual spring!'[26] (Ill. 5/7) At the same time however, such fervent proclamations of fantasised union were always undercut by Altenberg's reiteration of his age, constant reminders of the poignancy – and indeed the inevitably ludicrous aspect – of '50-year-old love'.[27]

Altenberg's idolisation of the child-woman as the distant object of unconsummated love is particularly apparent in the many picture postcards of Semmering churches in the '1912' picture album. With the inscribed postcards of the pilgrimage church of Maria Schutz (within walking distance of Semmering) Altenberg produced his own virgin cult, repeatedly apostrophising Klara Panhans as his *kleine Heilige* (little saint). At Maria Schutz and in the small chapel next to the Hotel Panhans, the poet claimed to have prayed not only 'for' but also, on occasion, 'to' Klara. From the viewpoint of readers today, Altenberg's passionate and ostensibly utopian preoccupation with pre-pubescent femininity is undoubtedly problematic. For the poet, it entailed certain difficulties. Following his stay in Semmering, Altenberg's brother had him admitted to the Am Steinhof asylum (just outside Vienna) on the grounds of alcoholism, but also because Georg Engländer was concerned about Altenberg's self-proclaimed infatuations with young girls.[28] Like the bohemian lifestyle, these hospital stays became part of the poet's subject matter and persona. For historians of early twentieth-century modernism, it remains important to explore the full significance of Altenberg's proclamations of unconsummated love. The narcissistic identifications with young girlhood suggest that there was more at stake in these publicly enacted infatuations than a desire for young women and girls. Revealingly, in *'Semmering 1912'* accounts of such infatuation coexist with rather more misogynistic sentiments. 'Bobby', for example, pronounces the companionship of a fox terrier as preferable to that of women.[29] Proclamations of prohibited, unfulfilled love were intrinsic to the fiction 'Peter Altenberg' – the poetic means of effecting a transformation of 'himself' through the contemplation of a feminine other. Altenberg's work was distinctive in its tortured, highly self-conscious fabrication of a new masculinity. Contemporary admirers of

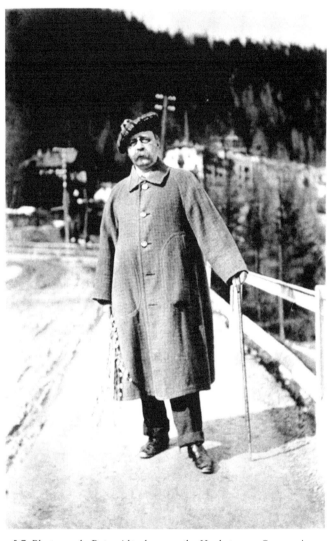

5.7 Photograph, Peter Altenberg on the Hochstrasse, Semmering,
Easter 1912. Copyright Wienmuseum.

Altenberg's writing often spoke of his 'feminine' soul and ways of seeing.[30] But this was masculinity rendered 'modern' not only in its feminine sensibilities, but also in its instability – shifting, contingent and fundamentally incomplete.

Of course Altenberg was far from unique in his attempts to create an artistic persona through reference to a feminine other. At this period, expressions of the author's desire for young women lay at the heart of literary practices such as that of Schnitzler and Kraus. Indeed both these authors were associated with specific types of femininity which they had elaborated (if not invented): the *süsses Mädchen* or *Mäderl*, the 'sweet' young, working-class woman, often from the Viennese suburbs who featured so prominently in Schnitzler's writing, and the archaic hetaera of Kraus with her primeval, unselfconscious sexuality.[31] If, in the context of such male fantasies of the feminine, the woman was legally under-age, then so much the better as an assertion of the supposedly anti-bourgeois sexuality of the male author which was presented as an essential component, the driving force, of male artistic creativity. With Schnitzler and Krauss however, sexual consummation (in the form of erotic conquest) was a crucial factor in such articulations of male artistic identity. Altenberg, by contrast, constantly stressed exactly the opposite in his delineations of infatuation – the unattainability of his objects of desire. (In this respect he identified with the well-known story of another artist's unconsummated passion, that of Schubert for Caroline Esterházy, the younger daughter of Schubert's Hungarian aristocratic patron.)[32] This did not necessarily receive an enthusiastic reception from his fellow artists. Indeed, Kraus disparaged Altenberg's endless litany of young women and girls as 'an aesthetic world of dolls'.[33] Some of the period's best-known literary figures were thus known, one might even say differentiated, through their phantasmic visions of femininity – whether the *süsses Mädchen*, the hetaera or the 'doll'. Nevertheless, the fact that all three reputations were to a certain extent based on an element of sexual fantasy was a shared attribute, and perhaps all too apparent even at the time. Schnitzler in *My Youth in Vienna* included the recollection of Anni Holitscher, to whom he and Altenberg had both played court while on holiday. She had apparently played along with their expressions of admiration, while at the same time

professing that there was not much to distinguish one man from the other. Revealingly, despite their dissimilar appearance, to Holitscher it seems that both were simply variations of a recognisable type, the no longer young, philandering Viennese poet.[34]

Indeed, Schnitzler, like Altenberg, construed erotic desire as a form of narcissistic self-preoccupation. He fondly remembered 'those wonderful, bittersweet summer days that had been saturated with longing and passion' as a means of achieving above all 'knowledge of myself'.[35] Somewhat differently however, Altenberg saw the young female objects of his infatuation as playing an active role in sustaining and developing his reputation as a poet. Despite the reliance in his writing on an apparently autobiographical voice, Altenberg was keenly aware that the significance of an artistic oeuvre can never simply be equated with 'the life'. (In this respect it is revealing that Kraus, one of the poet's most faithful supporters, disapproved of what was to become almost a literary genre in its own right of written and recited anecdotes about Altenberg's eccentricities.) However performative in life, any simple conflation between the person and the writing is problematised by the fact that 'Altenberg' was enacted not only by himself. His use of everyday, spoken language in many of his poems as well as the rhythmic qualities of his writing (partly the result of rhetorical repetition and highly expressive punctuation) meant that Altenberg's work was well suited to performance and recitation. Readings of his poems and sketches were popular in Germany as well as in Austria, with performances regularly given by women (the dancer Gertrude Barrison, for example, was acknowledged as a particularly accomplished reader of Altenberg's work) as well as by men – most famously, perhaps, Kraus.

Lina Loos, Adolf Loos's first wife, recited Altenberg's poetry at the inauguration of the Wiener Werkstätte's Cabaret Fledermaus in October 1907. The 'Altenberg' persona was thus elaborated not only in performances and readings, but also through innovatively designed venues of leisure and popular culture. It is thought that the Cabaret Fledermaus may have been conceived as a vehicle for Altenberg, and in 1908 Loos, who wished to dedicate his 'American Bar' to the writer, hung a portrait of the poet in the diminutive interior of this

exquisite establishment. Over and above such public tributes however, for Altenberg it was above all the preservation of his prized collection that he hoped would ensure the aesthetic coherence of his work for posterity. Altenberg's oeuvre was uniquely diverse, involving much more than simply his published writings and the performances of these. His collection of postcards and photographs, framed on the wall, or stored in boxes and albums, functioned both as poetic inspiration and as an extension of the poetry itself. His various hotel rooms were thus not merely a domestic environment but also a kind of highly personalised *Gesamtkunstwerk*. At the end of 1911, Altenberg wrote to his sister, asking her to send him his collection so that it could be housed in his room at the Hotel Panhans. In January 1912, he wrote a new version of his will leaving the collection to Klara Panhans, and requesting that she establish and act as custodian of 'ein kleines zartes Altenberg Museum' ('a small tender Altenberg Museum').[36] A letter to his brother Georg around this time reiterates Altenberg's ongoing concern that his collection should stay together after his death and not be dispersed.

Altenberg regularly wrote and rewrote his wills (a kind of parody almost of Beethoven's famous Heiligenstadt Testament), nominating different young women in the hopes that they would agree to act as guardians of his collection after his death. However impractical, these wills (like that in favour of Klara Panhans, they were usually revised under pressure from his brother) cast another light on Altenberg's publicly pronounced infatuations. They suggest something of the importance that Altenberg attached to the visual but also to the spatial aspects of his work and practice. He wished for a version of his hotel rooms to be preserved, thus displaying the framed photographs and postcards with which he had surrounded himself. During his lifetime this had been a display that was never fixed, involving not only moves from one hotel to another, but also the rotation of images between boxes, albums and walls. His reference to 'a small, tender Altenberg Museum' in the will to Klara Panhans, should be read not so much as a matter of self-deprecating modesty but rather as the wish that the 'museum' somehow convey those attributes – of innocence and the diminutive – which Altenberg associated with the feminine and hence with his own writing. In the poet's own terms, an Altenberg Museum

would necessarily be under the curatorship of a young woman. This was not only to reinforce the sense of woman as 'muse' but also to commemorate the working practices of a poet enamoured with mass-produced visual ephemera as a means of artistic creation.

At a number of different levels, Semmering offered Altenberg an exemplary environment in which to work. The landscapes of the region were identified by both Altenberg and Schnitzler as somehow 'magical', linked to the 'return to childhood' that such summer sojourns evoked. Altenberg spoke of a 'Märchenland der Kindheit' ('fairy-tale world of childhood') and a 'Zauberreich meiner Kinderjahre' ('magic realm of my childhood').[37] The Semmeringbahn may well have provoked recollections of childhood train rides at fairgrounds through magical grottoes. However, as we have seen in the writings of others such as Arthur Schnitzler, the 'Märchen des Lebens' ('the fairy tale of life') afforded by a stay in Semmering also involved the adult eroticisation of the Alpine milieu, its society as well as its natural glories.[38] Summer holidays in the countryside, away from the city, were commonly associated with romantic dalliances, particularly in resorts such as Semmering, where husbands and fathers returned to their jobs in Vienna during the week. In the case of Altenberg, the reiteration of Semmering as a fairy-tale environment also resonates with the connotations of fairy tales as a literary genre, with their tales of transformation and wish fulfilment.[39] Fairy stories regularly involve the metamorphosis of one being into another (these narratives of transformation a kind of parallel to the poet's desire to reform his masculinity) and of course, such stories often feature young female protagonists. More generally, Altenberg's references to fairy tales formed part of his invocation of a diminutive world of childhood innocence.

At first glance, it might seem paradoxical that a resort so closely identified with panoramic views of the Alps should have provided such fertile terrain for literary works characterised by their diminutive, smallscale format. Altenberg, it will be remembered, likened his work to the view into a hand-mirror, not a largescale mirror reflection of the world: 'Toilettespiegel, kein Welten-Spiegel'.[40] Despite the apparent contradiction however, the panoramic mode of experience accorded well with Altenberg's literary practice. The affinity with his work with

panoramas had less to do with the depiction of a *mise-en-scène* than in the ways in which modern mechanisms structured processes of looking. Panoramas involved not only scenes of natural beauty (such as those at Semmering) but also the artificial construction of views through a proliferation of various kinds of technical devices and buildings.[41] In Vienna for example, a variety of different panoramas had been regularly on show in the Prater since the earliest years of the nineteenth century. Indeed by 1912, what is often described as the heyday of the panorama was drawing to a close. Such panoramic depictions often involved cityscapes and battle scenes, but ever since the early days of the genre, panoramas had been intimately connected to Alpine tourism. Stephan Oettermann has identified panoramas as a specifically modern phenomenon, one of several technological innovations in the realms of mass communication and entertainment. He considers panoramas as incorporating a specifically bourgeois, modern view of nature, a means of secularising the Baroque depictions of heaven, which so often appeared on church ceilings. At one level, such panoramas offered a liberating experience, enabling their viewers to look at nature from a new angle and to appreciate it as a new form of paradise. The references to Semmering landscapes by Altenberg and other visitors to the resort as a 'paradise' were no doubt at least in part mediated by the modern form of the panorama as a mechanism for display and mass entertainment.

Visits to panoramas were generally described as exhilarating, albeit on occasion unsettling, events. Accounts of dizziness and disorientation on the part of visitors were quite common. Such encounters with a sweeping view were however dependent on a carefully calculated and restricted position on the part of the viewer. The panoramic experience was characterised by its combination of vicarious excitement and physical immobility. Oettermann speaks of the panorama visit as a form of 'regeneration through the eyes'.[42] Modern transport, in particular train journeys, involved a similar conjunction of claustrophobia with dramatic views. In a letter to his wife Alma in 1903, for example, Gustav Mahler lamented the cramped physical conditions of the railway carriage which formed the vantage point for the ever-changing panoramic views out of the train window.[43] Significantly, the *Sehlust* which commercial panoramas,

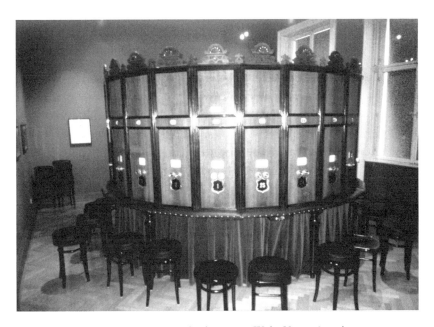

5.8 *Kaiserpanorama*, Stadtmuseum Wels, Upper Austria.
Photograph Paul Overy.

such as those in the Prater, both encouraged and satisfied involved a situation in which the object of the audience's gaze was necessarily untouchable.

Sweeping views rarely formed the subject of Altenberg's poems and sketches. However, like the visit to the panorama, it was the experience of looking intently at something intrinsically – necessarily – untouchable which defined the dynamic of his writing. In this characteristically Altenbergian *mise-en-scène*, rejuvenation was sought not so much through the *Luftkur* available in Semmering but rather through the longing gaze at an unattainable object of desire. As with so many kinds of panoramic encounter at this period, the poet's desire was formulated in terms of ambivalent and often contradictory feelings: fantasies of control did not preclude sensations of being overwhelmed; a meditative frame of mind could coincide with visual excitement and arousal. It is in this sense, rather than merely in terms of picturesque settings, that the Semmering 1912 project can most productively be identified with the panoramic. Semmering's distinctive (one might almost say over-determined) association with the panoramic experience thus facilitated an intensification of, rather than a deviation from, Altenberg's practice as an urban poet.

However, as mentioned above, there were several types of panorama in existence by 1912. Largescale panoramas, usually housed in purpose-built buildings, often involved painted landscapes. The smaller, more portable *Kaiserpanorama* was a mobile structure which displayed a series of stereoscopic photographs to viewers seated around its circular structure.[44] (Ill. 5/8) The evocatively named *Kaiserpanorama* was, like Altenberg's own picture collection, a symptom of the public fascination with mass-produced visual images and most often showed photographs of either current events or travel scenes. A sequence about Semmering is still sometimes shown in the *Kaiserpanorama* preserved in the Stadtmuseum in Wels in Upper Austria. A characteristic of viewing photographs through the *Kaiserpanorama* was that visitors did not necessarily begin at the start of the series; they took their seat and waited for the half-hour sequence to make its full round. This was therefore a rather different sequential experience from that organised by the lithographs and photographic 'panoramas' sold as souvenirs of the trip to Semmering, which often followed the trajectory of the train

journey. The *Kaiserpanorama* presented a series of three-dimensional visual images, but this could commence at any point, and it was of course dynamic, in that the pictures moved past the viewer. There are perhaps parallels to be drawn here with the way in which Altenberg seems to have used his picture albums, not as a static scrapbook, but rather as a mechanism for moving the cards and photographs around in order to consider different sequences and juxtapositions. The albums could be characterised as a kind of panoramic device that was simultaneously the stimulus for poetry, and in certain senses, a form of poetry in itself. The albums did not offer the *Kaiserpanorama*'s drama of frozen three-dimensionality (almost like a waxworks display), but they did involve vistas which, page by page, offered a similar conjunction of stasis and movement. Unlike panoramas however, such picture albums solicited the touch of the viewer in composing and turning pages, thus incorporating a rather more interactive encounter.

In considering analogies between mass-produced visual imagery and Altenberg's complex practice as a poet, perhaps the most telling comparison might be with the 'leporello', which usually consisted of lithographic or photographic images printed on a continuous piece of accordion-pleated paper or card. The leporello was in effect a kind of mini-panorama and could take the form either of a continuous view or a series of images (a sequence of fold-out postcards, for example). Popular, even today, as a form of souvenir, the leporello could also perform a celebratory function. Ghega organised the publication of a leporello illustrating the route from Payerbach to Semmering to coincide with the opening of the Semmeringbahn in 1854.[45] Although usually small in scale, the viewing mechanisms involved with this diminuitive form of panorama were intriguingly varied: two-dimensional images could be propped up as a three-dimensional structure, looking could be enjoyed both as a framed and as a continuous experience. As a panorama format, the leporello is perhaps unique in making a connection between the erotic and pleasure in looking. The name itself is associated with the figure of Don Giovanni's servant in Mozart's opera, who in Act 1 sings out the long list of his master's sexual conquests. This erotic account is dramatised in the form of Leporello's long folded-paper list, which in some performances is hurled to the

ground and allowed to cascade down a staircase. In its guise as panorama, the rhythms of folding and unfolding associated with the leporello add a further dimension to the panoramic experience. To engage with the visual as a form of unravelling or release contrasts appealingly with other forms of panoramic encounter, which so often took the form of constrained and passive viewing.

The 'panoramas of desire' that feature in Altenberg's *'Semmering 1912'* relate to the literary aspirations and attitudes of his male contemporaries, like Schnitzler, while at the same time delineating Altenberg's own distinctive version of masculinity. The panoramic aspect of Altenberg's work affords a useful means of reassessing the significance of the poet's collecting as well as his writing. In its choice of language, but also in its visual referants, Altenberg's 'Semmering 1912' book and album drew on mass forms of visual representation to shape a uniquely modern kind of poetry. Interactions between the panoramic experience (whether outdoors in nature as in Semmering or inside at one of the popular panoramas in Vienna) and smaller images as figured on postcards and in photographs formed part of the experience of nineteenth-century modernity. This complex visual dynamic between the vast and the smallscale – a means whereby people more generally engaged with the modern city and its relationship to the surrounding countryside – was crucial for Altenberg. He understood picture postcards not merely as the means of conveying terse and abbreviated messages, but also as components of the visual compositions of his walls and his albums. Photograph and picture albums – so often assembled by women – were, like postcard inscriptions or autographed photographs, important modes of communication and social contact.

The visual poetics of the Semmering 1912 project are thus made up of apparent contradictions: an elite society depicted in terms of the mass media; misogynistic attitudes combined with modes of representation usually identified as feminine and hence as 'trivial'. Altenberg appears here as the embodiment of a new masculinity, and at the same time as continuing the tradition of thwarted love as delineated by iconic figures such as Goethe and Schubert. Altenberg, it will be remembered, owned a reproduction of Klimt's wildly popular *Schubert* painting. Like so many other Viennese at this time,

he was fascinated by the stories of tragic *Fernliebe* – love at a distance – which formed such an important part of the Schubertian myth. The point here, however, is neither to resolve such apparent paradoxes, nor to condemn or absolve the carefully calculated performances that produced the Altenberg persona. It is more important to recognise Altenberg's *'Semmering 1912'* as symptomatic of the wider cultural preoccupation with gender and sexuality that characterised turn-of-the-century Vienna. With as much wit as apparent despair, Altenberg showed how not only the Viennese streets but also an (albeit highly cultivated) Alpine landscape might constitute a particularly rich symbolic terrain for the reconfiguration of gender categories and stereotypes.

Notes

1 Schnitzler, *My Youth in Vienna*, p. 20.

2 On the history and cultural significance of panoramas, see Oettermann, *The Panorama: History of a Mass Medium*, and Bernard Comment, *The Panorama*.

3 *'Semmering 1912'* was published by Fischer, Berlin in 1913, who also produced an extended third edition later that year. See 'Return to Paradise? *"Semmering 1912"'* in Barker, *Telegrams from the Soul*, pp. 150–65.
 A note on the stylistic conventions used in this chapter: *'Semmering 1912'* refers to Altenberg's book of published poems and sketches; 'Semmering 1912' to the photo album compiled by Altenberg; the two together I designate the Semmering 1912 project.

4 Lensing and Barker (eds), *Peter Altenberg Semmering 1912*. This includes an exact photographic reproduction of the original Semmering picture album, showing the postcards as they occur (some are in colour, some in black and white) as well as the blank spaces on certain pages where not all four available slots have been utilised. See n. 15 below regarding the Semmering poems in the 2002 edition.

5 'The leisurely quality of these descriptions fits the style of the *flâneur* who goes botanising on the asphalt' ('The Paris of the Second Empire in Baudelaire' in Benjamin, *Charles Baudelaire*, p. 36).

6 Kos, *Über den Semmering*, p. 27. See also Buchinger, *Villenarchitektur am Semmering*, and Vasko-Juhász, *Die Südbahn*.

7 Retler, *Das Traumhaus*.

8 Paul Stefan writing in 1913, cited in Barker, *Telegrams from the Soul*, p. 155.

9 In fact, the Semmeringbahn was one section of a larger project, the rail link between Vienna and Trieste, which was finally completed in July 1857. For a history of the railway, see *Faszination Semmeringbahn*.

10 Kos, *Über den Semmering*, p. 157.

11 More indirectly, the same might also be said for Adolf Loos. Although Loos had criticised the Viennese cult of youthful femininity (see Chapter 1 above 'The Inner Man', n. 41), as Peter Haiko has pointed out, much of Loos's 'anti-decorative' discourse relies on metaphors of the pre-pubescent female body. See 'The "Obscene" in Viennese Architecture of the Early Twentieth Century' in Werkner (ed.), *Egon Schiele*, pp. 89–100.

12 Goethe, *The Man of Fifty*, first published in German as part of *Wilhelm Meisters Wanderjahre* in 1829.

13 See, for example, Werkner (ed.), *Egon Schiele*; also Whitford, *Egon Schiele*.

14 On Altenberg's citation of the age of female children in his writing and inscribed photographs vis-à-vis fourteen as the age of legal consent, see Messing, 'Klimt's Schubert', pp. 17 ff. Altenberg was fascinated by the Schubert myth, with its

stories of male creative genius inspired by the encounter with an unattainable young woman.

15 'Psychologie'in Altenberg, *'Semmering 1912'*, p. 71. References are to the second edition. Lensing and Barker (eds), *Peter Altenberg Semmering 1912*, p. 71; the editors have made a number of modifications to the first 1913 edition on the basis of later versions of certain poems.

16 In their 2002 *Peter Altenberg Semmering 1912* edition, Lensing and Barker have substituted another photograph of Altenberg for that which appears in the earlier editions of *'Semmering 1912'*. This shows the poet's face in close-up (also illustrated in Lensing, 'Peter Altenberg's Fabricated Photographs', p. 55, fig. 4).

17 'Moderne Annonce' in Altenberg, *'Semmering 1912'*, p. 43. Lensing and Barker (eds), *Peter Altenberg Semmering 1912*, p. 43.

18 Altenberg's views on health, and what might now be called 'lifestyle issues' formed a major theme of his book *Pròdrŏmŏs*, published in 1905. However, Altenberg was not alone in this concern with his own health. Schnitzler admitted to a tendency to hypochondria, and Gustav Mahler's letters to his wife regularly touch on the subject of his diet and digestion; see Schnitzler, *My Youth in Vienna*, p. 105, and Beaumont (ed.), *Gustav Mahler: Letters to his Wife*. The difference is the extent to which Altenberg made such preoccupations the subject of his art, both in writing and in his public pronouncements and behaviour.

19 Schnitzler said of Altenberg: 'I couldn't feel [his behaviour] was quite genuine, rather like a professional neurotic' (*My Youth in Vienna*, p. 178). Kos refers to Altenberg as 'Leidensvirtuose im Kostum des öffentlichen Narren' (*Über den Semmering*, p. 164).

20 'Ende' in Altenberg, *'Semmering 1912'*, p. 104; Lensing and Barker (eds), *Peter Altenberg Semmering 1912*, p. 104: 'Vom 17. September 1911 bis 19. Oktober 1912 war sie seine kleine Heilige. Sie war geboren 9. April 1900. Dann erzählte ihr eine Dame der sogenannten "guten Gesellschaft", dass ich ein Säufer sei, und schon zwei Jahre im Irrenhaus inteniert gewesen sei. Hatte er sie seitdem weniger lieb?! Das war ja unmöglich. Aber sie schämte sich seitdem seiner Verehrung –.' ('From 17 September 1911 to 19 October 1912 she was his little saint. She was born on 9 April 1900. Then a woman, of the so-called "good society" told her that I was a drunk, and that I had already been commited for two years to an asylum. Does that mean I loved her any less?! That would be impossible. But since then she was ashamed of his devotion –.')

21 On Altenberg's concern to protect children, see Chapter 1 above 'The Inner Man', n. 52.

22 'Berghotel-Front' in Altenberg, *'Semmering 1912'*, p. 88; Lensing and Barker (eds), *Peter Altenberg Semmering 1912*, p. 88.

23 'Semmering' album, p.11.

24 'The Souvenir' in Susan Stewart, *On Longing*, pp. 132–51.

25 'Winter auf dem Semmering' in Altenberg, *'Semmering 1912'*, p. 45; Lensing and Barker (eds), *Peter Altenberg Semmering 1912*, p. 45.

26 This appears as an inscription (c. 1915) on a photograph showing Altenberg standing outside a photographer's shop. (This does not appear in the 'Semmering 1912' album.) The inscription reads: 'Ich bin alt, und Du, Albine, bist jung; aber in unseren Seelen, siehe, ist ein gleicher ewiger Frühling!' Lensing, 'Lektüre eines Albums' in Lensing and Barker (eds), *Peter Altenberg Semmering 1912*, p. 25, illustration 7; also reproduced in Lensing 'Peter Altenberg's Fabricated Photographs', p. 60, fig. 8, and Lunzer and Lunzer-Talos (eds), *Peter Altenberg: Extracte des Lebens*, p. 154. Relevant too are photographs such as that of Altenberg in Semmering holding a bunch of pussywillows – a portent of spring, particularly in connection with Easter (and resurrection), and hence a potent image juxtaposing renewal and age; see Lunzer and Lunzer-Talos (eds), *Peter Altenberg: Extracte des Lebens*, p. 177.

27 Schnitzler recounts a dialogue on 'fifty-year-old love' in *My Youth in Vienna*, p. 50: 'Why, you're in love just like a thirty-year-old!' 'No, gnädige Frau, like a fifty-year-old, et vous savez, Madame, c'est pire.'

28 On Altenberg's incarceration, see 'Madness and Confinement', ch. 5 in Barker, *Telegrams from the Soul*, pp. 140–65; also Lunzer, 'Irrenanstalt Am Steinhof 1912/1913' in Lunzer and Lunzer-Talos (eds), *Peter Altenberg: Extracte des Lebens*, p. 182. Altenberg sent his brother a postcard (a photograph of himself) on the occasion of Engländer's fifty-first birthday: 'Hättest Du mich doch, Bruder, auf meinem Semmering gelassen! Oh, mein Zimmerchen im "Panhans"!' ('If only, brother, you had left me in Semmering. Oh for my little room at the Panhans!')

29 'Bobby', in Altenberg, *'Semmering 1912'*, p. 69; Lensing and Barker (eds), *Peter Altenberg Semmering 1912*, p. 69.

30 On contemporary perceptions of Altenberg's femininity, see Chapter 1 above 'The Inner Man'.

31 See Wagner, *Geist und Geschlecht*, and Werkner (ed.), *Egon Schiele*, on the period's stereotypes of femininity in relation to masculine artistic identities.

32 See Messing ('Klimt's Schubert', p. 18), who points out that in 1911 Altenberg effused as follows in the *Wiener Allgemeine Zeitung*: 'Yes, is that not the greatest thing, to have helped a Franz Schubert with his songs, like the sun, dew and rain help the growth of plants!? Therefore why does she, this fourteen-year-old, actually need to be under the bare microscope of heartless uncomprehending men?!? She helped him with his songs, and without her these would not have arisen – !' Altenberg was apparently immediately corrected regarding Caroline's age; she was in fact older.

33 Timms, *Karl Kraus*, p. 92.

34 Schnitzler, *My Youth in Vienna*, p. 178 observed: 'she had decided that there was a strange inner resemblance between me and him [...]. Just as for the European, at a superficial glance, all Negroes look alike, to a young girl who

has not much experience with the breed, one poet might at first impress her as being exactly like the other.' Schnitzler also mentions a similar comment, subsequently made by Olga (p. 184).

35 Schnitzler, *My Youth in Vienna*, p. 214.

36 Lunzer, 'Semmering 1911/1912' in Lunzer and Lunzer-Talos (eds), *Peter Altenberg: Extracte des Lebens*, p. 176.

37 For example, 'Zauberreich meiner Kinderjahre!', 'Semmering 1912' album, p. 16. Kos (*Über den Semmering*, p. 9) quotes from a 1909 letter from Altenberg to his cousin Olga: 'Es war wie eine Wunderfahrt zurück, hinauf, ins Märchenland der Kindheit.' ('It was a wonderful journey back in time, up into the fairy-tale world of childhood.')

38 See, for example, the 'Semmering' album, p. 6: 'Märchen des Lebens! Vom Mittagstische auf der Terrasse aus sahen wir Dich in Sonnen-Nebeln, Rax!' ('Fairytale of life! From the table at lunch on the terrace we saw you in the sunny mists, Rax!')

39 On the significance of fairy tales, see, for example, Bettelheim, *The Uses of Enchantment*; Warner, *From the Beast to the Blonde*.

40 'I am a little hand-mirror, a boudoir mirror, no mirror on the world.' See '"Ich hasse die Retouche": Altenberg's letter to Schnitzler, July 1894' in Barker, *Telegrams from the Soul*, p. 32.

41 Oettermann, *The Panorama*, and Comment, *The Panorama*, provide extensive information on the many varieties of panorama which proliferated during the nineteenth century.

42 Oettermann, *The Panorama*, p. 45.

43 Beaumont (ed.), *Gustav Mahler: Letters to his Wife*, p. 109.

44 On the *Kaiserpanorama*, see Oettermann, *The Panorama*, pp. 229–32, and Comment, *The Panorama*, pp. 70–1. The reference was to the German Kaiser.

45 There were several panoramic depictions of the Semmeringbahn (both in construction and completed); see *Faszination Semmeringbahn*.

Conclusion

Preoccupations with aesthetic and intellectual innovation in 'Vienna 1900' often coincided with the desire for commemoration.[1] The 'inner-outer dialectic' of modernity in Vienna involved not only a spatial but also a temporal dimension. The modern was defined by comparison with the past, but also through a concern with the future. In many cases, the aspiration was to cement individual reputations through some form of association with the fabric of the modern city. Freud's wish for a commemorative plaque to himself has been realised. On the instigation of the Sigmund Freud Society, the City of Vienna installed a plaque on the site of the Belle Vue bearing his desired inscription in May 1977. (Ill. Conc/1) His chosen position for the memorial, high up in the Vienna hills, was a spot frequently visited for the enjoyment of panoramic views of the city. This was a place, in other words, dedicated to the processes of looking. Freud, more than many others however, might well have been aware of the chief characteristic of monuments: their propensity to be ignored.

Robert Musil addressed this paradox in his 1920s essay on 'Monuments' which appeared as part of a sequence entitled 'Ill-Tempered Observations': 'monuments are so conspicuously inconspicuous. There is nothing in this world as invisible as a monument.'[2] Part of the reason for this, according to Musil, was that 'anything that endures over time sacrifices its ability to make an impression'. This was particularly true he felt, in the case of statues representing the great figures of the past. These sculptural figures became part of the city's street scenery, condemned to invisibility by their inert and unchanging presence. The plaque eventually dedicated to Freud at his chosen spot might arguably have suffered a similar fate, were it not for its location. Elevated *points de vue* offer several pleasures: a new perspective on familiar places, combined with the opportunity of visually grasping the ongoing changes that characterise a largescale metropolis. A plaque may well be as static and unchanging as a statue, but due to the

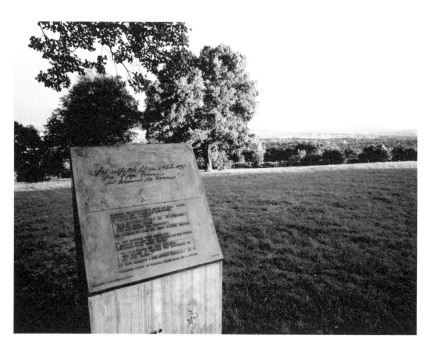

Conc.1 Memorial to Sigmund Freud, Cobenzl, Vienna.
Photograph Paul Overy.

dynamism of the modern city, the views afforded from Freud's plaque are subject to constant change.

Not everyone was so successful in achieving commemoration on their own terms. Altenberg's close friend Loos wrote to the poet concerning the importance of preserving his 'home' environment as a museum; he said he would recommend to the City of Vienna that Altenberg's abode be housed in the Museum der Stadt Wien.[3] But apart from the various reconstructions of his hotel room that have appeared in recent exhibitions on the cultural milieu of Vienna around 1900, no such Altenberg room exists today. Thus far at least, Altenberg has been denied his wish for a permanent 'kleines zartes Altenberg Museum'. There are however commemorations to be found in the sphere of commerce: the unnerving painted plaster effigy of Altenberg seated amongst the crowds at the Café Central and the small display of photographs on show in the foyer of his last Viennese residence, the Hotel Graben. (Ill. Conc/2) In terms of museal commemoration, Loos himself had somewhat more success. The living room (although not the bedroom) of the apartment he designed for himself and Lina Loos in 1903 is on show at the Wien Museum – the very location he had proposed for the Altenberg *Zimmer*.[4] As in the case of Altenberg however, it is the more commercial form of commemoration that attracts the greater crowds. The newly renovated Café Museum sits across the Karlsplatz from the Wien Museum, its gleaming, brightly lit interior presented as an historically accurate reconstruction of Loos's 1899 design. (Ill. Conc/3) Here Loos, like Altenberg, has been appropriated in the interests of twenty-first century commerce.[5]

The commemoration of the great figures of Vienna's artistic past produced by cultural tourism are by no means restricted to urban locations. At the Attersee, for example, it is possible to participate in a series of tours visiting the sites where Klimt holidayed and painted. (Ill. Conc/4) Strategically situated panels with viewing holes allow visitors to align their sightlines with those of the painter, ostensibly recreating the processes of looking that resulted in Klimt's distinctive landscape paintings. Artistic excursions have of course existed since the time of the eighteenth-century Grand Tour, but the Klimt tours form part of a specific sub-category of this genre, the trajectory

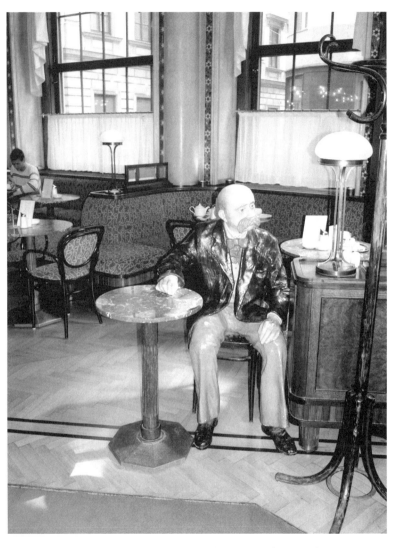

Conc.2 Painted plaster effigy, Peter Altenberg, Café Central, Vienna.
Photograph Paul Overy.

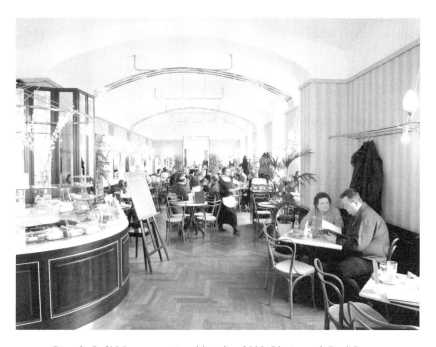

Conc.3 Café Museum, restored interior, 2003. Photograph Paul Overy.

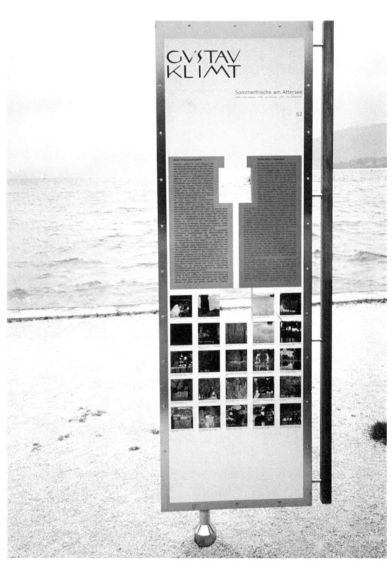

Conc.4 Gustav Klimt commemoration and viewing panel
at the Attersee, 2005. Photograph Paul Overy.

identified with a particular personality. Either in the form of carefully signposted walks (and, in the case of the Attersee, also trips by car) these journeys through space constitute another form of commemoration to the individual. Vistors to Vienna can follow numerous such walks, such as that dedicated to Joseph Haydn. At the same time, this 'tracing the steps' of the famous performs more than a merely commemorative function. In his advice on discovering Vienna, Loos referred to the Beethoven Walk in Heiligenstadt in spring as 'the most beautiful walk' in Vienna.[6] As well as a monument to the individual, these trajectories function as a tribute to an inspirational environment, whether in the city or the country. Nor is it necessary to actually move in order to participate in such an experience. The 'Tinte and Kaffee' literary readings which continue to take place in various Viennese cafés create a milieu in which viewers as much as performers can feel part of an 'historic' re-enactment.

In many such cases, commemoration is closely linked to what might be referred to as the museification of Vienna, the transformation of the whole city into a kind of museum. Like Musil's characterisation of the memorial, museification could well produce stasis and lack of change, a state quite at odds with the vibrancy associated with modern big-city life. According to Hermann Broch (1886–1951), this transformation of Vienna into 'a museum to itself' occurred well before the post-World War II tourist trade. In his posthumously published study on *The European Imagination 1860–1920*, Broch identified the ossification of Viennese culture with the later stages of the Habsburg regime. For Broch, the image that best summed up this condition was the imperial box which featured in commercial theatres throughout the Austro-Hungarian Empire: 'this continuously unused, continuously dark box clearly had the effect of a museumpiece and, indeed, because of this very museumishness, of a symbol of empty convention of monarchical Baroque gesture.'[7] Broch used 'museumish' as a derogatory term, and contrasted Austria's stagnation with what he saw as the more advanced cultural and political developments in countries such as France and Britain. By this period, he claimed, Vienna had become an 'un-world city', a retarditaire, Baroque metropolis.[8]

Many years later, Broch's compelling metaphor of the imperial theatre box was resurrected in order to propose a rather different argument about the significance of 'Vienna 1900'. In an essay for the catalogue accompanying the 1986 exhibition 'Vienne 1889–1938. L'Apocalypse Joyeuse' at the Centre Pompidou in Paris, Claudio Magris reiterated Broch's claim that 'all of Old Austria is in this empty theatre box of the emperor's,' emphasising that that 'this centre takes the form of an absence'.[9] By the mid-1980s however, ideas concerning precisely what constituted the 'modern' had changed. For Broch the void, or emptiness revealed by the imperial box, effectively epitomised what was un-modern about Vienna. According to Magris on the other hand, 'Old Austria is indeed a void, but in particular it is the awareness and the dissimulation of that void, of that nihilism of the real and of modern awareness'.[10] This void, in other words, far from connoting merely an inert absence, was the necessary prerequisite for the modern condition. Such an interpretation of modernity was of course itself a product of the intellectual concerns of the period in which Magris was writing, almost half a century after Broch.

The Centre Pompidou exhibition, along with the sequence of large-scale exhibitions on Viennese culture shown in Venice, Vienna and New York during the 1980s, was arguably as much to do with the current state of art and arts institutions in those countries as with the historical circumstances identified as 'Vienna 1900'. Magris's essay (like the French exhibition more broadly) formed part of new assessments of Viennese modernism carried out at the time of artistic and philosophical debates on postmodernism, in France as elsewhere in Europe and the United States. Whether in terms of the legitimation of ornament and decoration or due to a fascination with unstable and multiple subjectivities, these reassessments of Viennese culture seemed to offer a promising precursor to the postmodern developments taking place in the 1980s. Today, postmodernism is generally seen as a cultural phenomenon of the past, a product of the political and artistic circumstances of the later twentieth century. Nevertheless, the theatre box remains a useful image through which to consider the significance of Viennese modernity around 1900.

Indeed, far from being merely remnants of a past grandeur, one might argue that the multiplicity of darkened imperial boxes is a telling indication of Vienna as a modern *Grossstadt*. A small space within the larger space of the theatre, the box was simultaneously an intensely private and a highly visible public space. It suggests the importance of the interior – the 'great indoors' to borrow Hilde Spiel's expression – ideologically and symbolically as a component of modern life in Vienna.[11] Beatriz Colomina's study of the interior in her 1994 book *Privacy and Publicity: Modern Architecture as Mass Media* focuses in detail on Loos's domestic interiors. Here she draws extensively on the metaphor of the theatre box, citing Walter Benjamin's pronouncement in his 1930s essay on 'Louis Philippe, or the Interior' that for the private individual 'his living room is a box in the theater of the world'.[12] Colomina points out that Loos himself had referred to the motif of the theatre box in discussing his designs: 'the smallness of a theatre box would be unbearable if one could not look out into the large space beyond; hence it was possible to save space, even in the design of small houses, by linking a high main room with a low annexe'.[13] Colomina's essay elucidates Loos's concern with spaces inside the home, arguing that like the theatre box (an interior within an interior) these domestic rooms produced a 'look folded inward upon itself.'

Nevertheless, as Colomina acknowledges, these Loosian interiors problematised notions of inside and outside, thus undermining any strict separation of private from public life. However much domestic and public interiors may have represented a turning inward away from the city and from urban street life (as in the case of Moll's Hohe Warte villas or Altenberg's hotel rooms), the theatre box functions as a reminder that retreat into the interior was often put on public show. At a fundamental level, this was symptomatic of the theatricality of Viennese culture. Theatricality proved crucial in formulations of what it meant to be modern even (perhaps especially) in the case of Loos, who so disparaged drawing attention to oneself. Indeed, every instance explored in *Vienna: City of Modernity* attests to the importance of performativity in producing concepts of the modern self. With Klimt and Flöge at the Attersee or with Altenberg in Semmering we have

seen that the processes of making art were dependent on, and at the same time formed part of, complex relationships between the personal and the professional.

It has been clear that artistic practices were conceived very much with particular audiences in mind – whether these were art collectors, coffeehouse habitués or the viewers of photographs, as well as magazine readers. But the presentation of such art, along with its practitioners, involved not only the awareness of potential audiences. It also incorporated some acknowledgment that the artist or author was always simultaneously the object as well as the subject of a public gaze. Even when he was not physically present in the imperial box, the significance of the emperor was understood in a dual sense: at once the bearer of an all-seeing gaze and, at the same time, the focal point of the activities carried out for his viewing, whether on stage in the theatre, or elsewhere in the public realm. In whatever guise they may have appeared – whether Altenberg's bohemian persona, Loos's immaculately suited presence, Klimt in his painter's smock or Emilie Flöge wearing 'reform' dress – artistic identities were quintessentially performative and hence in need of constant re-enactment.

In certain ways the Emperor Franz Joseph seemed to embody the values of an earlier, Baroque age. His function as a symbol of ostensibly enduring, timeless values was reinforced by his much-vaunted resistance to certain manifestations of modern technology such as the telephone. But it was precisely through the adoption of modern technologies of representation that imperial omnipresence, as epitomised by the emperor's theatre boxes, could most effectively be ensured. Photography played an especially important role in this respect, and it is thus all too appropriate that the smaller-scale panorama displaying stereoscopic photographs should have been called *Kaiserpanorama.*[14] Photographs of the emperor were extensively produced and circulated throughout the Austro-Hungarian Empire. By the second half of the nineteenth century, photographs (and not only those of the emperor of course) had pervaded all aspects of everyday life. As we have seen, photography played an important role in the circulation of art, in fashion salons as well as in arts magazines. But the significance of photography in its relation to art was not limited to a simply passive, documentary role. Altenberg's lovingly assembled collection of inscribed

photographs and picture postcards was a self-reflexive meditation on the status of the photographic image. His hotel rooms, their walls covered with framed photographs, formed a kind of artistic installation in which the boundaries of high and low culture, visual as well as textual, were maintained in a constant state of flux.

As Broch pointed out, the many imperial theatre boxes were (like the imperial railway waiting room) nearly always uninhabited, carefully maintained as empty spaces. Otto Wagner's imperial waiting room inaugurated in 1898 was an architectural jewel box, designed to hover above the tracks of the municipal railway. But Wagner's pavilion was not fitted out with the cheap upholstery which Broch observed in the theatre boxes. Wagner's waiting room, no longer empty, has been converted into a small museum where visitors can admire the fabrics, furniture and artworks by members of the Vienna Secession with which it was originally adorned. Here modern architecture, art and decorative arts functioned as a kind of symbolic switchpoint, between the cultural and political elitism of imperial rule and the mass audiences served by Vienna's rapidly expanding transport and communication systems.[15] As numerous recent commentators have pointed out, by the time of Wagner's railway pavilion, the Habsburg dynasty was not associated simply with the past, ceaselessly enacting the empty rituals of bygone eras. Imperial rule depended on, and was also in certain ways a proponent of, the processes of modernisation that were transforming the urban fabric of the empire's capital city.[16] Far from being the meaningless relic of a Baroque past, metaphorically as well as metonymically the emperor's waiting room is a telling example of the spatial relationships which characterised Vienna as a modern city. Like the Hohe Warte villas built a few years later, Wagner's waiting room reveals how outdoor panoramic views and closeted interiors existed in a kind of contrapuntal relationship.

Moll's painting, a dominant feature of the interior of Wagner's waiting room, presents a 'bird's-eye view' of Vienna. The eagles (a reference to the double-headed eagle on the Habsburg crest) floating high above the city convey a sense of almost godlike omniscience. But the picture's function was not confined solely to this 'baroque' world view. It also constitutes a kind of smallscale panorama, a means of understanding the expanding dimensions and contours of the modern

city. In this sense it seems to accord with Walter Benjamin's explanation of the panorama as a modern phenomenon: 'The interest of the panorama is in seeing the true city – the city indoors.'[17] However, in Vienna the panoramic experience was not necessarily an indoor event based on a series of painted or photographic images. Moll's picture inevitably evokes the sweeping views of the city offered by numerous vantage points on the surrounding wooded hills – many of them reached by public transport.

Visits to the Wienerwald, like the panoramas on show in the Prater fairgrounds, were a popular, mass form of leisure entertainment. The popularity of indoor panoramic urban vistas may well have enhanced the desire for such outdoor excursions. It is also more than likely that the vogue for panoramic depictions of the city had an influence on how Vienna was viewed from its surrounding hills. But these were nevertheless two different kinds of looking. Whereas indoor panoramas (including the *Kaiserpanorama*) mainly presented static images – life fixed into an uncanny stillness – day-trips to the Vienna hills offered the opportunity to ponder the shifting configurations effected by change in the modern city. As we have now seen, the different ways in which such sweeping views from above – in the country as well as in the city – were deployed were in themselves an aspect of modernity, whether this was expressed as a concern with professional and posthumous recognition (in the case of Freud) or as the articulation of the male author's erotic desire (by Schnitzler and Altenberg).

How then, ultimately, do we assess the significance of Vienna as a city of modernity? Like the remnants of imperial Vienna more generally, 'Vienna 1900' has for some time been extensively assimilated to the interests of tourism and the heritage industries – to versions of the museification deplored by Broch. This book is written in the belief that studies of Vienna around 1900 can play an important role in offering alternatives to the narratives and stereotypes generated by these nostalgia industries. In Vienna at the turn of the nineteenth and twentieth centuries, the different art forms that claimed to express best what it meant to be modern were often manifested in ways that challenged or reconfigured ideas concerning relationships between 'old' and 'new', past and present, or 'high' and 'low' culture. Questions concerning the nature of masculinity and femininity endlessly recurred.

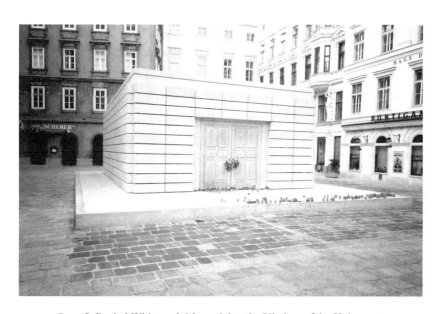

Conc.5 Rachel Whiteread, Memorial to the Victims of the Holocaust,
2000, Judenplatz, Vienna. By permission of the artist.
Photograph Paul Overy.

Indeed it is now widely recognised that in Vienna during this period debates on gender were of obsessive concern. *Vienna: City of Modernity* has considered a number of instances to explore the ways in which such art and debates were both the product and the critique of a distinctive urban environment. The questioning and uncertainties stimulated by this artistic and intellectual milieu render Vienna unrecognisable, either as the alternately *gemütlich* or glamorous city purveyed by the tourist industries or as Broch's ossified imperial capital. What emerges rather is the recognition of an altogether more dynamic (if dissonant) urban culture. It is perhaps this more unsettling version of 'Vienna 1900' that may yet resonate in new – and productive – ways in the twenty-first century, at a time which sees an ever greater preoccupation with celebrity and the performativity of daily life.

Let us close with a final instance of commemoration. What we remember as 'modern' is of course not just a matter of individuals, but also more collectively, of cities – of urban spaces and institutions. Many recent restorations, exhibitions and memorials have been aimed at promoting Vienna as an important city of modernity by highlighting its intellectual and artistic achievements. Newly embellished Viennese coffeehouses, for example, are presented as a form of cultural continuity with golden epochs such as 'Vienna 1900', and even earlier, the Biedermeier period. But for every surviving coffeehouse there are others that no longer exist.[18] Many were expropriated during the Anschluss.[19] Some of the former grand Ringstrassen *Kaffeehäuser* are now used for other purposes, such as car salesrooms. Today, numerous forms of commemoration around the city render visible such brutal eradications, determinedly resisting the anonymity and silence wrought by mass murder.[20]

One of the most prominent of these, Rachel Whiteread's 'Holocaust Memorial', opened in 2000, is a tribute to the intellectual life of Vienna, specifically to the city's Jewish population, the People of the Book. (Ill. Conc/5) Whiteread's bunkerlike monument located in the centre of Vienna is based on the plaster cast of the interior of a library. It consists entirely of bookshelves, although here viewers are confronted on four sides by the pages rather than the spines of the books. In a dramatic reconceptualisation of libraries such as might

have been found in Vienna's grander apartments, this monument effects a number of inversions: interior becomes exterior; the private public. Here the interior is no longer a space to be entered, but a solid and insistent presence. Despite its domestic scale, the Holocaust Memorial dominates the ancient city square of the Judenplatz. Inaugurated in the centenary year of 'Vienna 1900', it seems all too appropriate that it should be an interior turned inside-out which so effectively overcomes the invisibility Musil identified as the common fate of urban monuments.

Notes

1 See Riegl's essay (first published in 1903) 'The Modern Cult of Monuments'.
2 'Monuments' in Musil, *Posthumous Papers of a Living Author*, p. 61.
3 Adolf Loos: 'Deine Wohnung ist rührend, und ich fordere Wien, die Stadt Wien auf, diese Wohnung im Museum der Stadt Wien unterzubringen. Diese Kammer, in der P.A. gehaust hat, wird doch noch Platz finden' (as quoted in Ursula Storch, 'Das Altenberg-Zimmer im Grabenhotel in der Dorotheergasse 1913/1919' in Lunzer and Lunzer-Talos (eds), *Peter Altenberg: Extracte des Lebens*, p. 171).
4 Executed designs for domestic interiors are of course notoriously ephemeral, and few such interiors by Loos (or indeed other designers from this period) survive in their original form. However the Imperial Furniture Collection in Vienna displays the dining room designed by Loos for Eugen Stössler in 1899.
5 Not all critics have been convinced by the authenticity of these recent refurbishments. There is now a display of Gibson Girl prints in the Café Museum, although these are shown in what was the '*Extrazimmer*'.
6 'The Discovery of Vienna' (1907) in Loos, *On Architecture*, p. 62.
7 Broch, *Hugo von Hofmannsthal and his Time*, p. 63.
8 On contemporary (early twentieth-century) debates on Vienna and modernity, see 'The City Compared: Vienna is not Berlin' in Frisby, *Cityscapes of Modernity*, pp. 159–79.
9 Magris, 'Le Flambeau d'Ewald' in *Vienne 1880–1938*, p. 24: 'la vieille Autriche est tout entière dans la loge déserte de l'Empereur'; 'ce centre est un absence'.
10 Magris in *Vienne 1880–1938*, p. 24: 'la vieille Autriche est donc ce vide, mais elle est surtout la connaisance et la dissimultion de ce vide, de ce nihilisme du reel et du savoir moderne.'

11 'Idyll, Pageantry and the Great Indoors', ch. IV of Spiel, *Vienna's Golden Autumn*.

12 'Louis Philippe, or the Interior', part IV of 'Paris, the Capital of the Nineteenth Century', Exposé of 1935, p. 9, and p. 19 Exposé of 1939, in Benjamin, *The Arcades Project*.

13 'Interior' in Colomina, *Privacy and Publicity*, pp. 233–81; p. 370, n. 4.

14 Strictly speaking, as the *Kaiserpanorama* was invented in Germany, the reference was to the German emperor. However the implications of imperial omniscience and power would have been just as relevant in the Habsburg Empire.

15 On Otto Wagner and Vienna, see 'The City Designed: Otto Wagner and Vienna' in Frisby, *Cityscapes of Modernity*, pp. 180–235.

16 This applied not only to Vienna of course, but also to the new developments linking the city to the rest of the empire. Although he was not personally present at the official opening of the Semmeringbahn in July 1854, the emperor had taken two trips on the new railway earlier in the year, in April and again in May (on the latter occasion in the company of the Empress Elisabeth).

17 'Panorama' in Benjamin, *The Arcades Project*, p. 532.

18 See Perloff, *The Vienna Paradox*, pp. 19–21.

19 On the Nazi appropriation of Austrian properties, see Walzer and Templ, *Unser Wien:'Arisierung' auf österreichisch*.

20 For example, in 2003 the Freud Museum Vienna mounted the exhibition 'Freud's Lost Neighbours'. This diverted attention away from the Freud family to consider the fate of the tenants of eight other apartments at Berggasse 19. The displays documented the 'Aryanization' effected by National Socialist housing policy and also drew attention to recent debates concerning restitution for National Socialist expropriations. See Marinelli (ed.), *Freuds verschwundene Nachbarn*. As well as staging numerous temporary exhibitions, the Jüdisches Museum in the Dorotheergasse (located in the building which had previously housed the Galerie Miethke) displays a history of the Jews in Vienna.

Select Bibliography

Kathleen Adler, 'The Suburban, The Modern and "une Dame de Passy"', *Oxford Art Journal*, vol. 12, no. 1, 1989, pp. 3–13

Ingerid Helsing Almaas, *Vienna: A Guide to Recent Architecture* (Ellipsis: London), 1995

Peter Altenberg, *'Semmering 1912'*, second edition (Fischer: Berlin), 1913

Harriet Anderson, *Utopian Feminism: Women's Movements in Fin-de-Siècle Vienna* (Yale University Press: New Haven and London), 1992

Erna Appelt, 'The Gendering of the Service Sector in Austria at the End of the Nineteenth Century' in *Austrian Women in the Nineteenth and Twentieth Centuries: Cross-Disciplinary Perspectives*, David F. Good et al. (eds) (Berghahn Books: Providence, Rhode Island and Oxford), 1996, pp. 115–31

Emily Apter, 'Cabinet Secrets: Peep Shows, Prostitution, and Bric-a-bracomania in the Fin-de-siècle Interior' in E. Apter, *Feminizing the Fetish: Psychoanalysis and Narrative Obsession in Turn-of-the-Century France* (Cornell University Press: Ithaca NY and London), 1991

The Art Revival in Austria, special summer number of *The Studio*, 1906

Paul Asenbaum, Peter Haiko, Herbert Lachmayer and Reiner Zettl, *Otto Wagner: Möbel und Innenräume* (Residenz Verlag: Vienna and Salzburg), 1984

Judy Attfield and Pat Kirkham (eds), *A View from the Interior: Feminism, Women and Design* (The Women's Press: London), 1989

Colin B. Bailey, *Gustav Klimt: Modernism in the Making* (National Gallery of Canada: Ottawa), 2001

Martha Banta, *Imaging American Women: Idea and Ideals in Cultural History* (Columbia University Press: New York), 1987

Andrew Barker, *Telegrams from the Soul. Peter Altenberg and the Culture of Fin-de-Siècle Vienna* (Camden House: Columbia SC), 1996

Antony Beaumont (selected and trans.), *Alma Mahler-Werfel Diaries 1898–1902* (Faber & Faber: London), 1998

—— (trans. and ed.), *Gustav Mahler: Letters to his Wife*, first complete edition on the basis of the text prepared by Henry-Louis de la Grange and Günther Weiss in collaboration with Knud Martner (Faber & Faber: London), 2004

Edwin Becker and Sabine Grabner (eds), *Wien 1900: Der Blick nach innen*, organised in conjunction with the Österreichische Galerie Belvedere, Vienna and shown at the Van Gogh Museum, Amsterdam and Von der Heydt-Museum, Wuppertal (Waanders: Zwolle), 1997

Steven Beller, *Vienna and the Jews, 1867–1938: A Cultural History* (Cambridge University Press: Cambridge), 1989

—— (ed.), *Rethinking Vienna 1900* (Berghahn: New York and Oxford), 2001

Walter Benjamin, *Charles Baudelaire: A Lyric Poet in the Era of High Capitalism* (NLB: London), 1973

—— *The Arcades Project*, trans. Howard Eiland and Kevin McLaughlin, prepared on the basis of the German volume edited by Rolf Tiedemann (The Belknap Press of Harvard University Press: Cambridge, Mass. and London, England), 1999

Berggasse 19. Sigmund Freud's Home and Offices, Vienna 1938. The Photographs of Edmund Engelman (Basic Books: New York), 1976

Mary Bergstein, '"The Dying Slave" at Berggasse 19', *American Imago*, vol. 60, no. 1, spring 2003, pp. 9–20

Bruno Bettelheim, *The Uses of Enchantment: The Meaning and Importance of Fairy Tales* (Thames & Hudson: London), 1976

Hans Bisanz, *Peter Altenberg: Mein äusserstes Ideal. Altenbergs Photosammlung von geliebten Frauen, Freunden und Orten* (Brandstätter: Vienna), 1987

Marian Bisanz-Prakken, *Heiliger Frühling: Gustav Klimt und die Anfänge der Wiener Secession 1895–1905* (Brandstätter: Vienna), 1999

Cordula Bischoff and Christina Threuter (eds), *Um-Ordnung: Angewandte Künste und Geschlecht in der Moderne* (Jonas: Marburg), 1999

Christian Brandstätter, *Gustav Klimt und die Frauen* (Brandstätter: Vienna), 1994

—— *Klimt & die Mode* (Brandstätter: Vienna and Munich), 1998

—— *Wonderful Wiener Werkstätte: Design in Vienna 1903–1932* (Thames and Hudson: London), 2003

—— (ed.), *Vienna 1900 and the Heroes of Modernism* (Thames and Hudson: London), 2006

Hermann Broch, *Hugo von Hofmannsthal and his Time. The European Imagination 1860–1920* (University of Chicago Press: Chicago and London), 1984

Broncia Koller Pinell: Eine Malerin im Glanz der Wiener Jahrhundertwende (Jüdisches Museum der Stadt Wien: Vienna), 1993

Günther Buchinger, *Villenarchitektur am Semmering* (Böhlau: Vienna, Cologne, Weimar), 2006

Century City. Art and Culture in the Modern Metropolis, ed. Iwona Blazwick (Tate Modern: London), 2001

Claude Cernuschi, *Re/casting Kokoschka. Ethics and Aesthetics, Epistemology and Poetics in Fin-de-Siècle Vienna* (Fairleigh Dickinson University Press: Madison, Teaneck; Associated University Presses, London), 2002

Jean Clair, 'Une modernité sceptique' in *Vienne 1880–1938* (Centre Pompidou: Paris), 1986

Beatriz Colomina, 'On Adolf Loos and Josef Hoffmann: Architecture in the Age of Mechanical Reproduction' in *Raumplan vers Plan Libre*, ed. Max Risselada (Delft University Press: Delft), 1988, pp. 65–77

—— 'Interior', in *Privacy and Publicity. Modern Architecture as Mass Media* (The MIT Press: Cambridge, Mass. and London), 1994

Bernard Comment, *The Panorama* (Reaktion: London), 1999

Miguel Couffon, *Peter Altenberg: Erotisme et vie de bohème à Vienne* (Presses Universitaires de France: Paris), 1999

Brian Cowan, 'What was Masculine about the Public Sphere? Gender and the Coffeehouse Milieu in Post-Restoration England', *History Workshop Journal*, issue 51, 2001, pp. 127–57

—— *The Social Life of Coffee: The Emergence of the British Coffee House* (Yale University Press: London and New Haven), 2005

Alan Crawford, 'Ausstellung Adolf Loos, Vienna, 1 December 1989–25 February 1990', *Journal of Design History*, vol. 3, nos. 2 and 3, 1990, p. 185

Deutsche Kunst und Dekoration: Illustrierte Monatshefte für moderne Malerei, Plastik, Architektur, Wohnungskunst und Künstlerische Frauenarbeiten, Verlagsanstalt Alexander Koch, vol. XIX, October 1906–March 1907

Emilie Flöge und Gustav Klimt: Doppelporträt in Ideallandschaft (Historisches Museum der Stadt Wien: Vienna) 1988

Fairfax Downey, *Portrait of an Era as Drawn by C. D. Gibson* (Scribner's: New York and London), 1936

Felix Driver and David Gilbert, *Imperial Cities: Landscape, Display and Identity* (Manchester University Press: Manchester and New York), 1999

Hubert C. Ehalt et al. (eds), *Glücklich ist, wer vergisst [...]? Das andere Wien um 1900* (Böhlau: Vienna, Cologne, Graz), 1986

Markman Ellis, *The Coffee-House: A Cultural History* (Phoenix: London), 2005

Raymond Erickson (ed.), *Schubert's Vienna* (Yale University Press: New Haven and London), 1997

Faszination Semmeringbahn (Technisches Museum Wien and Marktgemeinde Reichenau an der Rax: Vienna), 2004

Wolfgang G. Fischer with assistance from Dorothea McEwan, *Gustav Klimt & Emilie Flöge: An Artist and His Muse* (Overlook Press: Woodstock, New York), 1992

Gottfried Fliedl, *Gustav Klimt 1862–1918: Die Welt in weiblicher Gestalt* (Taschen: Cologne), 1989 (English translation *The World in Female Form*, 1997)

Egon Friedell (ed.), *Das Altenbergbuch* (Wiener Graphischen Werkstätte: Vienna, Leipzig and Zurich), 1921

David Frisby, *Cityscapes of Modernity: Critical Explorations* (Polity: Cambridge), 2001

Diana Fuss and Joel Sanders, 'Berggasse 19: Inside Freud's Office'in *Stud: Architecture of Masculinity,* ed. Joel Sanders (Princeton Architectural Press: New York), 1996, pp. 112–39

Lynn Gamwell and Richard Wells (eds), *Sigmund Freud and Art. His Personal Collection of Antiquities* (Thames and Hudson: London), 1989

Gartenkunst: Bilder und Texte von Gärten und Parks (Historisches Museum Wien, Hermesvilla: Vienna), 2002

Malcolm Gee, Tim Kirk and Jill Steward (eds), *The City in Central Europe: Culture and Society from 1800 to the Present* (Ashgate: Aldershot, Hants and Brookfield, Vermont), 1999

Heinz Geretsegger and Max Peintner, *Otto Wagner 1841–1918: The Expanding City, the beginning of Modern Architecture* (Academy: London), 1979

Johann Wolfgang von Goethe, *The Man of Fifty* (Hesperus Classics: London), 2004

Benedetto Gravagnuolo, *Adolf Loos* (Art Data: London), 1995

G'schichten aus dem Wienerwald: Vom Urwald zum Kulturwald (exhibition catalogue des Landes Niederösterreich und der Stadt Wien: Kartause Mauerbach), 2002

Gustav Klimt & Emilie Flöge: Artist & Muse (Sotheby's: London), sale catalogue, 6 October 1999

Hohe Warte: Halbmonatschrift zur Pflege der Künstlerischen Bildung und der städtischen Kultur, vols 1–5, 1904–9

Die Hetaerengespraeche des Lukian. Deutsch von Franz Blei. Mit fünfzehn Bildern von Gustav Klimt (Julius Zeitler: Leipzig), 1907

Rebecca Houze, 'Fashionable Dress and the Invention of "Style" in Fin-de-Siècle Vienna', *Fashion Theory: The Journal of Dress, Body & Culture*, vol. 5, issue 1, March 2001, pp. 29–56

Andreas Huyssen, 'Mass Culture as Woman: Modernism's Other' in A. Huyssen, *After the Great Divide: Modernism, Mass Culture and Postmodernism* (Macmillan: London), 1986

Inselräume: Teschner, Klimt & Flöge am Attersee (Secession LXXXVIII: Seewalchen), 1989

Allan S. Janik and Hans Veigl, *Wittgenstein in Vienna: A Biographical Excursion Through the City and its History* (Springer: Vienna and New York), 1998

Julie Marie Johnson, 'From Brocades to Silks and Powders: Women's Art Exhibitions and the Formation of a Gendered Aesthetic in Fin-de-Siècle Vienna', *Austrian History Yearbook*, vol. XXVIII, 1997, pp. 269–92

—— 'Athena goes to the Prater: Parodying Ancients and Moderns at the Vienna Secession', *Oxford Art Journal*, vol. 26 no. 2, 2003, pp. 47–69

William M. Johnston, *The Austrian Mind: An Intellectual and Social History 1848–1938* (University of California Press: Berkeley, Los Angeles and London), 1972

Jane Kallir, *Viennese Design and the Wiener Werkstätte* (Thames and Hudson: London), 1986

Juliet Kinchin, 'Interiors: nineteenth-century essays on the "masculine" and the "feminine" room' in Pat Kirkham and Judy Attfield (eds), *The Gendered Object* (Manchester University Press: Manchester and New York), 1996, pp. 12–29

Stephan Koja (ed.), *Gustav Klimt Landscapes* (Prestel: Munich, Berlin, London, New York), 2002

Wolfgang Kos, *Über den Semmering: Kulturgeschichte einer künstlichen Landschaft* (Tusch: Vienna), 1991

Markus Kristan, *Adolf Loos Wohnungen* (Album: Vienna), 2001

Serge Lemoine and Marie-Amélie zu Salm-Salm, *Vienna 1900: Klimt, Schiele, Moser, Kokoschka* (Lund Humphries: London), 2005

Leo A. Lensing, 'Peter Altenberg's Fabricated Photographs: Literature and Photography in *Fin-de-Siècle* Vienna' in Timms and Robertson (eds), *Vienna 1900 from Altenberg to Wittgenstein*, 1990

Leo A. Lensing and A. Barker (eds), *Peter Altenberg Semmering 1912. Ein altbekanntes Buch und ein neuentdecktes Photoalbum* (Werner Eichbauer: Vienna), 2002

Jacques Le Rider, *Modernity and Crises of Identity* (Polity in association with Blackwell: Cambridge and Oxford), 1993

Harald Leupold-Löwenthal et al., *Sigmund Freud Museum. Wien IX. Berggasse 19 Catalogue* (Brandstätter: Vienna), 1994; English edition 1995

Adolf Loos, *Spoken into the Void: Collected Essays 1897–1900*, translated by Jane O. Newman and John H. Smith (The MIT Press: Cambridge, Mass. and London), 1982

—— *Ornament and Crime: Selected Essays*, selected and with an introduction by Adolf Opel, (Ariadne: Riverside, Caflifornia), 1998

—— *On Architecture*, selected and introduced by Adolf and Daniel Opel (Ariadne: Riverside, California), 2002

David S. Luft, *Eros and Inwardness in Vienna. Weininger, Musil, Doderer* (University of Chicago Press: Chicago and London), 2003

Heinz Lunzer and Victoria Lunzer-Talos (eds), *Peter Altenberg: Extracte des Lebens*, (Residenz Verlag: Salzburg–Vienna–Frankfurt), 2003

Kurt Lustenberger, *Adolf Loos* (Artemis: Zurich, Munich, London), 1994

Joseph Aug. Lux, *Das Moderne Landhaus. Ein Beitrag zur neuen Baukunst* (Anton Schroll: Vienna), 1903

Claudio Magris, 'Le Flambeau d'Ewald' in *Vienne 1880–1938. L'Apocalypse Joyeuse* (Centre Pompidou: Paris), 1986

Hans Makart Malerfürst (1840–1884), (Historisches Museum der Stadt Wien: Vienna), 2000

Lydia Marinelli (ed.), *Freuds verschwundene Nachbarn* (Turia + Kant: Vienna), 2003

Laura U. Marks, *Touch: Sensuous Theory and Multisensory Media* (University of Minnesota Press: Minneapolis and London), 2002

Siegfried Mattl, Klaus Müller-Richter, Werner Michael Schwarz, *Felix Salten: Wurstelprater. Ein Schlüsseltext zur Wiener Moderne* (Promedia: Vienna), 2004

Mary McLeod, 'Undressing Architecture: Fashion, Gender, Modernity' in *Architecture: In Fashion*, eds Deborah Fausch et al. (Princeton Architectural Press: New York), 1994

Scott Messing, "Klimt's Schubert and the Fin-de-Siècle Imagination" in *Music and Modern Art*, ed. James Leggio (Routledge: New York and London), 2002, pp. 1–35

Robert Musil, 'Monuments' in *Posthumous Papers of a Living Author* (Penguin: London), 1995

Tobias G. Natter, *Die Galerie Miethke: Eine Kunsthandlung im Zentrum der Moderne* (Jüdisches Museum der Stadt Wien: Vienna), 2003

—— 'Baron Nicolaus Dumba: geboren, um Mäzen zu werden', *Die Welt von Klimt, Schiele und Kokoschka: Sammler und Mäzene* (Dumont: Cologne), 2003

Tobias G. Natter and Gerbert Frodl (eds), *Carl Moll (1861–1945)* (Österreichische Galerie, Belvedere: Vienna and Galerie Welz: Salzburg), 1998

—— (eds), *Klimt's Women* (Yale: New Haven and Dumont: London and Cologne), 2000

Tobias G. Natter and Max Hollein (eds), *The Naked Truth: Klimt, Schiele, Kokoschka and other Scandals* (Prestel: Munich, Berlin, London, New York), 2005

Christian M. Nebehay, *Gustav Klimt Dokumentation* (Galerie Christian M. Nebehay: Vienna), 1969

—— *Vienna 1900: Architecture and Painting* (Brandstätter: Vienna), 1994

Irene Nierhaus, *ARCH Raum, Geschlecht, Architektur* (Sonderzahl: Vienna), 1999

Peter Noever (ed.), *Der Preis der Schönheit: 100 Jahre Wiener Werkstätte* (Hatje Cantz: Ostfildern-Ruit and MAK: Vienna), 2003

Stephan Oettermann, *The Panorama: History of a Mass Medium* (Zone Books: New York), 1997

Donald J. Olsen, *The City as a Work of Art: London–Paris–Vienna* (Yale University Press: New Haven and London), 1986

Eva B. Ottilinger, *Adolf Loos: Wohnkonzepte und Möbelentwürfe* (Residenz: Vienna and Salzburg), 1994

—— 'Vom Historismus zur Moderne: Aspekte der Wiener Wohnkultur 1870–1918' in Becker and Grabner (eds), *Wien 1900*, 1997

Susanna Partsch, *Gustav Klimt: Painter of Women* (Prestel: Munich and New York), 1999

Marjorie Perloff, *The Vienna Paradox: A Memoir* (New Directions: New York), 2004

Alfred Pfabigan (ed.), *Ornament und Askese im Zeitgeist des Wien der Jahrhundertwende* (Brandstätter: Vienna), 1985

Griselda Pollock, 'Modernity and the Spaces of Femininity' in *Vision and Difference: Femininity, Feminism, and the Histories of Art* (Routledge: London), 1988

Wolfgang Retler, *Das Traumhaus: Villenbauten um den Semmering vor 1914* (Tusch: Vienna), 1983

Alois Riegl, 'The Modern Cult of Monuments: its Character and Origins', *Oppositions* 25, Fall 1982, pp. 21–51

Ritchie Robertson and Edward Timms (eds), *The Austrian Enlightenment and its Aftermath, Austrian Studies 2* (Edinburgh University Press: Edinburgh), 1991

Burkhard Rukschcio and Roland Schachel, *La vie et l'oeuvre de Adolf Loos* (Pierre Mardaga: Brussels and Liege), 1982

August Sarnitz (ed.), *Architecture in Vienna* (Springer: Vienna and New York), 1998

Arthur Schnitzler, *My Youth in Vienna* (Weidenfeld & Nicolson: London), 1971

Carl E. Schorske, *Fin-de-Siècle Vienna: Politics and Culture* (Vintage: New York), 1981

—— *Thinking with History: Explorations in the Passage to Modernism* (Princeton University Press: Princeton), 1998

Werner J. Schweiger, *Wiener Werkstaette: Design in Vienna 1903–1932* (Thames and Hudson: London), 1990

Harold B. Segel (trans. and ed.), *The Vienna Coffeehouse Wits, 1890–1938* (Purdue University Press: West Lafayette, Indiana), 1993

Edward F. Sekler, *Josef Hoffmann: The Architectural Work. Monograph and Catalogue of Works* (Princeton University Press: Princeton), 1985

Chandak Sengoopta, *Otto Weininger: Sex, Science, and Self in Imperial Vienna* (University of Chicago Press: Chicago and London), 2000

Debora L. Silverman, *Art Nouveau in Fin-de-Siècle France: Politics, Psychology, and Style* (University of California Press: Berkeley, Los Angeles and London), 1989

Sherwin Simmons, 'Ornament, Gender and Interiority in Viennese Expressionism', *Modernism/modernity*, vol. 8 no. 2, 2001, pp. 245–276

Andrew Sinclair, *Death by Fame: A Life of Elisabeth Empress of Austria* (Constable: London), 1998

Lindsay Smith, '"Take Back Your Mink": Lewis Carroll, Child Masquerade and the Age of Consent', *Art History*, Representation and the Politics of Difference special issue, vol. 16, no. 3, Sept. 1993, pp. 369–85

Penny Sparke, *As Long as it's Pink: The Sexual Politics of Taste* (Pandora Press: London and San Francisco), 1995

Hilde Spiel, *Vienna's Golden Autumn: 1866–1938* (Weidenfeld & Nicolson: London), 1987

Janet Stewart, *Fashioning Vienna: Adolf Loos's Cultural Criticism* (Routledge: London and New York), 2000

Susan Stewart, *On Longing: Narratives of the Miniature, the Gigantic, the Souvenir, the Collection* (Duke University Press: Durham NC and London), 1993

Ursula Storch, *Das Pratermuseum* (Museen der Stadt Wien: Vienna), 1993

Robert Streibel (ed.), *Eugenie Schwarzwald und ihr Kreis* (Picus: Vienna), 1996

Alice Strobl, *Gustav Klimt: Die Zeichnungen 1904–1912* (Galerie Welz: Salzburg), 1982, vol. 2

Edward Timms, *Karl Kraus: Apocalyptic Satirist. Culture and Catastrophe in Habsburg Vienna* (Yale University Press: New Haven and London), 1986

—— 'The "Child-Woman": Kraus, Freud, Wittels, and Irma Karczewska', in Timms and Robertson (eds), *Vienna 1900 from Altenberg to Wittgenstein*, 1990, pp. 87–107

—— (ed.), *Freud and the Child Woman: The Memoirs of Fritz Wittels* (Yale University Press: New Haven and London), 1995

Edward Timms and David Kelley (eds), *Unreal City: Urban Experience in Modern European Literature and Art* (Manchester University Press: Manchester), 1985

Edward Timms and Ritchie Robertson (eds), *Vienna 1900 from Altenberg to Wittgenstein, Austrian Studies 1* (Edinburgh University Press: Edinburgh), 1990

Leslie Topp, 'Josef Hoffmann' (pp. 480–6) and 'Moments in the Reception of Early Twentieth-Century German and Austrian Decorative Arts in the United States' (pp. 572–82) in *New Worlds: German and Austrian Art 1890–1940*, ed. Renée Price (Neue Galerie: New York), 2001

—— *Architecture and Truth in Fin-de-Siècle Vienna* (Cambridge University Press: Cambridge), 2004

Traum und Wirklichkeit: Wien 1870–1930 (Historisches Museum der Stadt Wien: Vienna), 1985

Desirée Vasko-Juhász, *Die Südbahn: Ihre Kurorte und Hotels* (Böhlau: Vienna, Cologne, Weimar), 2006

Peter Vergo, *Art in Vienna 1898–1918* (Phaidon: London), 1975

—— 'The origins of Expressionism and the notion of the *Gesamtkunstwerk*' in *Expressionism Reassessed*, eds Shulamith Behr et al. (Manchester University Press: Manchester and New York), 1993

Vienne 1880–1938: L'Apocalypse Joyeuse (Centre Pompidou: Paris), 1986

Angela Völker, *Wiener Mode + Modefotografie: Die Modeabteilung der Wiener Werkstätte 1911–1932* (Schneider-Henn: Munich and Paris), 1984

Nike Wagner, *Geist und Geschlecht: Karl Kraus und die Erotik der Wiener Moderne* (Suhrkamp: Frankfurt am Main), 1982

Robert Waissenberger, *Wien 1890–1920* (Überreuter: Vienna and Heidelberg), 1984

—— *Vienna in the Biedermeier Era 1815–1848* (Mallard: New York), 1986

Tina Walzer and Stephan Templ, *Unser Wien: 'Arisierung' auf österreichisch* (Aufbau: Berlin), 2001

Marina Warner, *From the Beast to the Blonde: On Fairy Tales and their Tellers* (Chatto & Windus: London), 1994

Otto Weininger, *Sex and Character: An Investigation of Fundamental Principles*, eds Daniel Steuer and Laura Marcus (Indiana University Press: Bloomington), 2005

Patrick Werkner (ed.), *Egon Schiele: Art, Sexuality, and Viennese Modernism* (The Society for the Promotion of Science and Scholarship: Palo Alto, Calif.), 1994

Frank Whitford, *Egon Schiele* (Thames and Hudson: London), 1981 (reprinted 1996)

—— *Klimt* (Thames and Hudson: London), 1990

Das Wiener Kaffeehaus Von den Anfängen bis zur Zwischenkriegszeit (Historisches Museum der Stadt Wien: Vienna), 1980

Wiener Landschaften (Historisches Museum der Stadt Wien: Vienna), 1994

217

Mark Wigley, 'Untitled: The Housing of Gender', in Beatriz Colomina (ed.), *Sexuality & Space* (Princeton Architectural Press: New York), 1992

—— *White Walls, Designer Dresses: The Fashioning of Modern Architecture* (MIT Press: Cambridge, Mass. and London), 1995

Clare A. P. Willsdon, 'Klimt's Beethoven Frieze: Goethe, *Tempelkunst* and the fulfilment of wishes', *Art History*, 'Image: Music: Text' special issue, eds Marcia Pointon and Paul Binski, vol. 19, no. 1, March 1996, pp. 44–73

Janet Wolff, 'The Invisible Flâneuse: Women and the Literature of Modernity', *Theory, Culture and Society*, vol. 2, no. 3, 1985, 'The Fate of Modernity' special issue

Larry Wolff, *Postcards from the End of the World: An investigation into the mind of fin-de-siècle Vienna* (Collins: London), 1989

Zu Gast bei Beer-Hofmann: Eine Ausstellung über das jüdische Wien der Jahrhundertwende/Visiting Beer-Hofmann: An Exhibition on Jewish Vienna at the Turn of the Century (Vienna Jewish Museum: Vienna), 1999; (the Joods Historisch Museum Amsterdam: Amsterdam), 1998

Stefan Zweig, *The World of Yesterday. An Autobiography* (University of Nebraska Press: Lincoln and London), 1964 (first published 1943)

Index

Holitscher, Anni 176–7
Horn, Risa: photographs of hands 108–10, **109**
Hotel London 50, 58; Altenberg's room **39**, 40
Hotel Panhans (Semmering) *see* Semmering, Hotel Panhans
Huysmans, Joris Karl: *A Rebours* 34
Huyssen, Andreas: on mass culture 89

immigration: and cultural diversity 29–30, 88, 142
interiors: and exteriors 21, 30, 31, 90, 199; gendered as masculine 37, 57, 74–5; and intellectual life 20, 58; and interiority 38, 40; and public personae 20; retreat/withdrawal to 38, 59, 60; identification with women 31

'Judaisation' of Viennese society 52, *see also* Vienna Secesssion, as *goût juif*
Jung Wien circle 52

Kafka, Franz 19
Kaiserpanorama **181**, 182–3, 206 n. 14; of Semmering 182
Karczewska, Irma 143
Karlsplatz 93 n. 5
Katzler, Vinzenz: *Die Kassierin vom silbernen Kaffeehaus* 75–7, **76**
Kindweib (child-woman): cult of 51, 53, 143
Klimt, Ernst 137
Klimt, Gustav: artist's smock 146–8, 157 n. 57; at the Attersee 32, 119, 130, 137, 144, **145**, 193, **196**; characterizations of 146, 157 nn. 58 & 59; middle-class clients 38; exhibitions featuring 17; and Emilie Flöge 129–30, 136, 137, 143–4, 148, 151 n. 8, 154 n. 33, 157 n. 54; and Hoffmann 73, 157

nn. 55 & 56; and modern femininity 82, 83, 128; 'pagan vision' of 155 n. 45; photographs of **145**, 146, **147**; and photography 137; at Prater 81; splits from Secession 128; studio of 100; and tradition 80; visual devices used by 137; and women's dress design 80, 128, 152 nn. 14 & 18, 154 n. 31; working practices 137–8
—— works by: *Attersee I* **131**; *Beethoven* frieze 23; *Conversations of the Hetaera*, illustrations in 143, 155 nn. 43 & 44; *Damen-Porträt* (Margarethe Stonborough-Wittgenstein) 126; *Marie Henneberg* 82–3; *Roses under Trees* **141**; *Schubert at the Piano* 78–80, 81, 94 n. 22, 184; *Sonja Knips* 82, 83; Palais Stoclet murals (Brussels) 157 n. 55; *Waterserpents* (*Malerei auf Pergament*) 126
Klinger, Max: statue of Beethoven 21, 23
Knips, Sonja: Klimt's portrait of 82, 83
Koch, Alexander 128, 152 n. 15
Koller, Broncia: and Wiener Werkstätte 156 n. 51
Kos, Wolfgang: cultural history of Semmering 162, 170
Krafft, Johann Peter: *Marie Krafft at her Writing Desk* **48**
Krafft, Marie: portrait of 47
Kraus, Karl: and Altenberg 40, 177; circle of 38; exhibitions featuring 17; and hetaera/*Kindweib* 51, 53, 143, 176; and Loos 38, 114; Altenberg readings 177; *Die Fackel* 114; on Secessionists 59
Kulturlandschaft see Attersee, as cultural landscape; Hohe Warte, as cultural landscape

223

—— works of: *Beethoven Häuser* (prints) 23, **24**; *Bird's-Eye View of Vienna* **Frontispiece**, 27, 159, 201–2; *My Living Room* 44, **45**, 47–9; *Self-Portrait in the Studio* 40, **41**, 42–3, 44, 55, 66 n. 51

Moser, Koloman: middle-class clients 38; Hohe Warte house of 130; furniture for, by Hoffmann 73; and Loos 108, 123, 151 n. 1; *Mountain Peaks* **163**

Musil, Robert: on monuments 191, 205

Nähr, Moritz: photographs of Klimt 146
Nierhaus, Irene 107

Oettermann, Stephan 180
Olbrich, J.M.: at Darmstadt 152; and Hohe Warte artists' colony 62 n.17; and Secession building 43, 60, 69

Panhans, Klara 170, 172, 173, 174; as Altenberg's legatee 178
panoramas 179–80, 201–2; indoor 180–2, **181**, 200
patriarchy: in Austro-Hungarian Empire 30; and domestic harmony 55
personal-professional relationships 199–200, *see also* Flöge, Emilie, and Klimt; Klimt, Gustav, and Emilie Flöge
photography: and art 200–1; and the emperor 200; and professional identity 146, *see also* Flöge, Emilie, photographs of; *see also* Altenberg, and photography
Polgar, Alfred: on *feuilletons* 89
psychoanalysis: as archaeology 15–17

railways 27; imperial waiting room *see* Hofpavillon; *see also* Semmering, railway to
Raimund, Ferdinand 75
Reformkleid (reform clothing) 49, 136, 138, 153 nn. 30 & 36
Riegl, Alois 122 n. 48
Ringstrasse 29, 61 n. 1; as site of *Korso* 37, 61 n. 2
Ritter von Schlag family 15
Rodin, Auguste: at Prater 81; *Thinker* 23
Rosthorn-Friedmann, Rose von: Klimt's portrait of 82

Salten, Felix: on Altenberg 51
Schiele, Egon: and under-age models 170
Schindler, Alma (Mahler, Mahler-Werfel): photographs of 110; quoted 43, 80, 130
Schnitzler, Arthur 53, 187 n. 18; and Altenberg 40, 187 n. 19; on 'fifty-year-old love' 188 n. 27; and Helene Herz 107; and Anni Holitscher 176–7, 188 n. 34; *My Youth in Vienna* 100; and Semmering 32, 159, 162, 168, 179; and women 176
Schölermann, Wilhelm: critique of Café Museum 69; on Loos 78
Schorske, Carl E.: *Fin-de-Siècle Vienna* 33, 37, 38, 40; on Secessionist architecture 43
Schubert, Franz 80, 94 n. 23; exhibition on 80; and Caroline Esterházy 176, 188 n. 32; Klimt painting of 78–80, 94 nn. 20 & 22
Schuster, Ignaz 75
Schwestern Flöge 128, 136, 142; and Wiener Werkstätte 149, 156 n. 52; Wiener Werkstätte designs for salon 138–42, **139**; *see also* Flöge, Emilie

Secession *see* Vienna Secession

Selbstdarstellung 37

Semmering: Altenberg in *see* Altenberg, Peter, in Semmering; postcards of churches 174; Hotel Panhans 164, **167**, 172; in *Kaiserpanorama* 182; railway to 32, 162, 164, **165**, **166**, 179, 186 n. 9, 189 n. 45, 206 n. 16; as spa resort (*Kurort*) 32, 149–50, 162–4, 171, 172

Semper, Gottfried 104

Sengoopta, Chandak 116

Stewart, Susan 173

Stoclet, Adolphe 57; Klimt's murals for 157 n. 55

Stonborough-Wittgenstein, Margarethe: Klimt's portrait of 126

Stössler, Eugen: Loos's work for 93 n. 4, 103, 205 n. 4

Strauss, Johann 75

studios, artists' 100

Suttner, Bertha von 30

Symbolism: and interiority 33

tailoring, men's 32, 99; and architecture 104, 105

textiles: and architecture 97–8,104, 105, 106, 110, 120 n. 3

theatres: imperial boxes in 197–8, 199, 201

Timms, Edward 17

'Tinte & Kaffee' 25, 197

touch 32, 108, 110; as feminine sense 110

Van Gogh, Vincent: portrait of his mother 44

Ver Sacrum 108

Vienna: *Altstadt* 29; anti-semitism 38, 59; Beethoven Walk 197; cafés *see* coffeehouses, Viennese; child murder trials 55, 65 n. 50; coffeehouses *see* coffeehouses, Viennese; as cultural centre 17, 19, 148, 156 n. 46, *see also* 'Vienna 1900'; cultural tourism in 193–7; exhibitions featuring 17–19, 198, 204; expansion of 20–1, 29, 46; as *Grossstadt* 198; as imperial capital 15, 142; and Holocaust Memorial **203**, 204; industrialisation 133; intellectual life, 17, 23–5; and international scene 60; Jews in 88, 204, 206 n. 20; *Korso see* Ringstrasse, as site of *Korso*; modernisation 20–1, 153 n. 26; museification of 197; panoramas as entertainment 180–2, **181**; political movements 38, 59; population 29–30; and postmodernism 198; railways *see* transport systems; suburbs (*Vorstädte*) 46, 88; theatre 34; transport systems 27, 29; 'Venice in Vienna' 86; views of 15, 159, 202; women in 30; women's movements in 90, 96 n. 56

'Vienna 1900' 17, 20, 25, 198, 202, 204

Vienna Secession: and architectural interiors 40, 59, 83; and Austrian-ness 80; and Biedermeier culture 78, 91, 123–4; Building 43, 60, 69, **71**, 74, 77, 102; domestic architecture 43–4; exhibitions by 21, 23, 43, 81, 108; founded 30; as *goût juif* 59, 88; split in 63 n. 25; and Symbolist art 108; and women's dress 84, 126; *see also* *Gesamtkunstwerk*

Vienna Woods: views from 15, 133–4

views, *see* panoramas; Vienna, views of

Waerndorfer, Fritz 100

Wagner, Otto: on men's dress 115